HARRY CLARKE'S WAR

Dedication

To those who served

HARRY CLARKE'S WAR

ILLUSTRATIONS FOR
IRELAND'S MEMORIAL
RECORDS 1914–1918

MARGUERITE HELMERS

IRISH ACADEMIC PRESS

First published in 2016 by
Irish Academic Press
8 Chapel Lane
Sallins
Co. Kildare

© 2016 Marguerite Helmers

British Library Cataloguing in Publication Data
An entry can be found on request

978-07165-3308-5 (Cloth)
978-07165-3309-2 (PDF)

Library of Congress Cataloging in Publication Data
An entry can be found on request

CONTENTS

ACKNOWLEDGEMENTS

This book would not have been possible without the encouragement and support of many people. Librarians and archivists in America, Ireland, and England have helped me track down copies of *Ireland's Memorial Records* and related documents. Accordingly, the staffs of many libraries deserve thanks: Peter Harrington, Anne S.K. Brown Military Collection, Brown University Library; University College Dublin; Royal Irish Academy; National Library of Ireland; Early Printed Books, Trinity College Dublin; University of Reading; Imperial War Museum; British Library; Mary Evans Picture Library; and Victoria and Albert Museum, including the archives of the Royal Institute for British Architecture. Maria Choules and Andrew Featherstone at the Commonwealth War Graves Commission offered me a table to review files, and Maria took me under her wing and included tea in the mix. A number of people in Ireland guided me toward resources: Andy Bielenberg, Nicola Gordon Bowe, Tom Burke, James Cronin, Brian Donovan, Catriona Crowe, Christy Cunniffe, Gabriel Doherty, Myles Dungan, Simon Gregor, Fianna Griffin, Angela Griffith, Richard Hearns, Gavin Hughes, Michael Hughes, Roisin Kennedy, Vera Kreilkamp, Angus Mitchell, Ellen Murphy, Stephen Regan and David Rundle.

Generous support from the University of Wisconsin Oshkosh Faculty Development Program and College of Letters and Science allowed me to spend one year as a fellow of the Institute for the Humanities at the University of Wisconsin Madison. Susan Stanford Friedman's expert guidance and the marvellous insights of the other fellows shaped the early drafts of the book. Particular gratitude goes to Richard Leson, University of Wisconsin Milwaukee.

At the University of Wisconsin Oshkosh, I thank Dean John Koker

and Department Chair Roberta Maguire for the release time to pursue research; Robert Wise, faculty head of the Faculty Development Board; and Provost Lane Earns for support. About my kind colleagues in the Department of English, I cannot say enough, but let me list Paul Klemp, Ron Rindo, Pamela Gemin, Douglas Haynes, Stewart Cole, Pascale Manning, Margaret Hostetler, and Christine Roth for listening. Joshua Ranger's expertise as an archivist has helped me out many times. My students at the university have been gracious enough to listen to my thoughts about the significance of the First World War in literary studies. Justus Poehls, in particular, deserves special thanks for compiling the bibliography.

The Milwaukee Irish Fest Foundation funded travel to Ireland for research. A thousand thanks to Patrick Boyle and Cathy Ward. Bewley's Dublin, where the lovely windows by Harry Clarke grace the dining room and where I've enjoyed many cups of tea, contributed to the acquisition of the illustrations. In addition, Castle Leslie, home of my distant cousins Shane Leslie and Norman Beauchamp Leslie, who was killed in the First World War, dedicated funds to acquire images as well.

To Lisa Hyde at Irish Academic Press, thank you for your patience. Conor Graham, thank you for your enthusiasm and sound advice. To the copyeditors, artists, typesetters and printers without whom this book and others could not exist: you are integral to the process and deserve all readers' gratitude for your skills.

This book would not have been possible without the patience and support of my family, Bill, Emily, and Caitlin. Caitlin, in particular, managed many of the details of the Harry Clarke images. Gladys Helmers provided the gift of travel. As I grew up, my parents Helen and Garry filled our house with art, culture and inspiration, and to them I owe the greatest thanks of all.

Foreword

In context: Harry Clarke's decorative borders for the Irish National War Memorial Committee's Books of the Dead, *Ireland's Memorial Records, 1914–1918*

In 1923, when these eight volumes were privately published by George Roberts of Maunsel and Roberts, Harry Clarke (1889–1931) was at the peak of his all-too-short artistic career. Aged thirty-four, he had already published a series of critically acclaimed illustrated books with George G. Harrap in London, issued in limited luxury editions as well as regular editions.[1] He had also drawn a series of illustrations to Coleridge's 'Rime of the Ancient Mariner', which would have been his first published book with Maunsel & Company (as the firm was originally known[2]), had not the blocks of the main illustrations, the title page, and the head and tailpiece originals perished when the Dublin publisher's premises were destroyed by fire in the 1916 Easter Rising.[3]

The following year, 1917, Roberts and Clarke, acquainted through mutual friends in Dublin's literary and arts circles, collaborated on the first purpose-designed and printed catalogue for the Arts & Crafts Society of Ireland's Fifth Exhibition. Clarke's striking cover for the Foreword demonstrated his skill as a highly original graphic designer whose intricately drawn framework embellishes the text which it directly illustrates while idiosyncratically interrupting its inner and outer linear boundaries with spirited ornamentation. Roberts's skill as a printer did full justice to Clarke's exacting pen and ink work by using

velvet-black ink impressed onto finely receptive, cream handmade paper. An earlier more compacted design by Clarke, drawn in 1914 around his ornate lettering for a Higher Certificate awarded to exceptional National School Teachers, had been routinely, and therefore much less effectively, printed by the Commissioners of National Education.

His predilection for offsetting dense matt-black and plain white with a mass of swirling, spiralling and unfurling foliate, floral and geometric decoration can be found in all his earlier graphic work. He was deemed able to obtain 'effects of perspective and relief' with 'the finest pen and the most fluid ... pure black ink' which 'others can only procure by the lavish use of wash'.[4] Such devices can be seen framing text in the Contents page of his first published book, *Fairy Tales by Hans Christian Andersen* (1916), in his printed letterheads for the Irish National Assurance Company and *The Irish Builder and Engineer*, and for the dust-jacket of his black-and-white illustrated *Tales of Mystery and Imagination by Edgar Allan Poe* (all 1919). The 'horror and intense feeling ... depicted with a grace and beauty of detail'[5] with which Clarke illustrated Poe was considered perfectly matched by his 'arabesque, grotesque' images, and doubtless contributed to his choice as the ideal illustrator of the Memorial Records volumes. The *Irish Times* affirmed: 'Beauty's loss – the death of loveliness – was his most frequent theme.'[6] His illustrations for *The Year's at the Spring*, an anthology of recent, including war, poetry published by Harrap in 1920, included memorable images evoking Rupert Brooke's 'The Dead', Julian Grenfell's 'Into Battle' and James Elroy Flecker's 'The Dying Patriot'. After the deaths of Arthur Griffith and Michael Collins in August 1922, Clarke's fitting cover for the simple quarto booklet, *A Pictorial Record of the Lives and Deaths of the Founders of the Irish Free State*, issued in their memory in Dublin, depicted a grieving woman kneeling at the water's edge beneath two crosses set against the setting sun.[7] On either side of the political spectrum, his ethereal graphic and stained glass memorial images on both sides of the Irish sea convey dignified, idealized sorrow during 'the sad and mournful time when he was reaching the zenith of his genius' and 'parents all over Ireland were mourning lost sons'.[8]

As Marguerite Helmers suggests, the link between Clarke's decorations for *Ireland's Memorial Records* and such earlier commissions is likely to have been Laurence Ambrose Waldron, wealthy, well-connected Dublin stockbroker, bibliophile and collector, who served on the original Committee of the Irish National War Memorial which commissioned Clarke's illustrations, and on that of the Arts & Crafts Society of Ireland. Waldron, among Clarke's most devoted and influential patrons, filled his County Dublin seaside villa with books and the best eighteenth century and contemporary Irish decorative arts. He continued to champion the prize-winning young artist's pen and ink work and stained glass until he died in 1923, the year the *Memorial Records* were published. The Irish High Cross memorial Clarke incorporated into the title page of the War Memorial volumes anticipates the similar Lutyens-esque cenotaph cross he drew for Waldron's memorial card in December 1923.[9]

In June 1919, Viscount French, as Lord Lieutenant of Ireland, launched an appeal pledging the British Army's commitment to perpetuate 'the names and personalities of over 49,000' gallant Irish men and women in Irish and British regiments who had sacrificed their lives throughout during 'the Great European War, 1914–1918'.[10] £5,000 of the National War Memorial funds were spent on this project which gave as much relevant information as possible on each individual person commemorated.[11] The Committee's hope was to incorporate the names on this Roll of Honour into 'some permanent building or memorial worthy of their memory'. However, by the time one hundred sets of the volumes were printed in 1923, ready for international distribution 'through the principal libraries', churches and clubs within Ireland and beyond, this had been precluded by 'circumstances prevailing in Ireland since 1919' as Civil War raged throughout the country. Despite the 'great publicity' and effort given to obtaining 49,435 names listed 'from private sources and through the Press', the delegated sub-committee expressed its profound regret 'that they ha[d] not been able to obtain a complete list of the fallen Irishmen in the Navy, Air Force, and Colonial Regiments'.

The Committee ensured that the printing and decoration of the volumes were 'carried out by Irish artists and workers of the highest reputation and efficiency', particularly in the case of the special *de luxe* edition presented to the King, George V, in 1924 – as described by Dr. Helmers. George Roberts supervised the setting and photo-engraving of each page of the clearly arranged text, before they were set within the series of eight repeated and reversed 'beautiful symbolical borders ... designed by Clarke'. These, and the decorative title page, were engraved separately by the Irish Photo Engraving Company and the Dublin Illustrating Company, before the whole book was masterfully printed on handmade paper.[12] The morocco binding, onlay and tooling on the cover of the special edition were by a Dublin man, William Pender, who exhibited his tooled morocco leather bindings for the writer Lord Dunsany with the Irish Arts & Crafts Society.[13] The doublures for the *de luxe* edition were crafted by Percy Oswald Reeves, the distinguished Arts and Crafts metalworker and pioneering teacher, who had designed and collaborated with fellow Dublin colleagues in making a fine Arts and Crafts enamelled war memorial triptych in 1920.[14] Reeves had earlier singled out Clarke as having 'gone further in achievement than any of his fellows' in the Irish Arts and Crafts movement not only as regards craftsmanship but also because his work epitomized 'how a genuine Celtic character marks the best Irish Applied Art'.[15]

Clarke's title page, signed and dated 1922, reprinted with alphabetical amendments at the start of each volume, is contemporary with his illustrations to *The Fairy Tales of Charles Perrault* published by Harrap that year. It features columnar, elaborately winged angels bearing the arms of the four provinces of Ireland who hover above the diminutive figure of Hibernia, drawn on same small scale as his half-title Perrault line drawings. Doll-like, turbaned and costumed in *Ballets Russes* mode, Hibernia stands with her token unstrung harp and wolfhound bearing a flaming torch of remembrance, flanked by the traditional high cross, round tower and ruined chapel associated with her image. The radiating lines of the sun setting over the sea's horizon behind her symbolize the hope of resurrection while

suggesting the symbolically rising sun of the Fianna. Rhythmic loops fall like theatrical curtain rings from the elongated snout of the all-seeing beast framing the Celtic Revival lunette enshrining her. The swirling flowery dots that decorate her robe and the bodies of the beasts beside her recur in both Clarke's full-page borders and in his Perrault illustrations. Similarly, other signature Clarke devices like the poignant use of silhouettes and neo-Baroque swags and unfurling curlicues can be found in the Perrault. The beguiling zoomorphic Celtic strapwork cornering and bordering the decorative interlaced framework on the title page is particularly vigorous yet restrained in its flattened overlay, as though paraphrasing ancient silver hinges. Close observation reveals cavorting beasts with plumed heads and knowing eyes, vestigial limbs and spiralling chameleon tails amidst motifs loosely drawn from Early Christian burial monuments. Here is a modern reworking of an illuminated 'carpet' page, whose almost imperceptibly pierced border is modulated in Clarke's inimitable miniaturist pen and ink technique.

There is nothing tenuous about Clarke's eight borders within the Books of the Dead. Stylistically, their 'lavish ornamentation, superlative craftsmanship and fine materials' may conform to definitions of Art Deco.[16] But the restless, relentlessly fluid unfurling arabesques ebbing and flowing like crested waves, threatening to engulf poignantly observed pictorial vignettes, and the flattened leafy, feathery swags interlaced like ropes around the accoutrements and insignia of war are unique in Clarke's work. As the tragedy unfolds in tiny silhouetted scenes derived from contemporary photographic records of soldiers engaged in battle, angels and risen warriors await the dead, bearing laurel wreaths and military honours.

It would be ten years before the Trustees of the Memorial Fund and the Free State Ministry of Finance agreed to acquire a ten-acre site beside the River Liffey at Islandbridge, near Dublin's Phoenix Park, in order to erect a permanent Irish War Memorial. When this was finally opened on Armistice Day 1940, the Books of the Dead were placed not in pairs in each of the four granite pavilions Sir Edwin Lutyens had conceived as book rooms, but arranged in facing lines

in a dedicated Book Room.[17] Sadly Harry Clarke had himself died nearly ten years earlier so never saw them there. This study serves as a timely reminder of their unique importance in the context of Irish war memorial studies.

Nicola Gordon Bowe
© 2015

NOTES

1. See Nicola Gordon Bowe, *Harry Clarke: The Life & Work* (Dublin: Irish Academic Press, 1989; new ed. Dublin; History Press, 2012) for full details; also Martin Steenson, *A Bibliographical Checklist of the Work of Harry Clarke* (London: Books & Things, 2003).

2. For the origins of Maunsel and Company, see Clare Hutton (ed.), *The Irish Book in the Twentieth Century* (Dublin: Irish Academic Press, 2004), pp. 36–46. Maunsel was the middle name of Joseph Maunsell Hone, a founding co-director of the firm with Roberts, 'who really ran the company throught its existence – between 1905 and 1920 as Maunsel, and from December 1920 until 1925 as Maunsel and Roberts' (p. 44).

3. See Bowe, *Harry Clarke* (Dublin: Douglas Hyde Gallery, Trinity College, 1979), pp. 63–65 and Bowe, *Harry Clarke: His Graphic Art* (Mountrath: Dolmen Press, 1983), pp. 112–116.

4. Thomas Bodkin, 'The Art of Harry Clarke', *The Studio* (November 1919), Vol. 79, no. 320, pp. 44–52.

5. Harraps' prospectus, quoted in Bowe 1983, p. 52.

6. 'Books of the Week', *The Irish Times*, November 20th 1925, p. 3.

7. See Bowe 2012, p. 203.

8. Kevin Myers, 'An Irishman's Diary', *The Irish Times*, December 14th 1989, p. 13. Clarke's poignant war memorial windows of the period include those in Killiney, Co. Dublin, Nantwich, Cheshire, Wexford town and in Gorey, Co. Wexford (see Bowe 2012, pp. 312–9). The figure of St. Martin (1922) in Gorey resembles the saintly warrior in the *Memorial Records* borders.

9. Illustrated in Bowe 1983, p. 59.

10. Viscount Ypres, Foreword, dated 28th December 1922 and Introduction in *Ireland's Memorial Records, 1914–1918* (Dublin: Maunsel and Roberts, 1923), Vol. 1. Lord French was created Earl of Ypres in June 1922 after resigning as Lord Lieutenant of Ireland in April 1921.

11. See Bowe, 'Ireland's Memorial Records, 1914-1918', *Ireland of the Welcomes*, November/December 2006, pp. 18–23. With thanks to Miss Eva C. Barnard, secretary of the Committee, who compiled the list of names.

12. Two of the woodblocks faced with Clarke's designs photo-engraved on metal survive from Miss Barnard's private collection.

13. For Pender, see Bowe and Elizabeth Cumming, *The Arts and Crafts Movements in Dublin and Edinburgh, 1885–1925* (Dublin: Irish Academic Press, 1998), p. 126 and Bowe, 'Lord Dunsany 1878–1957. Portrait of a Collector', *The Decorative Arts Society 1850 to the Present*, 28 (2004), pp. 126–147.

14. See Bowe and Cumming 1998, pp. 174–5 and Bowe, 'Percy Oswald Reeves 1870–1967, Metalworker and Enamellist: Forgotten Master of the Irish Arts and Crafts Movement', *Omnium Gatherum 1994*, Journal Number Eighteen (1994), *The Decorative Arts Society 1850 to the Present*, pp. 61–68.

15. P. O. Reeves, 'Irish Arts and Crafts', *The Studio* (October 1917), Vol. 72, no. 295, pp. 15–22.

16. See Alastair Duncan, *Art Deco* (London: Thames & Hudson, 1994), pp. 7–10.

17. Letter dated 21 January 1936, sent by Lutyens from London to Miss H.G. Wilson, by then secretary of the Irish National War Memorial Committee in Dublin, referred to by Dr Helmers in her text. I am grateful to her for drawing my attention to this.

Introduction

'Cities, like dreams, are made of desires and fears, even if the thread of their discourse is secret, their rules are absurd, their perspectives deceitful, and everything conceals something else.'

Italo Calvino, Invisible Cities

The Missing

For several years, when visiting Dublin, I attempted to spend an afternoon at the Irish National Memorial Gardens at Islandbridge, but there was always some barrier. Once, it was dramatic. When Queen Elizabeth visited the city in 2011, I walked along the Liffey only to find the memorial secured and guarded. I should also clarify my first statement: I attempted to visit the Irish National Memorial Gardens at Islandbridge once I became aware that the gardens existed, for five years of travels to the city had come and gone before I knew the memorial was there. It's not featured on *Streetwise Dublin* or on city centre maps; tourist maps show bright bus lines circling from O'Connell Street to Kilmainham Gaol, but there's typically a large blank space on the map where the memorial should be. My own curiosity about the memorial comes from an unlikely source. I have been teaching and researching the poems, memoirs and art of the First World War for two decades, and my interest was piqued by an extended scene set at the gardens in Paul Murray's novel *Skippy Dies*, published in 2010. In that novel, erstwhile history teacher Howard

Fallon, tired of history taught from books, takes his secondary students from Seabrook College on an impromptu field trip to Islandbridge. The students are nervous, traveling into a part of Dublin that they are not familiar with, but once they are among the monuments and hear the stories of the soldiers who fought and died in the First World War, they are intrigued with recovering lost history.[1]

In the process of cursory research of the Irish National War Memorial Gardens, mostly through websites, I learned that there were illustrated books of remembrance in the pavilion bookrooms. I am, by training, a rhetorician, and my particular field of interest is in visual rhetoric. Visual rhetoric is a field of study that the American scholar W. J. T. Mitchell has called an 'indiscipline', on the borders between philosophy, rhetoric and art history. Visual rhetoricians return to Aristotle's concept of rhetoric as 'the capacity to observe in regard to any subject the available means of persuasion'.[2] Whereas art historians study the provenance of works of art, visual rhetoricians study the arts of communication and persuasion. We have the freedom to take literary criticism and theory and apply it to works of art, mass culture, and visual culture. Our intent is not to define, but to examine and provoke. Thus, the illustrated books of remembrance housed within the war memorial signalled to me an intriguing intellectual opportunity to consider the way that physical spaces and material objects relate to collective memory.

Writers who describe the research process often speak of a special moment of serendipity, a combination of luck and what rhetoricians call *kairos* – being in the right place at the right time. It's likely true that luck favours those who are prepared; I was very lucky to be prepared enough to discover Harry Clarke's illustrations for *Ireland's Memorial Records* when I did, in May 2013, on the eve of the First World War Centenary. The war memorial is a space charged with a unique task: to hold eight beautifully bound books created by an important Irish artist of the early twentieth century. This purpose is replicated only at a few national memorial sites from the First World War, most notably in Scotland and Australia. Within a single bookroom at the memorial site, the full eight volumes of the set of *Ireland's Memorial Records* lie open

in glass cases. That bookroom is locked, but once it opens, the sight of sixteen Harry Clarke engravings is unforgettable. In this book, I will do my best to tell the history of these beautiful volumes. Frustrations and breakthroughs are part of the research process. It's not uncommon to discover that a key document from an archive is missing, nor is it unusual to travel hundreds or thousands of miles to an archive only to find it unexpectedly closed on the very day that you arrive with your notebook. In many ways, this book about *Ireland's Memorial Records* is a tale of research and writing. Yet a century of silence has intervened between their commission and this publication. Documents, if they ever existed, are missing. Library copies of rare publications, among them, Harry Clarke's diary from the 1920s, have been lost, destroyed, or stolen. *Ireland's Memorial Records* themselves have been locked away.[3]

The Walls

One of the key questions that the history of *Ireland's Memorial Records* raises is about memory: how can something be a memorial if it is lost or forgotten? John Horne, Keith Jeffery, Fergus d'Arcy, and Paul Murray have all pointed out that the Irish National War Memorial Gardens have been neglected culturally (and, until recently, uncared for physically as well), their significance erased from Irish history.[4] The art historical significance of these records, held by this culturally marginalized memorial, are modestly acknowleged but overlooked in the greater stories of First World War art.

Let me note, as well, the diverse names that the memorial takes. It is variously referred to as the War Memorial Gardens, Ireland's War Memorial, National War Memorial Gardens, Irish War Memorial Gardens, Irish National War Memorial, and the Irish National War Memorial Park. Officially, the site should be termed the Irish National War Memorial Gardens. The proliferation of terms suggests an uncertainty over their role: Are they gardens? Are they a memorial? What is a memorial garden?

In addition to the name, tangible obstructions and a consistent pattern of not naming the site limit access to the Irish National War

Memorial Gardens. While there are several gateways to the gardens from all directions, imagine a westerly walk along the south bank of the River Liffey to visit them.

As anyone who has strolled up the river on a bright weekend will be able to envision, the city of Dublin shines under the light. The sun highlights the low eighteenth-century buildings that line the quays and tips the pillars and dome of the Four Courts with golden light. The alleys and streets running north and south are filled with shoppers and visitors, crossing the bridges over the Liffey.

At a certain point near the Guinness brewery, the pedestrians are scarce, the road begins to turn, and the points of ingress to the north and south are blocked by fencing. The high walls of the brewery and the lorries that enter and exit the complex push the walker closer to the embankment. Beyond the brewery and Croppies Acre, the road divides and turns to pass Heuston Station; the Luas Line cuts the road in two; and two bridges cross the river. The walker is faced with a choice at the crossroads: left or right? If the walker is looking for some sign that points to the Irish National War Memorial Gardens, the walker will seek in vain.

Left or right? A logical choice, if seeking a park, is to turn right towards Phoenix Park, brave the oncoming traffic at the convergence of the Luas Line and Parkgate Street, and start up the hill. Not long after, the stone pillars and wide tree-lined boulevard of Phoenix Park appear on the opposite side of the road. Large tour coaches coming from the city to the east turn into the park; none of the coaches continue west along Conyngham Road, past the blank walls of the bus depot and the new apartment block. It's at this point that a walker will notice two things: all the cars are moving quickly, either toward the city center or away from it; and most of the sidewalk and street is blocked off by walls and fences. There are still no signs for the Irish National War Memorial Gardens.

Following the fences as the road gently slopes down toward the river, the walker will turn left at Con Colbert Road and follow it a short distance to an unnamed road, just past several older houses. Here, at last, is a sign. It is a small sign that announces in Irish and

English, 'Gairdíní Cuimhneacháin Cogaidh, Irish Memorial Gardens'. The walker turns to the right, only to encounter more walls, some with graffiti on them, parked cars and lorries. The lane takes another turning and draws between some high decorative gates. Through them, down another path and past the parking area for the Trinity Boat House, are more decorative, high metal gates – locked. Upon them, a second sign: 'Ireland's War Memorial'.

The Margins

I tell this story because it introduces the prevalent theme of the margins to the study of *Ireland's Memorial Records*. Harry Clarke's contributions to *Ireland's Memorial Records* consist of decorative borders in the style of medieval illuminated manuscripts – marginalia. His subject was a topic that was pushed to the margins of Irish history. While the elaborate artwork makes *Ireland's Memorial Records* a lasting, significant contribution to modernist art of the early twentieth century, knowledge of the illustrations is generally limited. Recently, websites have been developed to help locate names of the Irish who were killed in the First World War; however, the names from the *Records* are decontextualized from the elaborate ornamentation designed by Clarke. In other words, anyone searching online can't see the images.

This book attempts to build a pathway through the history of *Ireland's Memorial Records*. Any new writing about Harry Clarke is indebted to the considerable scholarship of his biographer, Nicola Gordon Bowe. Her publications are not only thorough, but beautifully illustrated and carefully written. There is no better place to begin than *Harry Clarke: The Life and Work*.

My own work is intended for a general audience. It draws on historical documents, scholarly sources, and some critical theory. My hope is that the criticism will illuminate some of the interpretive aspects of Clarke's work and offer questions for further research.

Chapter One situates Harry Clarke's commission to create the illustrations within the major political conflicts of the war years,

1914–18. Although a single chapter of this book cannot do justice to the complexities of the conflicts of the First World War and the 1916 Easter Rising in Dublin, it is necessary to envision *Ireland's Memorial Records* emerging from differing national allegiances. On the one hand, supporters of the British government wanted to remember the service of the Irish in the First World War as heroic; on the other hand, Irish nationalists found such service to be traitorous. I would hope that readers unfamiliar with the relationship of these two significant events might be encouraged to read further in the many excellent histories of both conflicts.

Chapter Two positions *Ireland's Memorial Records* within various art historical movements, including the development of war art, the Arts and Crafts Movement, and popular silent film. In addition, *Ireland's Memorial Records* were connected to an important movement by England's Imperial War Graves Commission[1] and London's Royal Academy of Arts to establish a common memorial language, given that nation's unprecedented struggle to honour the millions of dead. Accordingly, I introduce the publication of Imperial War Graves Commission cemetery registers by Douglas Cockerell to this discussion.[i]

Chapter Three examines the detailed drawings for each of the nine plates in *Ireland's Memorial Records*. The record of an artist's thought is often found within the work itself. Clarke did not leave any written or sketched record of his commission, other than the printed pages of the books. Bowe, who had access to the family papers as she worked on her many detailed studies of his stained glass and graphic art, reports that there are no known extant sketches, preliminary drawings, or correspondence related to the commission.[5] I have relied on my research into First World War posters and my previous publications on the visual culture of the war to build an interpretation for readers.

[i] The Imperial War Graves Commission (IWGC) was created by Royal Charter in 1917. In 1960, its name became the Commonwealth War Graves Commission. Throughout this book I refer to it by the name in use from 1917–39.

Chapter Four takes up the story of the Irish National War Memorial Gardens, which I contend were designed as an archive, a Palladian construction of four bookrooms where copies of *Ireland's Memorial Records* could be housed and consulted. Sir Edwin Lutyens, who drew up the architectural plans for the Irish National War Memorial Gardens, replaces Clarke as the protagonist in this chapter, for Clarke passed away in 1931, just as the ground was broken for the memorial in Islandbridge. This chapter concludes with reflections on the irony of the two forgotten spaces: *Ireland's Memorial Records* and the bookrooms of the Irish National War Memorial Gardens.

My position as an American researcher has allowed me to weigh the facts as I have found them. I have treated Harry Clarke's engravings as I have treated other aspects of visual culture that I have written about in the past: examining the way that the illustrations came into being, the details of the artistic work, and how the set of *Ireland's Memorial Records* are displayed. This is a work about rhetoric and the particular rhetorical trope of *epediectic*, or display. It is not a work about politics. That Harry Clarke's illustrations for *Ireland's Memorial Records* were intended to be housed in an Irish national war memorial does not mean that this war memorial is being elevated above other memorial sites in Dublin or Ireland.

Although the legacy of the war once known as the Great War is still contentious, we need to remind ourselves that Harry Clarke was in no way celebrating war and that *Ireland's Memorial Records* are not instruments of propaganda. Clarke was creating art – and art matters. Art mattered just as much in 1923, when the books were published, as it matters now. Art can restore the soul and refresh the senses. Art can make us think and see the world around us in a new way. Clarke's decorative designs gave voice to his intellect and his sentiment, and they should engage our minds as well as release our emotions. If they ask us what we believe, so much the better, as that is one province of art. *Ireland's Memorial Records* are distinctive; they are the only national roll of honour completed by an internationally renowned artist to emerge from the 1914–18 conflict. This singular feature is a distinction for Ireland, for Dublin, and for art.

NOTES

1. P. Murray, *Skippy Dies* (New York: Macmillan, 2010), pp.552–53.
2. E. M. Cope, *Commentary on the Rhetoric of Aristotle*, (Cambridge: Cambridge University Press, 1877).
3. H. Clarke, National Library of Ireland, MS 39,202/B, contains diaries from 1914 and 1919.
4. J. Horne and E. Madigan, *Towards Commemoration: Ireland in War and Revolution, 1912-1923*, (Dublin: Royal Irish Academy, 2013); K. Jeffery, *Ireland and the Great War*, (Cambridge: Cambridge UP, 2000); F. D'Arcy, *Remembering the War Dead: British Commonwealth and International War Graves in Ireland Since 1914* (Dublin: The Stationery Office, 2007); P. Murray, *Skippy Dies.*
5. N. Bowe, personal conversation, June 2014.

The Irish in Gallipoli

Francis Ledwidge, 1917

Where Aegean cliffs with bristling menace front
 The Threatening splendor of that isley sea
Lighted by Troy's last shadow, where the first
 Hero kept watch and the last Mystery
Shook with dark thunder, hark the battle brunt!
 A nation speaks, old Silences are burst.
 Neither for lust of glory nor new throne
This thunder and this lightning of our wrath
 Waken these frantic echoes, not for these
Our cross with England's mingle, to be blown
On Mammon's threshold; we but war when war
 Serves Liberty and Justice, Love and Peace.
Who said that such an emprise could be vain?
Were they not one with Christ Who strove and died?
 Let Ireland weep but not for sorrow. Weep
 That by her sons a land is sanctified
 For Christ Arisen, and angels once again
Come back like exile birds to guard their sleep.

I

Things Fall Apart: Art Emerges from Conflict

1919. In Dublin, the artist Harry Clarke is struggling with a commission to illustrate an anthology of poetry edited by Lettice d'Oyly Walters, titled *The Year's at the Spring*. Harrap's in London has just published Clarke's macabre illustrations for Edgar Allan Poe's *Tales of Mystery and Imagination*. William Butler Yeats writes 'The Second Coming', reflections on the aftermath of the First World War. Dáil Éireann assembles in January, but by September is ruled illegal. Two members of the Royal Irish Constabulary are killed in Tipperary. The aviators John Alcock and Arthur Whitten Brown cross the Atlantic in their First World War era Vickers Vimy bomber, landing in Clifden, Connemara. The complete poems of Francis Ledwidge, who was killed in the Battle of Passchendaele, are published posthumously.

The Treaty of Versailles is signed on 28 June 1919, marking five years to the day after the murder of Archduke Franz Ferdinand. Anarchy and revolution spread throughout Germany. In Berlin, Max Beckmann completes his painting, *Die Nacht*. On Bastille Day in Paris, a two-hour victory parade marches under the Arc de Triomphe, passing a towering pyramid of cannons along the Champs Élysées. In London, Edwin Lutyens designs a cenotaph to the dead and wounded that will be the centerpiece of Allied Peace Day celebrations. In Dublin, the Viceroy, Sir John French, decides that in Ireland, too,

there will be a parade and a permanent memorial to the missing and wounded. Harry Clarke receives the commission to illustrate the eight volumes of *Ireland's Memorial Records.*

Ireland's Memorial Records are Commissioned

Ireland's Memorial Records were commissioned in 1919 and published in 1923 by the Dublin firm Maunsel and Roberts.[1] These volumes contain the names of 49,435 individuals of Irish birth, ancestry, or regimental association who were killed in action or died of wounds in the First World War. There are eight volumes and 100 sets of *Ireland's Memorial Records.* They are distinctive as honour rolls because of the richly illustrated borders by Harry Clarke, who is recognized in

FIGURE 1.1
Harry Clarke Diary 1919. Image Courtesy of the National Library of Ireland, MS 39, 202 (B)(2).

Ireland as one of the foremost artists of the early twentieth century. Clarke contributed an evocative Celtic-themed title page and eight illustrated borders. When Harry Clarke was awarded the commission to create decorative margins for *Ireland's Memorial Records*, the only trace he left of any conversations was a line in his pocket diary for 29 September 1919, which reads simply, 'Irish Nat Memorials'.[2]

One hundred years later, computer programs and web-based interfaces allow *Ireland's Memorial Records* to be searched online for names, regiments, and dates of death. The ease of international access to the data has meant that the artistic achievement of *Ireland's Memorial Records* has been lost. The artwork has been removed from the online search capability; the illustrations are considered secondary to the text, mere decoration. What if we were to set aside the text for a time and consider only the borders? What if *Ireland's Memorial Records* were considered not a flawed collection of names, but a superior realization of memorial art?

Maunsel and Roberts were known for printing nationalist literature including J. M. Synge's *The Well of the Saints* (1907) and the *Collected Works of Padraic [Padraig] H. Pearse* (1917). Thus, they were a suitable publisher for printing the roll of the Irish dead. Given the choice of publisher and artist it appears as though Clarke's illustrations and George Roberts's visual design were symbolic acts of repatriation of the Irish soldiers, removing them from Britain's army into a realm of purely Irish aesthetics. Each volume of *Ireland's Memorial Records* measures twelve inches by ten inches. Following the decorative title page, eight images are repeated throughout the volumes, in recto and verso (reversed) – including soldiers in silhouette, ruined houses, graves, trenches, the Gallipoli Peninsula, cavalry, airplanes, tanks, bursting shells and searchlights. Sets were delivered to libraries and cathedrals in Ireland, England, Canada, Australia, and the United States. A very fine set was presented to King George V on 23 July 1924 and, also at that time, a set was conveyed to the Vatican.[3]

Who was Harry Clarke? He is known as a talented and visionary stained-glass artist. He was born in Dublin, educated at Belvedere College, and left school at age 14 to enter into a series of apprenticeships.

While he began to refine and perfect his stained-glass technique through plating and aciding the glass, he also was working on pen and ink illustration. In 1913, Clarke received the commission to illustrate the *Fairy Tales of Hans Christian Andersen* for George Harrap & Co., London and he was occupied with his illustrations and travels on the continent throughout 1914. When England declared war on Germany on 4 August 1914, Clarke did not enlist. From 1914 onward, he was dedicated to a commission to complete eleven stained-glass windows at the Honan Chapel in Cork, which are now considered among his masterpieces.[4]

The Lord Lieutenant of Ireland, Sir John French, instigated the idea for a national war memorial on 17 July 1919, the day prior to the Peace Day celebrations.[5] The year marks the beginning of a great age of war memorials in Britain and the Commonwealth, with public and private monuments raised to commemorate over one million British troops dead or missing in the war. The pressing desire for post-war remembrance fostered two exhibitions held in London in 1919 by the Victoria and Albert Museum and the Royal Academy War Memorials Committee. Clarke's domestic stained-glass panel 'Gideon' was among the new works exhibited at the V&A exhibit that opened in July 1919.[6] In Ireland, a core group that would become the sustaining subcommittee for Irish memorials came together at the 1919 meeting, including in particular, Andrew Jameson (director of the whiskey distillery) and Clarke's patron, the former MP Laurence Waldron.[7]

This meeting in July 1919 resulted in two resolutions that were 'unanimously passed': first, 'to erect in Dublin a permanent Memorial to the Irish Officers and men of His Majesty's Forces who fell in the Great War'; and to prepare 'parchment rolls' upon which 'should be recorded the names of Irish Officers and men of all services who had fallen in the war'.[8] At this point in 1919, from the first meeting of a group of interested and, it appears, mostly loyalist parties, *Ireland's Memorial Records* were joined with a permanent memorial structure to house them, which we know today as the Irish National War Memorial Gardens. Although *Ireland's Memorial Records* were

completed in 1923, the memorial would not be complete until 1938, the eve of Britain's entry into the Second World War. Consequently, the memorial was not officially opened until 1988.[9]

Given an absence of historical records, it is difficult to answer with any certainty why Harry Clarke was chosen as the illustrator or Maunsel as the publisher. Extant historical documents are silent on the official decisions and parlour conversations that might shed light on the making of the books. It is likely that his friendship with Waldron led to the commission, for Waldron was present at the initial meeting at the Viceregal Lodge. Descriptive, illustrative announcements of their publication appeared in key publications in the early 1920s, the books were exhibited to the public, and copies were distributed to libraries. However, due to the political climate in Ireland that challenged any affiliation with the crown and the absence of a suitable memorial space for display, *Ireland's Memorial Records* slipped into a long period of obscurity.

War Memorials in Ireland

On 4 August 1914, the date that England declared war on Germany, the Irish people were governed by Great Britain. Four years later, on Armistice Day, 11 November 1918, Ireland was on the brink of a war to secure independence from England. The intervening four years were momentous, including the granting and subsequent suspension of the Government of Ireland Act in 1914, the 1915 military disaster at Suvla Bay, the 1916 rebellion in Dublin raised by the Irish Volunteers, and the 1916 devastation of the Battle of the Somme. By the conclusion of the First World War, Irish soldiers returned to a country divided, their status as British military veterans complicating their relationship with the emerging Irish Free State.

The historian Fergus D'Arcy opens his survey of war memorials in Ireland by noting that the service of Irish soldiers to the First World War was for many years 'a story woefully neglected and willfully forgotten'.[10] This sentiment has been echoed by the historian John Horne, who has argued that 'from the Second World War the memory

of the Great War was increasingly denied in the public life and self-understanding of independent Ireland'.[11] While many recent histories have rectified the denial and neglect, the question of remembering and commemorating the Irish dead of the First World War continues to provoke controversy.

What role do *Ireland's Memorial Records* play in remembrance? The intent of books of remembrance is to offer a tangible object for reflection. Not only do they provide evidence of the service record of the dead, but also they elevate the names to a semi-sacred status of sacrifice for the nation. Paired with a memorial space, such as a chapel within a cathedral or a dedicated war memorial, rolls of remembrance offer powerful connections between the individual and the nation. In several major Anglican cathedrals in England, such as Canterbury, St Paul's, and Manchester, services of remembrance surrounding the regimental rolls of the dead continue to take place daily, weekly, or monthly. These rituals of 'turning of the pages', connect the living, the dead, the church, and the state. *Ireland's Memorial Records* are displayed within Church of Ireland cathedrals, and similar page-turning rituals were intended initially to take place in Ireland.

Abstracted from memory rituals, as richly illustrated, finely-produced books, the *Records* tell us about the relationship of art and culture to Irish politics during the pivotal decade that encompassed the First World War and Irish independence. To build a modern and identifiable Irish cultural identity, Irish arts were inspired by history. In 1916, Padraig Pearse, one of the leaders of the Easter Rising, published four pamphlets outlining the political philosophy of past leaders Wolfe Tone, John Mitchel, Thomas Davis, and James Fintan Lalor, thereby connecting their ideals and sacrifices to the contemporary Irish cause. Exploring similar paths in literature and the arts, William Butler Yeats, Lady Augusta Gregory, and John Millington Synge were instrumental in creating a national Irish voice in literature and drama. An Irish Arts and Crafts movement, led in part by the Yeats sisters, Susan (known as Lily) and Elizabeth (known as Lolly), investigated the means for incorporating Irish themes with Irish materials.[12] Also working to establish a Celtic Revival were

George Russell (known by the pseudonym AE, short for Aeon, or 'life') and his group of mystical visionary poets. Harry Clarke was part of this immense creative moment in Ireland. However, Clarke, like his contemporary James Joyce, not only looked to the symbols and stories of Irish history, but also was influenced by European modernism. Clarke's social connection with advanced nationalists from Ireland enabled him to synthesize continental elements of the *avant-garde* with the artistic language of the Celtic Revival. The power of the illustrations for *Ireland's Memorial Records* is evident in their complicated design, which demonstrates influences of modernist art while incorporating Celtic themes. Just as the First World War was an event in which modern technology was introduced into nineteenth-century battle tactics, so also Harry Clarke's illustrations blended international modernism with the nineteenth-century aesthetics of the Celtic Revival and Arts and Crafts movements.

As later chapters will detail, there are many influences on the design of the borders in *Ireland's Memorial Records*, including the *Book of Kells*. For one, Nicola Gordon Bowe records that Clarke consulted photographs in *The Irish Soldier*, a six-issue magazine about the war published by Eason's, and part of a British ministry of information recruiting initiative.[13] Secondly, Clarke's striking use of silhouetted figures in the *Records*, were suggested by a widely used recruiting-poster technique. Clarke would have seen these posters in Dublin and during his trips to England. Captain H. Lawrence Oakley was to become particularly well-known for his posters and his series of trench-life silhouettes in the *Illustrated London News*, titled 'Oakley of the *Bystander*'.[14] Third, several drawings of soldiers in motion suggest that Clarke had army training manuals at his disposal; these manuals offered photographs and diagrams of the proper way that grenades should be handled. I argue in a later chapter that Clarke also drew on the innovations of cinema, a popular new visual technology that promised narrative possibilities for arranging images in sequence.

Therefore, rather than an isolated creative work, *Ireland's Memorial Records* are part of an outpouring of commemorative art and architecture

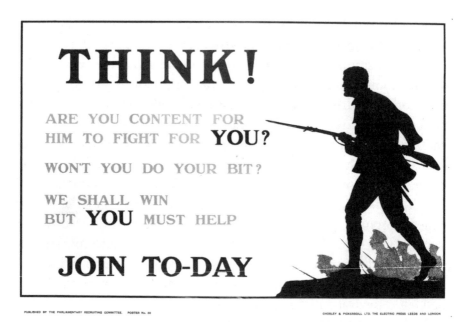

FIGURE 1.2
'Think!' (1914) by Harry Lawrence Oakley. Parliamentary Recruiting Committee, Great Britain. ©Imperial War Museum Q33144.

that extended around the globe. With over one million dead in Great Britain, individual artists and religious and cultural institutions sought ways to respectfully commemorate the dead. As already mentioned, this need was so great that the Victoria and Albert Museum and the Royal Academy of Arts held exhibitions to inspire and provide guidelines for memorials. Issues of *The Studio* from 1919 and 1920, which Clarke read, are filled with articles about new memorial work.[15] Therefore, not only were artists busy with commissions, they were interested in uniting traditional memorial styles with their own artistic vision.

The general historical trend of the past few decades has been to see *Ireland's Memorial Records* as a static list of military information, focusing particularly on the 49,435 names printed in the eight volumes. They have been compared to the official publications by His Majesty's Stationary Office, *Soldiers Died in the Great War* (1921) and *Officers Died in the Great War* (1919) – and they have been found wanting in

their level of comprehensiveness and detail. Clarke's illustrations are almost incidental in the case of debates over the textual content.

If we step back, however, we can see that even the list of names is mobile: it has been challenged, authenticated, studied, and changed. Historians, journalists, and citizens have uncovered hundreds of names of Irish servicemen in the war.[16] The centennial's focus on ordinary citizens, the contributions by the Irish citizenry to the war effort, the peace movement, and the discourse surrounding the war demonstrate that a bound list of 49,435 names represents only a fraction of those whose lives were lost as a result of the war. The list might include munitions workers, veterinarians, and those who died of physical wounds long after the Armistice. In other words, it's important to recognize that *Ireland's Memorial Records* have informed and developed dialogue for decades. Any Irish historian working with the First World War has had some engagement at some level with *Ireland's Memorial Records*.

This book is designed to tell the story of how and why *Ireland's Memorial Records* were published, how they were conceived from the beginning as part of a physical national memorial, and how Harry Clarke infused the decorative borders with his own distinctive vision. While *Ireland's Memorial Records* have been listed as part of Clarke's *oeuvre*, they have not been extensively studied in terms of their art and their history. The history of *Ireland's Memorial Records* offers a glimpse into the life of Dublin during the wars. The cast of characters is sweeping, including, in addition to Clarke himself, Andrew Jameson, William Orpen, Edwin Lutyens, Seán Keating, Joseph Maunsell Hone, George Roberts, and Sir John French, all of whom, in one way or another, affected the outcome of the books or the disposition of the Irish National War Memorial Gardens. What emerges is a fascinating story of how Dublin's unionist and nationalist leaders worked together to create a unique memorial record of the Irish dead from the First World War, the same unionism and nationalism that ultimately divided Ireland and fostered competing narratives about the First World War.

The centenary of the First World War has provided the opportunity to tell new stories, stories other than military engagements or lines of

command. War affects civilians and soldiers alike, noncombatants as well as combatants. Continued newspaper coverage of those serving on front lines, houses draped in black crepe, soldiers in uniform in the city, the activity at training camps, recruiting posters, the requisition of horses and mules, food and paper shortages, and the changing face of labour influenced the perceptions of old and young, women and men. The outpouring of art from the war is one consequence of the heightened awareness of wartime conditions.

Much has been written about British art of the First World War, particularly about the official war artists who where employed through the War Propaganda Bureau at Wellington House in London to record their impressions of the front lines.[17] These artists included well-known names, such as William Orpen, Christopher Wynne Nevinson, Paul Nash, Eric Kennington, and Muirhead Bone. Their works were featured in exhibitions in London and published in a full-colour series titled *British Artists at the Front*. The paintings of Nevinson, Nash, Kennington, and Orpen eventually came to record their profound disillusion with the horrors of the war, in keeping with the works of the poets published after 1916. Among their public statements and private sentiments, Nash's comment stands out: 'I am no longer an artist. I am an artist who will bring back word from the men who are fighting to those who want the war to go on forever. Feeble, inarticulate will be my message, but it will have a bitter truth and may it burn their lousy souls.'[18]

Orpen, born in Dublin, an instructor at the Dublin Metropolitan School of Art, and Harry Clarke's teacher, became an official war artist for the War Propaganda Bureau in 1917. The Irish painter John Lavery was recruited by the War Office to paint the home front. While recent reappraisals of what constitutes war art have broadened the canon to include the Belfast painter William Conor[19] and Elizabeth Thompson, Lady Butler,[20] Harry Clarke's illustrations are notably absent from scholarship on art and war. This may be because Clarke's border art for *Ireland's Memorial Records* was neither heroic nor horrific. Clarke's art reveals a distinctive vision, a purposiveness mingled with the macabre. Illuminated manuscripts from the medieval period were

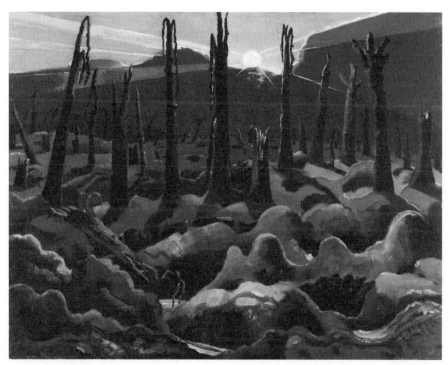

FIGURE 1.3
'We are Making a New World' (1918) by Paul Nash. ©Imperial War Museum Art.IWM ART 001146.

often irreverent, demonstrating the artist's wit and point of view.[21] Clarke borrows from this tradition, encoding the border designs for *Ireland's Memorial Records* with visual puns, commentary on the text, parodies, and riddles. They enter a realm of the fantastic in which imagination merges with documentary evidence and symbolism to produce something so unique that it defies easy classification.

Recruiting in Ireland

The complex status and Irish identity of the Irish soldiers memorialized in *Ireland's Memorial Records* is related to questions of why the men enlisted. The horrible conditions of the Dublin slums in the early twentieth century give credence to suggestions that Irish soldiers who served with British regiments in the First World War were

essentially conscripted by poverty, having no other choice than to enlist and take 'the King's shilling'. At the time, it was the Labour Party leader James Connolly who advanced the idea that the working class had been sacrificed by the war,[22] and this attitude was promoted by his contemporary, Dublin resident and pacifist Francis Sheehy-Skeffington, who believed the enemy was not Germany, but 'English militarism – Kitchenerism'.[23] More recently, Terence Denman has asserted that 'the urban poor, labourers and the unemployed, disproportionately formed the mass of Irish recruits in the south'.[24]

In 1914, unemployment was close to 20 per cent in Dublin, and a lack of manufacturing meant that most of the workforce was unskilled. Close to one quarter of the Dublin-city population occupied tenements that were ripe with overcrowding, disease, and poor sanitation. The transport workers' strike from 26 August 1913 to January 1914 resulted in 20,000 employees losing their wages and the declaration of war in August 1914 led to a rise in prices for coal, meat, milk, and bread.[25] Thomas Dooley points to these basic needs as a factor in enlistment, but adds that military service also 'meant a job which offered escape from drudgery. It promised excitement, the potential for advancement and a future'.[26]

Catriona Pennell's important study of enlistment in Ireland demonstrates that enlistment figures were consistent with those of England. In addition to the regular armies, Patrick Callan cites a figure of 140,460 men enlisting during the war's duration.[27] Over 20,000 Irishmen enlisted by 15 September 1914, predominantly from industrial areas of the island. Yet, as Terence Denman notes, the 'class known in Ireland as "farmer's sons" were largely disinclined to join up' because they were needed at home.[28]

Pennell is careful to avoid any overwhelming motivation assigned to those soldiers who enlisted, yet she does point out that genuine belief in the rightness of the war was a motivating factor for many young men to enlist in the British forces.[29] This sense that the war was a just war, 'in defense of right, of freedom, and religion', was encouraged by Sir John Redmond, the nationalist MP for County Waterford.[30] On 27 August 1914 Redmond announced to Parliament that the Irish

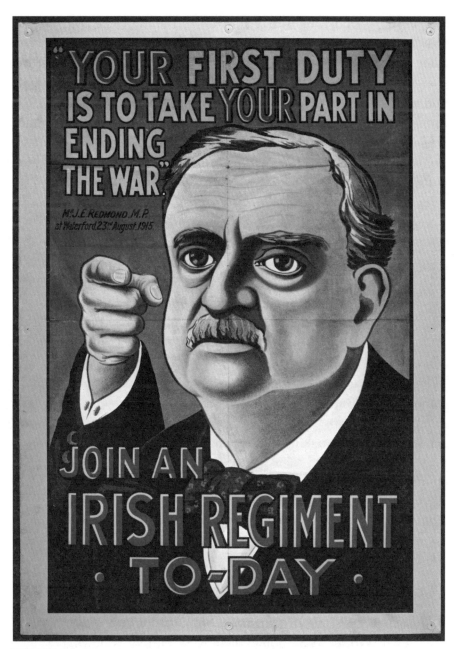

FIGURE 1.4

'Your first duty is to take your part in ending the war', Mr J. E. Redmond, M. P., at Waterford, 23 August 1915. Central Council for the Organization of Recruiting in Ireland. Image Courtesy of the National Library of Ireland, WAR/1914–1918.

would fully support the war: 'I am glad and proud to be able to think that at this moment there are many gallant Irishmen willing to take their share of the risks and to shed their blood and to face death in the assistance of the Belgian people in the defense of their liberty and their independence.'[31] A month later, on 20 September 1914, upon passing through Woodenbridge, County Wicklow and seeing a parade of the Irish Volunteers, Redmond reiterated his support for the war, drawing on the stereotype of the fighting Irish to encourage enlistment:

> it would be a disgrace for ever to our country and a reproach to her manhood and a denial of the lessons of her history if young Ireland confined their efforts to remaining at home to defend the shores of Ireland from an unlikely invasion, and to shrinking from the duty of proving on the field of battle that gallantry and courage which has distinguished our race all through its history.[32]

While the majority of the Irish people hoped that war would be avoided, once war was declared, many believed it was necessary and relief organizations mobilized to support the war by fund-raising, sending food, and making clothes and bandages.[33] Pennell writes,

> As in Britain, Irish individuals, regardless of political affiliation, volunteered for a variety of reasons. For some it was a combination of an opportunity for adventure and/or a sense of duty. Many identified with Ireland's ideological support of the war. ... Support for Belgium was a significant motivating factor. ... As has been explored elsewhere, a strong tradition existed of Irishmen enlisting in the British army, both before and after the First World War. Some men were simply following a family tradition of soldiering, entering into a respectable career. ... The readiness of individuals to join the colours was largely determined by the attitudes and behavior of

comrades – kinsmen, neighbours, and fellow-members of organisations and fraternities.[34]

Tom Johnstone lists old soldiers, young men 'from all classes', rugby football players, and 'a company of tough Dublin dockers' among the recruits.[35] Philip Orr, chronicling the history of the 10th (Irish) Division under the command of General Bryan Mahon, records that 'Frank Browning, President of the Irish Rugby Football Union, sent a circular to his players, just a few days after war was declared. Within a short space of time, he had established a 300-strong "Volunteer Corps", which drilled at the Lansdowne Road rugby ground for several evenings each week. During these sessions Browning would encourage his men to enlist.'[36] Browning's volunteers were members of the loyalist Protestant professional class who lived in Dublin while training for careers elsewhere. The players would form the core of the famous D Company of the 7th Battalion, Royal Dublin Fusiliers, who would be almost completely wiped out at Suvla Bay in Gallipoli on 6 August 1915.

Regular and New Armies

In 1914, Ireland was home to nine regular regiments of infantry, which were subsequently attached to the British Expeditionary Force. These included the Irish Guards, the Royal Irish Regiment, the Royal Inniskilling Fusiliers, the Royal Irish Rifles, the Royal Irish Fusiliers, the Connaught Rangers, the Leinster Regiment, the Royal Munster Fusiliers, and the Royal Dublin Fusiliers. In addition, Ireland's military included four regular regiments of cavalry. These included the Royal Irish Dragoon Guards, the Inniskilling Dragoons, the Royal Irish Lancers, and the King's Royal Irish Hussars.[37]

On 11 August 1914, the War Office in London established thirty New Army divisions, which came to be known as Kitchener's Army or the Pals. Pals divisions were designed to aid recruiting by promising ordinary working men the opportunity to train, travel, and fight side by side with family, friends, and co-workers.[38] By November

1914, three new divisions were established in Ireland: the 10th (Irish) Division, the 16th (Irish) Division, and the 36th (Ulster) Division. The 10th (Irish) was the first division that could be called 'Irish', a term that John Redmond argued would instil pride and aid recruiting. As Captain Stephen Gwynn later claimed to potential recruits, 'Each battalion in each Irish Brigade bears the name of an Irish regiment long established in the British service, and this high inheritance must be upheld.'[39] Thus, the nine regular regiments became reorganized as battalions within the 10th (Irish) Division and 16th (Irish) Division.

Recruitment and enlistment were heaviest in the industrial areas of Dublin and Belfast. Agricultural labourers were needed at home, resulting in lower enlistment from rural areas. Given the specific geographical character of the new Irish divisions, their outlook on the question of Home Rule carried into the predisposition of the membership. The 36th (Ulster) Division was made up of 90,000 members of the Ulster Volunteers, with the addition of recruits from Scotland and northern cities in England.[40] The nationalist Irish Volunteers were divided in their support of the war effort. Over 170,000 supported Redmond and enlisted in the new divisions, changing their name to the National Volunteers. A cadre of 11,000 members of the Irish Volunteers did not enlist; a core group of these Volunteers would form the rebel force that led the Easter Rising in April 1916.[41]

Drafts were not always placed with Irish regiments. If battalions at the front were in need of replacements, Irishmen might be sent to units that required them. Johnstone lists Irish recruits being sent to the Black Watch, the 13th Middlesex, and the Scots Guards.[42] Furthermore, 'since Napoleonic times, English Roman Catholics were usually sent to Irish regiments'.[43] As a result, between the regular and new armies of the British Expeditionary Force, Irish-born Irishmen could be found in almost all regiments, whether these were designated Irish or non-Irish.[44]

While this book addresses the artistic achievement of *Ireland's Memorial Records*, some attention has to be given to the ongoing question of the 49,435 names in the eight volumes, including a discussion of the number of enlisted men and the numbers of dead.

Historians and military enthusiasts alike acknowledge that the names listed were neither complete nor accurate. In fact, the 1923 preface to *Ireland's Memorial Records* duly notes their incompleteness:

> The sub-committee regret profoundly that they have not been able to obtain a complete list of the names of the fallen Irishmen in the Navy, Air Force, and Colonial Regiments, but these volumes contain names of such Irishmen in these Services as have been available from private sources and through the Press. The compiling of these records was given great publicity, and every effort was made to procure complete and accurate information, and accordingly if any names have been omitted, or any particulars are incorrect, the Committee cannot accept whole responsibility.

Eva Barnard, secretary to the Dublin-based Irish National War Memorial Committee, undertook the work of collecting the names that would be printed in the eight volumes. To do so, she sent letters asking for information and looked at the lists of dead in the newspapers. Her work was completed independently of Harry Clarke. Clarke was responsible only for the artistic vision and production of the decorative borders surrounding the names. The borders and the roll of names were even printed independently of one another.

As definitive military records of Irishmen who died in the First World War, *Ireland's Memorial Records* contain many inconsistencies and discrepancies. To begin, they purport to contain the names of 49,435 Irish casualties of the war, dating from 1914 to 1918. Yet Casey asserts that a significant number of these names, about 19,000 in fact, 'were not Irish'.[45] Cross-referencing the names in *Ireland's Memorial Records* with the soldiers listed in the 1921 publication *Soldiers Died in the Great War, 1914–1919*, Casey identified only 30,216 known casualties of Irish birth.

Furthermore, as Fergus D'Arcy has demonstrated, hundreds of soldiers who fought in the First World War died of wounds or illness

in Ireland and were buried on Irish soil. While *Ireland's Memorial Records* include soldiers who died between 1914 and 1918, due to official Imperial War Graves Commission policy, the soldiers could be considered 'war dead' until 31 August 1921, regardless of their cause of death. For example, in Dublin, the private burial ground at Glasnevin Cemetery contains the graves of 168 soldiers who were entitled to receive a headstone from the Imperial War Graves Commission; these same names are listed on the two monument stones now located near the chapel. Grangegorman Military Cemetery, adjacent to the northeast corner of Phoenix Park, contains 613 war dead from the First World War. [46] The last grave to receive an IWGC headstone is that of Private M. Scully of Dublin, who died on 30 August 1921, leaving an 18 year-old widow.

It is worth pointing out that further inconsistencies related to the criteria for inclusion in the volumes arise from regimental insignia designs. Clarke wove badges of seventeen regiments within his engravings, which the index to the volumes list as:

1. Royal Inniskilling Dragoon Guards
2. Royal Irish Rifles
3. Royal Field Artillery
4. Tank Corps
5. 8th (Royal Irish) Hussars
6. Royal Dublin Fusiliers
7. Royal Inniskilling Fusiliers
8. Royal Irish Dragoon Guards
9. 5th (Royal Irish) Lancers
10. Royal Munster Fusiliers
11. Royal Irish Regiment
12. 15th Hussars
13. Irish Guards
14. Connaught Rangers
15. Royal Berkshire Regiment
16. Leinster Regiment
17. Royal Irish Fusiliers

In addition, Clarke included a kangaroo to honour the contributions of the Australian and New Zealand Allies, and a maple leaf for the Canadians. However, badges of the North Irish Horse and South Irish Horse are not included, nor are the colours of the Royal Engineers, the Royal Army Medical Corps, or the Labour Corps, all of which contributed several hundred Irish casualties to the war effort. There is no record of why certain regiments were included in the *Records* or why others are absent. Two regiments are decidedly non-Irish: the 15th (King's) Hussars and Royal Berkshire Regiment. Inclusion of the 15th (King's) Hussars can be explained because they served at Suvla Bay with the Royal Irish Fusiliers and the Royal Dublin Fusiliers.

However, the inclusion of the Royal Berkshire Regiment is a minor mystery. According to Casey, the Royal Berkshire Regiment contributed twenty-eight casualties to the total of Irish-born Irish dead in the war, while the 15th Hussars contributed four.[47] The 3rd (Special) Battalion of the Berkshires trained recruits at Portobello Barracks in Dublin from 1917 to 1918, which may have resulted in a connection with Irish families; however, ironically, the 2nd Battalion was sent to Dublin in 1919 to fight against the IRA.[48]

This brief survey does not do justice to the complications that arise from trying to identify a definitive set of names that could or could not be included in *Ireland's Memorial Records*; however, we can make some conclusions. For one, while the method of gathering names of the committee was perhaps not 'haphazard' as Casey purports, it was definitely imperfect. Second, the regimental badges represented in Clarke's borders are incomplete; many Irishmen were killed while serving with non-Irish regiments. For example, the 11th Hampshires trained with the 10th (Irish) Division at the Curragh and ultimately lost sixty-three Irishmen enlisted with their regiment.[49] In addition, there were hundreds of Irish born who served with Scottish and Northern English regiments, such as the Northumberland Fusiliers famous 103rd (Tyneside Irish) Brigade, which suffered heavily at the Battle of the Somme. While these regiments are not artistically rendered in the decorative borders, the names of the soldiers themselves are listed in *Ireland's Memorial Records*.

Ultimately, these are questions for the military historians to winnow and sift. I have chosen to consider the eight volumes of *Ireland's Memorial Records* as a complete artefact of their time and place. While the numbers and names can be contested, and their value as military records falters today, the history of their publication and the neglected history of Harry Clarke's accomplishment are important to the legacy of Ireland's artistic achievements in the twentieth century.

Significant Conflicts in 1915 and 1916

Irish people were involved in all aspects of the military campaigns from 1914–18, filling medical, combat, and labour roles. In each major battle, Irish soldiers served and died, whether fighting with Irish divisions or English. In addition, 11,000 military-trained Irish Volunteers remained at home, taking decisive steps toward Irish independence. A brief history of the Irish involvement in the First World War must take into account three events of military importance involving dedicated Irish divisions: Gallipoli, the Easter Rising, and the Battle of the Somme.

Gallipoli, 1915

One of the most popular songs to emerge after the 1916 Easter Rising was 'The Foggy Dew', an old melody with new rebel lyrics penned in 1919. The song pits the gallant efforts of the martyred Irish rebels fighting for freedom in Dublin city in April 1916 against the disastrous events of the British military campaign against the Turks in the Dardanelles, concluding ''Twas better to die 'neath an Irish sky than at Suvla or Sud el Bar.' Still popular today, the song embodies the continuing tensions between the memory of the Easter Rising and the memory of the First World War. Geographically, Suvla Bay and Sud el Bar are in the Aegean, indeed a long way from Tipperary. Suvla Bay is on the western side of the Cape Helles peninsula; it was the site of V Beach, a landing zone for two Irish battalions. 'Sud el Bar' is a corruption of Sedd el Bahr, a village south of Suvla Bay, at the approach to the Narrows, along the Dardanelles Straits.

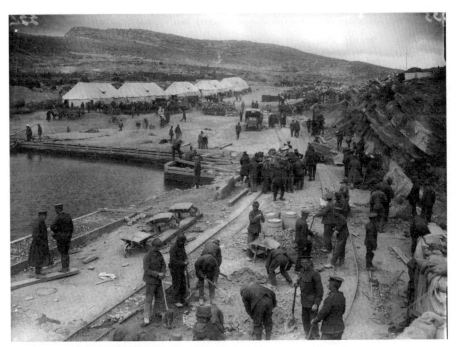

FIGURE 1.5
Construction work in progress on a beach in Suvla Bay (1915), photographed by Ernest Brooks. ©Imperial War Museum Q13552.

When naval bombardment of forts at the Dardanelles began on 19 February 1915, the 10th (Irish) Division was still spread across Ireland in training camps at Fermoy, the Curragh, and Dublin. They were sent to England in April. The official orders for the 10th to depart for the Dardanelles arrived on 1 July 1915, while they were stationed in Basingstoke, Hampshire. On 5 August, the division was divided in order to assist other divisions; the 29th sent to Anzac Cove and the 30th and 31st were sent to support the 11th Division at Suvla.[50] Limited to one pint of water per day on a rocky peninsula surrounded by salt water in the middle of summer, the soldiers were desperately thirsty. Although the objectives of seizing Chocolate Hill and Green Hill were met on 7 August, the fighting continued for several weeks. While it may have established the Anzac legend, the Gallipoli campaign is remembered for its 'disorganised chaos'.[51] With no central or unified command, the plans of attack were delayed and often contradictory.

'All semblance of command and control had disappeared. No one had any idea of what was happening, or indeed any apparent grasp of their objectives.'[52] The men suffered from lack of water to drink or to tend to wounds with, an absence of shade, high temperatures, rocky terrain, spoiled food, and dysentery.[53]

Eventually, two devastating attacks were launched at the end of August, the advance on Scimitar Hill by the 29th Division and the Anzac attack on Hill 60. Peter Hart contends that neither attack was 'likely to result in significant gains'[54]: 'If there was ever a futile battle it was the assault at Suvla by IX Corps on 21 August.'[55] Compounding the heat, lack of water, exhaustion, and disease, bombing and machine gun fire set the brush alight, burning the dead and wounded.[56] Corporal Colin Millis recalls,

> An awful death trap this was and it claimed many victims,
> the poor devils simply dropped in dozens and were speedily
> burnt with the flames – a sight that I shan't forget.[57]

Unfortunately for the Irish, in the legends that would ensue of the peninsular campaign, they were portrayed as cowardly and disorganized.[58] While it is not the place of this book to point out the inaccuracies of nationalistic war rhetoric, it is significant that the contributions of the 10th (Irish) Division were lost to the greater lines of this story after 1916. After continuing their service in Palestine and Salonika (where they may have come into contact with some of the Berkshires), what was left of this New Army division returned to a much-changed Ireland, one that would come to be ambivalent about their contributions and sacrifices. As one commentator put it, when the 7th marched out of Dublin, they marched out of history. By contrast, Australia and New Zealand commemorate the first day of fighting at Gallipoli annually on April 25. The Anzacs – Australian and New Zealand Army Corps – lost over 8,000 men during the eight-month period on the peninsula.[59]

From April to August, the war correspondent E. Ashmead-Bartlett worried that the public was completely unaware of the horrible

conditions and high losses in the Dardanelles. With the help of Keith Murdoch (father of newspaper magnate Rupert Murdoch), Ashmead-Bartlett was able to smuggle news of the fighting past the censors to the British Press.[60] Historian Philip Orr recounts that, by September 1915, *The Irish Times* carried an eyewitness account of the battle and the *Irish Independent* was 'filled every day with photographs of dead, wounded and missing officers, usually with a pen portrait that included information about their family, their peacetime career and – in guarded detail – the manner of their demise'.[61] Some of these illustrated accounts may have influenced Harry Clarke's choice of content for his borders. We can be certain that the reports influenced public opinion about the war. The last British troops left the Dardanelles in January 1916, marking the end of the failed campaign to open the Black Sea. In Ireland, January 1916 marked the beginning of a significant decline in enlistment.

Easter Rising 1916

In 1926, during the protracted and contested conflict over the location of the Irish National War Memorial Gardens, it was the Easter Rising of April 1916 that was invoked as the founding conflict for the Irish Free State, not the First World War. The Rising marks the point when those whom Padraig Pearse called the 'risen people' claimed the moment for independence.[62]

An estimated 11,000 members of the Irish Volunteers resisted enlisting in the British Army at the outbreak of war with Germany. Seeing a tactical opportunity while Britain's armies were fighting in Europe and Asia, members of the Volunteers joined with the Irish Citizen's Army to occupy locations around Dublin and proclaim the city as the centre of a Provisional Irish Government. On Easter Monday, 24 April 1916, a force of revolutionary nationalists occupied prominent buildings in central Dublin, making its headquarters at the General Post Office (GPO) on Sackville (now O'Connell) Street. Padraig Pearse, schoolteacher and visionary, read aloud a proclamation announcing a Provisional Government, and called for 'the readiness of its children to sacrifice themselves'. Pearse's younger brother William

(Willie), an artist who trained at the Metropolitan School of Art, was also involved in the Rising, headquartered with his brother at the GPO. Working to supply the revolutionaries with guns and material support was Roger Casement, a champion of human rights, who sought aid from Germany to purchase guns and reinforcements.[63]

During the week of occupation, central Dublin was heavily shelled by British forces recruited from training camps in Ireland and England. Houses and businesses closest to the quays were completely destroyed; Eden Quay, Henry Street, Lower Abbey Street, Middle Abbey Street, North Earl Street and Sackville Street were reduced to rubble. Fires from the city centre could be seen for miles. Communications from the city centre were poor and relatives waited and watched for news. Rumours abounded. Describing the evening of Friday, April 28, Kathleen Clarke, captures the way that lack of knowledge and fear mixed in the minds of combatants and non-combatants alike. Her husband Tom Clarke was in the GPO.

FIGURE 1.6
Abbey Street Corner (1916). Image Courtesy of the National Library of Ireland Ke 105.

That night I watched, from the upper windows of the house, the smoke and flames of what seemed to be the whole city in flames. I watched all night; it seemed to me no-one could escape from that inferno. The picture of my husband and brother caught in it was vividly before me, and their helplessness against that raging fire appalled me. [64]

Although he was not a participant in the revolutionary measures, Clarke and some among his circle were directly affected by the fighting. As Nicola Gordon Bowe relates, because the studios at 33 North Frederick Street were within the combat zone, 'The military refused permission for the men to leave the building, so they were held there for four days, and work was at a standstill until 8 May.'[65] Joshua Clarke related that he was anxious, not knowing 'whether my house was blown down or my sons killed in Dublin'.[66] Sheltering against bullets, shells, and fires, Clarke experienced first-hand the conditions of combat, personal experience which he most certainly drew upon when designing the borders for the *Records*. The publishing house of Maunsel was located along Abbey Street, which was destroyed by fires that consumed many of the buildings along the North Dublin quayside. Inside were plates of Clarke's illustrations for 'The Rime of the Ancient Mariner'.

By Saturday, April 29, Pearse surrendered the forces from the GPO and those who occupied other sites soon followed. The Irish rebels from the central city were gathered in the Parnell Square at the north end of Sackville Street, where they spent a night outdoors and in the rain, huddled together in stillness and discomfort under the rifles and eyes of British guards.

Though the Rising was not immediately or generally popular with the Dublin citizens, the summary execution of the leaders of the military coup turned public opinion in support of the revolutionary heroes. Fourteen were swiftly shot after secret tribunals at Kilmainham Gaol in west Dublin. On May 3, only four days after the surrender, Padraig Pearse, Thomas MacDonagh, and Thomas Clarke were executed by firing squad. Five more leaders were shot in the next two days. Within

the week, six more men were executed. Thousands more were deported to prison camps in Ireland, England, and Wales. In total, there may have been as many as 500 dead by the end of the week,[67] among them Francis Sheehy-Skeffington, war protestor, pacifist, and friend to artist Seán Keating, who left his home to stop looting in the city.

The dead of the Easter Rising, including the leaders and the civilian casualties, are memorialized in the Garden of Remembrance in central Dublin's Parnell Square, the site where rebels huddled in discomfort after the surrender. A written and illuminated record of the rebellion was begun by the artist Art O'Murnaghan in 1924 as *Leabhar na hAiséirghe*, Book of the Resurrection, a twenty six-page book of remembrance that may be compared to *Ireland's Memorial Records*. These beautiful illuminated pages are displayed at the National Museum, Collins Barracks.

The Somme, 1916

During the revolution in Ireland, British forces were engaged in battles in Mesopotamia and massive troops and equipment were moving into the Picardy region around the Somme River. What ensued was a series of battles that extended from late June 1916 to November 1916. These battles would be the proving ground for the 36th (Ulster) Division and the 16th (Irish) Division. The area had been occupied by the German army since the opening months of the war in 1914, which gave them sufficient time to deeply entrench themselves and heavily fortify the towns, including Beaumont, Bapaume, Thiepval, Guillemont, and Ginchy. By July 1916, German machine gun posts covered approaches to the area from the west, north, and south, effectively blanketing the thirty-kilometer line of the front with heavy fire. Working with the French troops under the command of Colonel Joffre, British General Douglas Haig planned to advance on 1 July 1916, following a weeklong bombardment of German lines that they anticipated would cut the wire and destroy the artillery. Beginning on June 23, the British launched a barrage of three million shells on German lines. Early in the morning of July 1, the BEF detonated seventeen mines under German positions.

At 7:30 a.m., whistles blew along the miles of trenches to send the advance waves of troops over the top.[68]

Among those in the first wave of July 1 were the 36th (Ulster) Division under the direction of Major-General Sir Oliver Nugent, who were in trenches dug within Thiepval Wood. Although they would achieve the objective of reaching the German lines, they were unable to hold the position. The division would face heavy losses. Casualties

FIGURE 1.7
Two British soldiers standing in a wrecked German trench at Ginchy (September 1916), photograph by John Warwick Brooke. © Imperial War Museum Q 4338.

from the first day of fighting numbered over 19,000 British soldiers. Martin Middlebrook estimates that 2,000 Ulstermen were killed on the first day of battle and 3,000 were dead by the third day.[69]

The Tyneside Irish (Northumberland Fusiliers) were situated to the east of the 36th (Ulster) Division; their objectives were La Boiselle and Contalmaison. The 1st and 2nd Battalions of the Royal Dublin Fusiliers were positioned to the northwest of the 36th (Ulster) Division, facing Beaumont-Hamel. By noon on July 1, over 60 per cent of the officers and men of the 2nd Battalion Royal Dublin Fusiliers were casualties of the advance. On July 3, roll call of the 9th Battalion of the Royal Irish Rifles, 36th (Ulster) Division, revealed only one of four officers was alive and thirty-four of the battalion's 115 men were dead, wounded, or missing.[70]

Although it was not their first action of the war, the 16th (Irish) Division is particularly associated with the attacks on the German-controlled towns of Guillemont and Ginchy on the eastern end of the line. Gerald Gliddon refers to the village of Guillemont as 'a fortress with a chain of dugouts and tunnels that defied the heaviest artillery barrages'.[71] The first attempts to take the village of Guillemont occurred on 23 July 1916. By August 27, with the rain now muddying the roads and the bodies of the dead filling the trenches, the 6th Connaughts, 7th Leinsters, 8th Munsters, and 6th Royal Irish were called in from the 16th Division for a new plan of attack from the north. This attack was successful, and in his official report, John Buchan wrote, 'The men of Munster, Leinster, and Connaught broke through the intricate defenses of the enemy as a torrent sweeps down rubble.'[72]

However, two other objectives beyond Guillemont remained: a heavily fortified area known as the Quadrilateral and the town of Ginchy. Until the advance on Ginchy, 'the brigades of the 16th Division were thrust piecemeal into a continuing battle under the command of other divisional commanders'.[73] On September 5, Major-General Sir William Hickie leading the assembled Irish Division was successful in taking the town. On September 9, Ginchy was secured. One of the casualties was Lt Tom Kettle of the 9th Royal Dublin Fusiliers, poet

and barrister, who was shot while leading his men into the ruins of the town. (Ironically, five months earlier, his brother-in-law Francis Sheehy-Skeffington was executed during the Easter Rising.) With Kettle was James Emmet Dalton, who, having survived the war, would go on to join the IRA. Dalton was with Michael Collins during the 1923 ambush and assassination at Béal na Bláth, Cork. The total number of casualties from Irish regiments at the battles at Guillemont and Ginchy are 11,500.

Harry Clarke and the Arts in Dublin

When Harry Clarke was awarded the commission to prepare borders for *Ireland's Memorial Records*, he was 30 years old, a father, and just beginning the decade that would be the most fruitful of his short career. That year, his friend Thomas Bodkin, a Governor of Ireland's National Gallery of Art and Clarke's lifelong friend, wrote an article titled 'The Art of Mr Harry Clarke' for the important artists' monthly, *The Studio*, which praised Clarke's artwork, citing over 250 of his completed works .[74] That same issue contained several articles relating to war memorial commissions. Ultimately, the *Studio* article gave Clarke exposure in England and America that would lead to many commissions and extend his work beyond Ireland.

Harry Clarke was born in Dublin on 17 March 1889, the son of Joshua, a stained-glass manufacturer and church decorator hailing from Leeds, and the former Brigid MacGonigal from County Sligo. Like James Joyce, he received a Jesuit education at Belvedere College on Dublin's north side. Clarke studied at the Metropolitan School of Art in Dublin and the South Kensington School of Design in London. Returning to Dublin to work in the stained-glass studio of his father, he became involved with the Arts and Crafts Society of Ireland and the Guild of Irish Art Workers, and he resumed studies at the Metropolitan School of Art with William Orpen. In his memoir *Some Memories, 1901–1935*, George Harrap recalls Clarke as 'an indefatigable worker,' citing the 'over two hundred finished works' that Clarke completed between 1915 and 1919.[76]

FIGURE 1.8
Harry Clarke, circa 1924. Image courtesy of Fianna Griffin.

The illustrations for Edgar Allan Poe's *Tales of Mystery and Imagination* represent a transitional moment in Clarke's illustrations, in which they move from a spare and gracious design to a darker and more complex pallet of line and ornamentation. Within the Poe drawings, viewers begin to detect the subversive elements that would dominate the drawings of the 1920s. It is as if Poe's literary explorations of heaven and hell, beauty, madness, sin, and horror awakened in Clarke a need to express his own experiences, the dichotomy of earthly physical existence with the teachings of the Catholic Church. For example, the plate that accompanies Poe's tale of Ligeia presents the lady elaborately bound in a black ribbon that straps her stomach, falls loose at the breast, and delicately balances a cloak at her back. Her bare breast draws attention to the way that she is sensually alive while physically dead. Beyond this image, Clarke carries the motif of binding and unwinding through other illustrations in the Poe volume. The most prevalent of these are the tattered winding cloths that trail from the corpses in the illustrations. Even some of the living characters are swathed in burial cloths that untwist elaborately; Clarke's visual puns twist the ribbons and shrouds into decorative scroll patterns on the pages, motifs that would recur in *Ireland's Memorial Records*.

Among his noted works in stained glass are the eleven Honan Chapel windows (1915–17) in Cork. Clarke used vivid azure, scarlet, royal purple and emerald green glass to represent Mary, our lady of sorrows, and the saints Patrick, Colmcille, Brigid, Finbarr, Ita, Albert, Gobnait, Brendan, and Declan. In 1924 Clarke completed an exquisite small decorative window based on John Keats's sensual poem of illicit love, 'The Eve of Saint Agnes'. His final work was the Geneva Window (1925–29), a spectacular series of panels inspired by fifteen Irish writers, including James Joyce, William Butler Yeats, and Padraig Pearse. The window was initially destined for the Hague, but was censored by the Irish government and is now at the Wolfsonian Museum, Florida. Suffering continually from chest ailments, Clarke traveled to a sanatorium in Davos, Switzerland in 1929. He was returning to Dublin in January 1931 when he died

in Coire, Switzerland.[77] Sadly, his body was not returned to Ireland and his gravesite is not known. Harrap concluded that Clarke 'will be remembered among the artists of his time for his imaginative power and originality, and it will be written that his early death, in 1930, at the age of 41, extinguished a genius'.[78]

Like fellow artists Austin Molloy, Seán Keating, and Jack Yeats, Clarke did not enlist in war service. As there was no conscription in Ireland, the artists were free to follow their own conscience. Given an absence of records, it is not possible to record what Clarke's attitude was toward the war itself, but if we consider the circle in which he traveled, we can perhaps find some answers. Clarke's friends included a group of outspoken and unmistakable nationalists: Seán Keating, Mary Keating, and George Russell (AE). Clarke's close friend at the Dublin Metropolitan School of Art and in later life was the artist Austin Molloy. Together with Seán Keating, Molloy and Clarke visited the Aran Islands, where so many artists and writers were seeking inspiration from the Irish landscape. John Millington Synge's literary reputation was founded on the plays and tales that emerged from his researches in the West. The Aran Islands and the Gaeltacht became the face of art for the new Irish State. Molloy later became a teacher at the Metropolitan School of Art, and he also contributed a weekly political cartoon to the Irish nationalist news weekly, *Sinn Féin*, edited by Arthur Griffith, signing his name variously in Irish as Maolmhuidhe, AóM, and Austin Ó Maolaoid. Molloy also created several book covers for an Irish government scheme to publish books in the Irish language, including translations of popular literature.[79]

One of Clarke's early biographers, William J. Dowling, commented, 'I do not think that Harry Clarke gave much thought to politics, but due to his associations with the cultural resurgence, of which he was part, it is inevitable that he would have absorbed its national atmosphere.'[80] Seán Keating offers an intriguing comparative point for Clarke's own life. Keating and Clarke both studied under Orpen at the Metropolitan School. Orpen himself was Dublin-born, but unlike his two students, he enlisted as a war artist and would be distinguished as

one of the most significant British war artists of the conflict. Keith Jeffery draws attention to an important dialogue between the teacher Orpen and the student Keating:

> In the early spring of 1916 Orpen's pupil and studio assistant Seán Keating, a noted artist in his own right, had to leave London and return to Ireland in order to avoid conscription (Michael Collins left England at the same time for the same reason). Keating tried to persuade Orpen to accompany him: 'Come back with me to Ireland. This war may never end. All that we know of civilization is done for ... I am going to Aran ... Leave all this. You don't believe in it.' But Orpen remained in London, claiming that everything he had he owed to England. 'This is their war', he said, 'and I have enlisted. I won't fight, but I'll do what I can.'[81]

In the comprehensive recent biography of Seán Keating's life and art, Éimear O'Connor identifies Keating as 'the painter of Ireland's fight for independence',[82] a 'hard-working artist with nationalist ideals and socialist tendencies'.[83] In the revolutionary year of 1916 he was a member of 'the most politically radical' branch of *Conradh na Gaeilge*, the Gaelic League, founded by Douglas Hyde in 1893 to promote the study of Irish language and culture.[84] Fighters in the 1916 rebellion and later influential members of the government, Cathal Brugha and Michael Collins, were also members of this branch. Keating's brother Joe was a member of the Irish Volunteers and 'active in the republican movement for a number of years', perhaps also as 'a member of the IRB'.[85] Seán Keating met his wife at the *Craobh* branch; she worked for Robert Barton, the nationalist cousin of Erskine Childers, and also the political activist Hanna Sheehy-Skeffington, who was married to the pacifist Francis Sheehy-Skeffington was a well-known opponent of recruitment by the British Army in Ireland, which led to his imprisonment in 1915 and execution during the week of the Easter Rising in 1916.

Before and during the war years, the Dublin Metropolitan School of Art was highly political.[86] Louise Ryan writes that 'many hopeful young artists flocked to Dublin' at the turn of the century, and '[s]ome of the best known and most active suffragists of this period were highly involved in the arts, literature and theatre'.[87] These feminists included the Sheehy-Skeffingtons, Margaret Cousins, Sir John French's sister Charlotte Despard, and Edith Somerville and Violet Martin, of the writing duo known as Somerville and Ross. A number of staff and students 'joined the British Army to fight in World War One',[88] while the nationalist students, most of whom predated Harry's time at the college, included Willie Pearse, Constance Markievicz, and Grace Gifford. Grace Gifford was a talented political cartoonist who, like Austin Molloy, promoted Sinn Féin, and was eventually elected to the executive board of the political organization. On 3 May 1916 she married Joseph Plunkett, only hours before his May 4 execution at Kilmainham Gaol for his role in the Easter Rising.

Postwar Displacement

In the 1920 poem 'Lament of the Demobilised', the English writer and Voluntary Aid Detachment worker Vera Brittain, who lost her brother and three friends to the war, expressed the sentiments of many: 'And we came home and found [. . .] no one talked heroics now.'[89]

This sense of displacement, coupled with the needs of many for mental and physical recovery, would define international postwar sentiment. In Ireland, while on leave and following the Armistice of 1918, returning soldiers could only go out in groups, for on their own they were stoned.[90] Denman points out that 'The growing indifference of the mass of Irish Catholics to the war after the Rising, as Stephen Gwynn admitted, left Irish soldiers "in great measure cut off from that moral support which a country gives its citizens in arms".'[91]

While parades and commemorative ceremonies marking the Armistice took place in Ireland from 1919 forward, the public

commemorative events were never without controversy. Eventually, the controversy would affect the siting and opening of the Irish National War Memorial Gardens. Yet, whether their noble sentiments or the art saved them at the time, *Ireland's Memorial Records* avoided censure by the critics of the war.

The eight volumes of *Ireland's Memorial Records, 1914–1918* are exceptional among the Allied countries of the First World War because of the particular attention given to design and printing. Following the Armistice, English and Irish universities, businesses, and villages began to honour their dead with a variety of memorial works, including parchment scrolls, metalwork tablets, and stone carvings. For example, the Scottish National War Memorial in Edinburgh contains leather-bound rolls of honour lining walls and alcoves devoted to difference branches of the military. Handwritten rolls of remembrance have been placed in a silver casket within a shrine that honours close to 150,000 Scottish soldiers lost in the First World War. Similar rolls of honour may be found in cathedrals throughout England; as I note later, a particularly dramatic example is in York.

The illustrations by Harry Clarke make *Ireland's Memorial Records* distinctive among other rolls of honour. Harry Clarke's vision fused the ancient arts of Ireland with the modern dispositions toward abstraction, thus creating an internationally significant work of art.

NOTES

1. Maunsel and Company changed its name to Maunsel and Roberts in December 1920. C. Hutton and P. Walsh describe the history of the company in *The Oxford History of the Irish Book, Volume V: The Irish Book in English, 1891–2000* (Oxford: Oxford UP, 2011), p.561.
2. MS 39,202/ B, in Harry Clarke Papers, National Library of Ireland. Pocket diary, 1919.
3. C.121.f.1, British Library.
4. N. G. Bowe, *Harry Clarke: The Life and Work* (Dublin: History Press Ireland, 2012) passim.
5. N. C. Johnson, 'The Spectacle of Memory: Ireland's Remembrance of the Great War, 1919', *Journal of Historical Geography 25*, 1 (January 1999), pp.44; N. G. Bowe, 'Ireland's Memorial Records, 1914–1918', *Ireland of the Welcomes*, November / December 2006, pp.18-23.

6. Royal Academy of Arts, *War Memorials Exhibition 1919* (London: William Clowes and Sons, 1919); C. Smith, Victoria and Albert Museum, *Catalogue of the War Memorials Exhibition, 1919* (London: HMSO, 1919).

7. Jameson, et al. v. Attorney-General, Affidavit, RDFA 020/001, Folder No.1: 1926, (3 March 1926): p.1.

8. Jameson, et al. v. Attorney-General, Affidavit, RDFA 020/001, Folder No.1: 1926, (3 March 1926): p.2.

9. Bowe lists an opening date of 1940 in *Harry Clarke*, p.203.

10. F. D'Arcy, *Remembering the War Dead: British Commonwealth and International War Graves in Ireland Since 1914* (Dublin: The Stationery Office, 2007), p.1.

11. J. Horne, *Our War: Ireland and the Great War* (Dublin: Royal Irish Academy 2008), p.14.

12. K. Brown, *The Yeats Circle, Verbal and Visual Relations in Ireland, 1880–1939*, (London: Ashgate, 2011), pp.34–35.

13. N. G. Bowe, 'Ireland's Memorial Records, 1914–1918', *Ireland of the Welcomes*, November/December 2006, pp.18–23.

14. J. Rendell, *Profiles of the First World War: The Silhouettes of Captain H.L. Oakley* (Stroud, Gloucestershire: Spellmount, 2013); L. Gosling, *Brushes and Bayonets: Cartoons, Sketches and Paintings of World War I* (Oxford: Osprey, 2008).

15. For example, 'The Great War, Depicted by Distinguished British Artists,' *The Studio: An Illustrated Magazine of Fine and Applied Art*, (1919).

16. T. Burnell, *The Tipperary War Dead: History of the Casualties of the First World War* (Dublin: Nonsuch, 2008); G. White and B. O'Shea, *A Great Sacrifice: Cork Servicemen Who Died in the Great War*, (Cork: Echo, 2010).

17. *British Artists at the Front*, (London: Published from the offices of *Country Life*, 1918); A. E. Gallatin, *Art and the Great War* (New York: E.P. Dutton & Co., 1919); R. Cork, *A Bitter Truth: Avant-Garde Art and the Great War* (New Haven: Yale, 1994).

18. P. Nash, *Outline: An Autobiography* (London: Faber & Faber, 1949), p.211. This letter from Nash to his wife dated 16 November 1917, is also cited in S. Malvern, '"War As It Is": The Art Of Muirhead Bone, C. R. W. Nevinson and Paul Nash, 1916–17', *Art History*, 9, 4 (December 1986), p.499.

19. K. Jeffery, 'Artists and the First World War', *History Ireland*, 1, 2 (Summer 1993), pp.42–45.

20. C. Bowen, 'Lady Butler: The Reinvention of Military History', *Revue LISA / LISA e-journal*, 1, 1 (2003), pp.127–137.

21. M. Camille, *Image on the Edge: The Margins of Medieval Art* (London: Reaktion, 1992). p.43.

22. C. Pennell, *A Kingdom United: Popular Responses to the Outbreak of the First World War in Britain and Ireland* (Oxford: Oxford UP, 2012), p.184.

23. Pennell, *A Kingdom United*, p.184.

24. T. Denman, *Ireland's Unknown Soldiers: The 16th (Irish) Division in the Great War, 1914–1918* (Dublin: Irish Academic Press, 1992), p.134.

25. Pennell, *A Kingdom United*, p.167.

26. T. Dooley, *Irishmen or English Soldiers? The Times and World of a Southern Catholic Irish Man (1876–1916) Enlisting in the British Army During the First World War* (Liverpool: Liverpool University Press, 1995), p.214.

27. P. Callan, 'Recruiting for the British Army in Ireland During the First World War', *Irish Sword* 17 (1987), pp.42–56. The number of Irish who fought in the war is debated; however, Keith Jeffery's figure of 210,000 seems to be the accepted number. See *Ireland and the Great War* (Cambridge: Cambridge UP, 2000), pp.6–7.

28. Denman, *Ireland's Unknown Soldiers*, p.134.

29. Pennell, *A Kingdom United*, p.171.

30. John Redmond quoted in W. Wells, *John Redmond: A Biography* (London: Nisbet and Co., 1919), p.165.

31. J. Redmond, 'Address to his Majesty,' Hansard HC Deb 27 August 1914 vol 66 cc191-4.

32. W. Wells, *John Redmond*, p.165.

33. C. Pennell, *A Kingdom United*, pp.65–68.

34. C. Pennell, *A Kingdom United*, p.194.

35. T. Johnstone, *Orange, Green, and Khaki: The Story of the Irish Regiments in the Great War, 1914–18*, (Dublin: Gill and MacMillan, 1992), p.11.

36. P. Orr, *Field of Bones: An Irish Division at Gallipoli* (Dublin: Lilliput Press, 2006), p.13. Frank Browning was killed in the defense of Dublin during the Easter Rising on 26 April 1916.

37. Summary Information Document Detailing the Irish Regiments of the British Army up to 31st July 1922. 9 November 2010. http://www.military.ie/fileadmin/user_upload/images/Info_Centre/Docs2/archives_docs/summary_information_document_on_the_irish_regiments_of_the_british_army.pdf.

38. P. Simkins, *Kitchener's Army: The Raising of the New Armies, 1914–1916* (Pen and Sword, 2007).

39. S. Gwynn and T. Kettle, *Battle Songs for the Irish Brigades* (Dublin: Maunsel & Co., 1915), p.v.

40. Johnstone, *Orange, Green, and Khaki*, p.13.

41. Johnstone, *Orange, Green, and Khaki*, p.13.

42. Johnstone, *Orange, Green, and Khaki*, p.11.

43. Johnstone, *Orange, Green, and Khaki*, p.12.

44. P. Casey, 'Irish Casualties in the First World War', *Irish Sword* 20, 81 (1997), p.194.

45. P. Casey, 'Irish Casualties', p.194.

46. See D'Arcy, *Remembering the War Dead*. In addition, the program for the dedication of a Cross of Sacrifice by Reginald Blomfield at Glasnevin Cemetery in Dublin lists '5,500 Commonwealth war dead buried or commemorated' in Ireland. *Dedication of the Cross of Sacrifice by the President of Ireland, Michael D. Higgins and centenary commemoration of the First World War attended by HRH Prince Edward, Duke of Kent*, Commonwealth War Graves Commission, (31 July 2014), p.12.

47. P. Casey, 'Irish Casualties', pp.188–205.

48. Unit History: Royal Berkshire Regiment, Forces War Records, http://www.forces-war-records.co.uk/units/475/royal-berkshire-regiment/; M. McIntyre, Royal Berkshire Museum, Research Enquiry – Royal Berkshire Regiment, Personal communication, 9 March 2014. Email.

49. Unit History: Royal Hampshire Regiment, Forces War Records, http://www.forces-war-records.co.uk/units/256/royal-hampshire-regiment/.

50. P. Hart, *Gallipoli* (Oxford: Oxford University Press, 2011), p.47.

51. Johnstone, *Orange, Green, and Khaki*, p.131.

52. Hart, *Gallipoli*, p.349.

53. Johnstone, *Orange, Green, and Khaki*, p.133.

54. Hart, *Gallipoli*, p.384.

55. Hart, *Gallipoli*, p.369.

56. Hart, *Gallipoli*, p.377.

57. Hart, *Gallipoli*, p.377.

58. Hart, *Gallipoli*, p.366-67.

59. WWI Gallipoli, Australian Army, http://www.army.gov.au/Our-history/History-in-Focus/WWI-Gallipoli.

60. J. Macleod, *Reconsidering Gallipoli* (Manchester: Manchester UP, 2004), pp.103–146.

61. Orr, *Field of Bones*, p.183.

62. P. Pearse, 'The Rebel', *Plays, Stories, Poems* (Dublin: Maunsel, 1917), pp.337–339.

63. C. Townshend, *Easter 1916: The Irish Rebellion* (London: Allen Lane, 2005).

64. K. Clarke, *Kathleen Clarke: Revolutionary Woman* (Dublin: The O'Brien Press, 2008), p.120.

65. Bowe, *Harry Clarke*, p.87.

66. Bowe, *Harry Clarke*, p.87.

67. D. Benest, 'Aden to Northern Ireland, 1966-76,' in H. Strachan (ed.), *Big Wars and Small Wars: The British Army and the Lessons of War in the 20th Century* (London: Routledge, 2006), p.124.

68. J . Keegan, *The First World War* (New York: Knopf, 1999), p.291.

69. M. Middlebrook, *The First Day on the Somme, 1 July 1916* (New York: Norton, 1972), p.224.

70. T. Bowman, 'The Irish at the Somme', *History Ireland* 4, 4 (Winter 1996), pp.48–53.

71. G. Gliddon, *The Battle of the Somme: A Topographical History* (Stroud: Sutton Publishing, 1998), p213.

72. Johnstone, *Orange, Green, and Khaki*, p.254.

73. Johnstone, *Orange, Green, and Khaki*, p.246.

74. T. Bodkin, 'The Art of Mr. Harry Clarke,' *The Studio* 79, 320 (November 1919).

75. Bowe, *Harry Clarke*, p.64.

76. G. Harrap, *Some Memories, 1901–1935* (London: Harrap, 1935), p.61.

77. Bowe, *Harry Clarke*, p.291.

78. G. Harrap, *Some Memories, 1901–1935*, p.62.

79. M. D. Staunton, 'The Nation Speaking to Itself: A History of the Sinn Féin Printing and Publishing Co. Ltd., 1906–1914,' *The Book in Ireland*, J. Genet, S. Mikowski and F. Garcier (eds), (Newcastle: Cambridge Scholars Publishing, 2008), pp.221–222.

80. W. J. Dowling, 'Harry Clarke: Dublin Stained Glass Artist', *Dublin Historical Record*, 17, 2 (March 1962), p.61.

81. K. Jeffery, 'Artists and the First World War', p.44.

82. É. O'Connor, *Seán Keating: Art, Politics and Building the Irish Nation* (Dublin: Irish Academic Press, 2013), p.63.

83. O'Connor, *Seán Keating*, p.79.
84. O'Connor, *Seán Keating*, p.76.
85. O'Connor, *Seán Keating*, p.34.
86. O'Connor, *Seán Keating*, p.43.
87. L. Ryan, 'A Question of Loyalty: War, Nation and Feminism in Early 20th Century Ireland', *Women's Studies International Forum*, 20, 1 (1997), p.24.
88. O'Connor, *Seán Keating*, p.45.
89. V. Brittain, 'Lament of the Demobilised', *Oxford Poetry* (Oxford: Basil Blackwell, 1920), p.7.
90. Denman, *Ireland's Unknown Soldiers*, p.148.
91. Denman, *Ireland's Unknown Soldiers*, p.151.

The Wayfarer

Padraig Pearse, 1916

The beauty of the world has made me sad.
This beauty that will pass.
Sometimes my heart has shaken with great joy
To see a leaping squirrel on a tree
Or a red ladybird upon a stalk.
Or little rabbits, in a field at evening,
Lit by a slanty sun.
Or some green hill, where shadows drifted by,
Some quiet hill, where mountainy man has sown,
And soon will reap, near to the gate of heaven.
Or little children with bare feet upon the sands of some ebbed sea,
Or playing in the streets
Of little towns in Connacht.
Things young and happy.
And then my heart has told me:
These will pass, will pass and change, will die and be no more.
Things bright, and green.
Things young, and happy.
And I have gone upon my way,
Sorrowful.

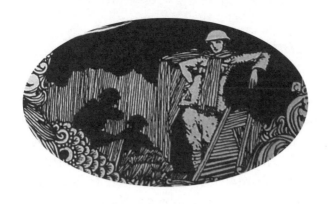

II

Art, Cinema, and War: Harry Clarke's Dublin

The Irish Arts and Crafts movement that influenced Harry Clarke was indicative of turn of the century artistic nationalism. In music and the fine arts in particular, artists gravitated toward the idioms of the peasants, whether language, folk tales, or folk dance. Representing the Irish past was essential to the Gaelic League and Celtic Revival movements, which existed comfortably alongside Arts and Crafts. In Eastern Europe, similar folk revivals were occurring and these too were as much political as artistic. Classical composers were experimenting with folk melodies, a trend that reached its apex with the performance of Stravinsky's minimalist, guttural peasant ballet *The Rite of Spring* in 1913. Yet, there are early signs in Clarke's art that he was sensing a strain on the nationalist art movements. In his illustration of Ligeia for *Tales of Mystery* by Edgar Allan Poe, for example, the phantom heroine treads upon a bed of dissipating scrollwork. Among the scrolls are Celtic motifs, unravelling, unwinding, becoming almost unrecognizable.

With roots in the politics of socialism, the Arts and Crafts Movement viewed machines with suspicion, as machines replaced humans with automated processes. Philosophically, the proponents of Arts and Crafts blamed mechanization for an essential dehumanization of the worker.

The noise and danger of the factory, the dirt and disease of the row house in the factory town, and the crowds and inevitable anonymity of the industrialized city, further reduced the worker to an anonymous urban being. Ironically, the social effects of the First World War were very similar. Under bombardment, war zones were transected by noise, light, and fumes; the soldiers, mere numbers to the commanding officers, had traded the crowded tenement for the muddied trench. And again, the arts sought to represent the experiences of the ordinary soldier. Painters turned to pallets of brown, green, and red; musicians deconstructed traditional tonality, with Arnold Schönberg developing a twelve-tone musical scale; and grammar reached extremes of intentional non-sense, exemplified by the poetry of Gertrude Stein.

Artists were faced with the conundrum of the machine and it became an object of fascination and disruption. English sculptor Jacob Epstein produced *The Rock Drill* between 1915 and 1916, a human figure made from machines. In France, Marcel Duchamp exhibited in 1917 the modern convenience of the man-made public urinal as an art object and a commentary on mass production. At the same time, cinema was a new art form created created by a machine – the motion picture camera. Immediately fascinating because it broke down the relationship between a still life and two-dimensional art, cinema was able to project humans larger than life in a public space that could be accessible and enjoyed by hundreds at a time. Away from the demands of bosses and schedules, city dwellers might seek entertainment and respite in the darkened theatre that ironically depended on a further machine – the projector.

Thus, Harry Clarke considered his commission for *Ireland's Memorial Records* during a significant confluence of the conservative and nationalistic Arts and Crafts Movement in Ireland and the new technologies of cinema and the arts.

Arts in Wartime

The European war of 1914 gave rise to a new type of artist, that of the official war artist. The combat nations of the First World War quickly

seized upon war as an opportunity for artistic propaganda. In an early effort of what we now know as 'embedding' reporters, artists joined troops in the front lines. France, Germany, and England hoped that heroic images of soldiers' brave deeds would consolidate public opinion around the war effort. Consequently, Allied nations created official offices for war art, and official war artists from England, Canada, Australia, New Zealand, and America were given the freedom to represent the battles, landscapes, and people in their own styles and techniques. During the First World War, many British artists served as representatives for Britain's War Propaganda Bureau. Britain's official war artists included William Orpen, Muirhead Bone, James McBey, C. R. W. Nevinson, John Lavery, Paul Nash, Eric Kennington, Frank Brangwyn, G. Spencer Pryse, Francis Dodd, William Rotherstein, and Wyndham Lewis.[1] In addition to official portraiture, many artists were interested in images of ordinary soldiers; this often included their own reflective self-portraits, as if to demonstrate the changed nature of their own subjectivity due to combat. Battlefield landscapes were prevalent, primarily consisting of damaged buildings. Not all of the landscape work is representational. For example, the British artist Paul Nash's expressionist images of the Somme are significant as anti-war imagery and are often given ironic titles such as *We are Making a New World* (1918). After 1916, the Leicester Gallery in London exhibited the war artists' work, and the war office published several issues of the full-colour propaganda magazine *British Artists at the Front*. One of the issues was devoted to the work of Harry Clarke's teacher and friend, William Orpen.

Artists were also employed practically as *camoufleurs* and medical artists. Combat nations on both sides of the war used the irregular-patterned painting techniques of camouflage for land and sea operations. The French, British, and Americans established formal camouflage sections that employed painters, sculptors, and stage designers. Among the most recognized product of the Allied *camoufleurs* was the practical wartime measure of painting 'dazzle ships', in which ocean-going vessels were covered with irregular patterned blocks of colour designed to obscure ship direction and speed.[2] Credited to the British artist Norman Wilkinson, the effects of dazzle painting were quickly

adopted in imaginative works by Cubists and the Italian Futurists. Its influence can be seen in the artistic output of Nevinson and Lewis as well as Gino Severini, Umberto Boccioni, David Bomberg, and Max Ernst. One of the most famous paintings is Edward Wadsworth's *Dazzle-ships in Drydock at Liverpool* (1919).

Artists also assisted the medical profession, representing injuries, developing prosthetics, and leading art rehabilitation schemes for the wounded. The Slade professor of art Henry Tonks served with medical officer Dr Harold Gillies at St Mary's Hospital in Sidcup, England where he was charged to create colour medical drawings of facial wounds. Tonks's delicate pastels were able to show the damage, disease, and repair needed for plastic surgery better than black and white photography. The British sculptors Francis Derwent Wood and Kathleen Scott, together with American Anna Coleman Ladd created 'tin masks', facial prosthetics designed to cover the soldiers' horrible wounds from shrapnel and gunshots.[3]

The reputations of the official war artists in Great Britain were established by their work from 1914–19. In the 1920s, German artists probed the psychological impacts of war on survivors; these works were often political commentaries on the declining economic situation of the Weimar Republic. Destructive machine warfare that disfigured combatants and psychologically damaging effects of bombardment are represented in the many sensitive and disturbing images of soldiers tortured and haunted by their experiences. No consideration of war art can be complete without an extended examination of Otto Dix's *Der Kreig* (*The Art of War*, 1924), which is perhaps the single most devastating critique of war in the twentieth century. The fifty-one etchings and aquatints in the series were modelled on the work of early nineteenth-century Spanish artist Francisco Goya, who completed *Los Desastres de la Guerra* in protest of the Napoleonic campaigns. Illustrating a profusion of bones, fragmented and dissected bodies, bombed houses, craters, trenches, and mud, Dix's work is at once hallucinatory and unflinchingly realistic.

The latter part of the nineteenth century is notable for dramatic changes in artistic philosophy and styles, and Clarke's life paralleled

the major aesthetic movements and philosophies of the era, including Decadence, Aestheticism, Symbolism, Art Nouveau, Modernism, and Arts and Crafts. Although the First World War has often been identified as the time of the breaking of tradition, experimentation in visual arts dated back to the latter decades of the 1800s. New ideas from Europe, particularly France, Germany, and Russia, were filtering into the art world through the publication *The Studio*. Russian design was fostered through the publication *Mir iskusstva* (*World of Design*), edited by Serge Diaghilev. Aubrey Beardsley, often cited as a design precursor to Clarke and an artist admired by Diaghilev, published in the first issue *Mir iskusstva*.[4] Diaghilev also established the Ballets Russes in 1909. Their tours of Paris were controversial and exciting, most famously the premiere of *The Rite of Spring (Le Sacre du printemps)*, with music by Igor Stravinsky and choreography by Vaslav Nijinsky. The Ballets Russes turned to the Symbolist Léon Bakst for costumes and set designs. Bakst's illustrated, full-colour designs were featured in exhibitions at the Fine Arts Society of London in 1913 and 1917.[5]

A programme for the Ballets Russes presentation of Ravel's 1912 *Prelude to the Afternoon of a Faun* offers an idea of Bakst's distinctive way of working with the human figure. He depicts the dancer in partial profile, left shoulder and back turned toward the viewer. Both legs are bent at the knee, the right leg crossing over the other, the foot bare. The dancer is supple and powerful, his bold black and white tights emphasizing his muscular thighs and shins, his lean and bare torso bronzed. Comparing the illustration to Clarke's figure drawings in his book illustrations as well as in the *Records*, we can see the debt to the Russian master, for the entire image is sensual and filled with movement. Reflecting on Clarke's *oeuvre*, James White, the former director of the National Gallery of Ireland, comments that Clarke's illustrations need to be read for tensions between the body and the ideal, which represents his own 'conflict of religion and sensuality'.[6]

Harry Clarke's designs for *Ireland's Memorial Records* draw from a tradition of European illustration. His style is cleverly adaptive and allusive, and in it the grotesques of Willy Pogany, the decadence of Gustav Klimt, the line of Bakst, and the playfulness of Beardsley are

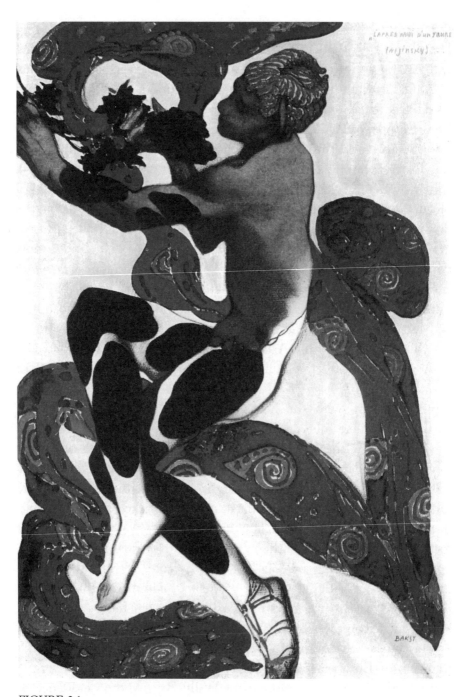

FIGURE 2.1
Bakst, Leon (1866–1924). Faun, costume sketch for Claude Debussy's ballet *L'apres-midi d'un Faune*, 1912. Gouache, watercolour and gold, paper on cardboard, 39.9 × 27.2 cm. ART 171472. Photo Credit: Erich Lessing / Art Resource, NY.

evident. Clarke wove illustrations out of artistic associations with Decadents such as Beardsley, designs from the costumes of Bakst, and liberating sexual mores from the flickering artistry of silent film. While scholars often speak of Modernism as if it were a holistic movement, each country developed distinct artistic approaches to the Modern. Developments in art prior to the turn of the century continued to fuel artistic experimentation after the First World War. There is a difference in judgment about whether the Dadaists responded to the disruption of the war or retreated from it. Art historian Elizabeth Kahn points out that the centrality of experience is a key way of dividing the arts of war: 'The Dadaists in neutral Switzerland and Picasso and Company in the safety of an unoccupied Paris certainly reacted to the same events, but their art was several steps removed and their comprehension of the crisis came from a huge distance.'[7] On the other hand, historian Modris Eksteins argues that 'the most radical artistic response to the war came from a group of people who made a complete break with traditional loyalties': the 'anti-art' of Dada.[8] The Dada group included Hugo Ball, Hans Arp, Raoul Hausmann, and Max Ernst. Hugo Ball was denied enlistment on medical grounds and escaped to Zurich, while Max Ernst (initials M. E.) had served on both the Western and Eastern Fronts in the war, and famously proclaimed his rebirth by fire on the front lines: 'On the first of August 1914 M.E. died. He was resurrected on the eleventh of November 1918,'[9] the Armistice serving as the entry into a new world, a postwar realm of reconstruction and memory.

Modernism's signature emphasis on interiority and alienation fused with postwar political and economic critique, particularly in the Weimar Republic. Weimar fostered the terrifying inner visions of Dix, Georg Grosz, and Ludwig Kirchner. In Paris, Pablo Picasso and Georges Braque experimented with Primitivism and Cubism. The works of these artists have defined the Modern period, for each artist visually represented a rupture from the past, exploiting fractured line, surprising juxtapositions, and absence of direct representation.

In Ireland, Clarke and his art-school contemporaries Seán Keating and Wilhelmina Geddes are the noted Modernists. Each

artist responded uniquely to the political turmoil of the war and revolutionary years as well as the religious conservatism of the 1920s. During this period in Ireland, the Arts and Crafts Movement was a strong influence on design and the arts. The fascinating confluence of Arts and Crafts and Modernism reveals yet another tension in Clarke's work, another point where conservatism and the avant garde place pressure on each other. Clarke's illustrations for *Ireland's Memorial Records* combine the representational aspects of the frontline war artists with the playfulness, disorder, and social critique of the Dadaists.

The Arts and Crafts Movement

Ireland's Celtic Revival drew inspiration from the international Arts and Crafts Movement. A major aesthetic development in England, Ireland, Scotland, Scandinavia, and America, Arts and Crafts was as much a philosophy of living as a distinct artistic concern. The direct response to the rise of industrialization and mass production in northern English factories, Arts and Crafts married the beauty of handcrafted design with the craft of producing useful material objects. In England, its most notable proponents were John Ruskin and William Morris. Ruskin encouraged the movement on philosophical grounds. Morris established a firm to produce textiles and wallpapers using hand wood-block techniques; in 1891, he founded the Kelmscott Press, which re-introduced medieval illumination to the book trade. His distinctive style featured floral, fruit, and bird motifs, particularly intertwined vines and leaves.[10] Morris influenced many of the major artists in the latter part of the century, among them, Dante Gabriel Rossetti, Ford Madox Brown, and Edward Burne-Jones. Burne-Jones, in particular, was a noted designer of stained glass. Nicola Gordon Bowe cites him as one of the significant influences on Harry Clarke.[11]

In addition to his aesthetic theories, William Morris was an ardent supporter of Irish Home Rule, and visited Ireland in April 1886 to deliver four lectures on politics and art. William Butler Yeats, at the time an art student at the Dublin Metropolitan School of Art, heard

THIS IS THE PICTURE OF THE OLD HOUSE BY THE THAMES TO WHICH THE PEOPLE OF THIS STORY WENT. HEREAFTER FOLLOWS THE BOOK IT. SELF WHICH IS CALLED NEWS FROM NOWHERE OR AN EPOCH OF REST & IS WRITTEN BY WILLIAM MORRIS.

FIGURE 2.2
Kelmscott Manor, Gloucestershire, frontispiece to *News from Nowhere*, c1892 (1901). Illustration from *The Connoisseur* (December 1901). AP963980. Photo Credit: HIP/Art Resource, NY.

Morris speak at the Dublin Contemporary Club and subsequently became an enthusiastic proponent of Arts and Crafts and its link to Socialism. In his essay 'Ireland and the Arts', Yeats specifically praised William Morris; he then enjoined Irish artists to follow Morris's teachings, writing, 'I would have our writers and craftsmen of many kinds master Ireland's history and legends.'[12] This interest in a reimagined Celtic past that was as much historical as mythical would be evident in Yeats's poetry and collections of folktales. Bowe describes the way that 'archaeological discoveries and scholarship' and 'national fervour' aligned with the poetic visions of Yeats and AE (George Russell) to form the aesthetic of the Celtic Revival.[13] Romantic nationalism 'became manifested in a longing for the past, particularly for peasant cultures, which were perceived as unspoiled and as representing the continuity of ancient traditions'.[14] In his essay on national consciousness, AE wrote:

> Our civilization must depend on the quality of thought engendered in the national being. We have to do for Ireland … what the long and illustrious line of German thinkers, scientists, poets, philosophers, and historians did for Germany, or what the poets and artists of Greece did for the Athenians: and that is, to create national ideals which will dominate the policy of statesmen, the actions of citizens, the universities, the social organizations, the administration of State departments, and unite in one spirit urban and rural life.[15]

It's important to remember that the Arts and Crafts Movement extended the practical fight for working conditions. Both reintroduced humanity to the factory. Morris's lectures in Dublin were primarily about the Socialist movement. As a response to industrialization, the utopian vision of the Arts and Crafts Movement signified a belief that machines had dehumanized the worker. Not only were workers surrounded by the noise of machines, they crowded into dark and dirty city tenements. Danger, disease, and psychological alienation of

the worker would be the result. In turn, mass-produced commercial items increased the divide between the purchaser and producer, a gulf that was social and economic. Too many inexpensive goods on the market led to a consumer society, alienating the people from their history and from the sources of production. Today, we might call the interests of the Arts and Crafts proponents a fascination with 'haptics', the idea that the hand must touch the materials of production, whether rag paper, linen, clay, or ink. The stress on 'creative labour and craftsmanship'[16] might cause production to be slowed, but the worker would ultimately feel more fulfilled because he or she would have time to create only those items that truly mattered, those that served a definite use. Outside of Belfast, Ireland was much less industrialized and thus workers did not react against mechanization in the same way. Nonetheless, the Arts and Crafts Movement offered an appealing blend of 'moral aesthetics, adherence to regionalism, and glorification of "the simple life" and the handmade'.[17] Romantic nationalism was evident not only in Ireland, but in Norway, Finland, Russia, and Scotland. It was a shift in thinking that was 'both progressive and conservative, modern and anti-modern'.[18]

As Nicola Gordon Bowe and Elizabeth Cumming write, when the Arts and Crafts Movement took hold in Ireland in the later decade of the nineteenth century, revitalized design was connected to 'health, and national pride'.[19]

> In Ireland, the movement was as much concerned with political, social and cultural ideology as the making of beautiful, functional, materially fitting objects and, in Dublin, with a passionate striving for individual, 'modern' visual expression based on glorious past achievement in craftsmanship, set against an urban backdrop of decay, unemployment and disease.[20]

Lady Ishbel Aberdeen, the wife of John Hamilton-Gordon, Earl of Aberdeen and twice Lord Lieutenant of Ireland, was a key figure in the establishment and promulgation of the Arts and Crafts Movement.

A dedicated Home Ruler and feminist, Lady Aberdeen was appalled by the conditions of Dublin slums and the poverty of the people. Finding Dublin a fertile ground for practical and aesthetic reform, she established the Irish Industries Association in 1886.[21] Its focus was on needlework, weaving, and indigenous Irish crafts. The 1890s saw two important developments in traditional arts: the establishment of the Gaelic League, designed to revive the Irish language; and the founding of the Arts and Crafts Society of Ireland (ACSI), devoted to the question of a national style in art and design. In the next decade, two established English artists relocated to Dublin to teach at the Dublin Metropolitan School of Art, and both of these artists would have a direct influence on Harry Clarke: the stained-glass designer Alfred Child in 1901 and metalwork and enameller Percy Oswald Reeves in 1903. Reeves' contribution to *Ireland's Memorial Records* are the doublures for the set of books presented to King George V.[22]

Arts and Crafts was embraced by a number of well-known names in Ireland. As Bowe notes, 'a circle of Dublin professionals' supported the Irish Arts and Crafts Movement, including the solicitor John O'Connell, the senator Laurence Waldron, and doctor Oliver St John Gogarty.[23] Evelyn Gleeson established Dun Emer Industries, which employed local women in creating weavings and printed material. Through Dun Emer, Elizabeth Yeats set up a hand-operated printing press, which used paper made in Dublin by Swiftbrook Mills in Saggart. Sarah Purser's studio An Túr Gloine was created 'to combine the former glories of metalwork, illumination, jewelry, and sculpture, but in a modern idiom'.[24]

These practical efforts in training were backed by a sympathetic press. Sir Horace Plunkett established the Irish Agricultural Organization Society, which published the periodical *The Irish Homestead*, edited by AE from 1905. Under AE's guidance, *The Irish Homestead* sought 'to evoke practical and national aspiration by representing the economic along with the spiritual'.[25] AE employed illustrators such as 'Jack and Mary Cottenham Yeats, Beatrice Elvery, Sarah Purser, Constance Gore-Booth and John Campbell' to decorate 'seasonal covers, decorative layout and synthesis of words and images

by young, contemporary, romantic nationalist poets, writers and artists'.[26] Many of these authors and illustrators also published works with Maunsel and Co., thereby reaffirming the connection between Irish nationalism and the Arts and Crafts Movement. Furthermore, Maunsel published the catalogue for the seventh exhibition of the Arts and Crafts Society of Ireland in 1925, which is where *Ireland's Memorial Records* were exhibited publicly for the second time.

As Bowe has pointed out, 'the Arts and Crafts Society of Ireland would play a key role in visualising the better-known literary and linguistic Celtic Revival over the next two decades as Ireland sought her own cultural identity'.[27] Between its founding in 1895 and the time it formally closed in 1925, the Arts and Crafts Society of Ireland held six exhibitions: 1895, 1899, 1904, 1910, 1917, and 1925. The Fifth Exhibition of the Arts and Crafts Society of Ireland was held during the war years in Dublin, from June 25–27 July 1917; the exhibition then moved to Belfast in October and Cork in November. The members of the Council that organised the Fifth Exhibition included several of those who would be involved in the creation of *Ireland's Memorial Records*: Harry Clarke, Oliver St John Gogarty, and Laurence Waldron. Harry Clarke designed the cover for the catalogue of the 1917 Fifth Exhibition; it features a maiden, a peacock, and his signature stylized flowers and sea anemones.

John O'Connell's foreword to the Fifth Exhibition catalogue is itself a survey of the Arts and Crafts Movement's relationship to nationalism and the First World War. With a purpose that might seem antithetical to the European Modernist Movement, he expressed the hope that the war would enable countries to invest deeply in their 'own art, the first fruits of the spiritual and aesthetic forces around it'.[28] Rather than advocating insularity, however, O'Connell was drawing from the inspiration of Ruskin and Morris, who believed in the spiritual efficacy of the arts to elevate historical understanding, human connection, and national pride. In lines that could have been drawn directly from Morris's own writings, O'Connell expressed the wish that, '[t]hose whose freedom has been preserved by the courage and self-sacrifice of men will feel that things of beauty fashioned by

the free hands of men and no longer by the mechanical processes of the factories, are possessions which they should seek out and cherish'.[29] By this point in the progress of the First World War, too, the potential of machines such as tanks and long-range guns for widespread destruction of life and land was recognized, adding urgency and poignancy to O'Connell's words. And thus the catalogue also expressed a hope that arts might encourage peace, despite the times 'unfavorable for the arts of peace'.[30]

The Fifth Exhibition featured a work that may have been influential in the development of *Ireland's Memorial Records:* the morocco-bound, inlaid and tooled books created by Eleanor Kelly for the Honan Chapel in Cork. Kelly employed Celtic designs in the Roman missal, the volume of the requiem mass, and the Rite of Service.[31] The requiem mass and Rite of Service were inlaid with gold-tooled crosses based on the interlace design of the stone slab covering the grave of St Berchert at Tullylease, County Cork, which dates from between the sixth and ninth centuries.

Other Arts and Crafts exhibits were hosted by the Royal Dublin Society (1888), the Gaelic League, the Dublin United Arts Club (1906), and Dublin Metropolitan School of Art. All exhibited work that demonstrated the influence of the Arts and Crafts' aesthetic and were designed to further the ACSI goal 'to efface, as far as possible, the distinction between artist and the artisan, and to carry the contemplation of beauty from public galleries and buildings into the homes of people and into their daily life'.[32] *Ireland's Memorial Records* were exhibited at the 1924 Aonach Tailteann art exhibition and again at the 1925 ACSI exhibit.[33] They won prizes in both.

The Aonach Tailteann, 1924

In 1924, efforts to establish a place for arts in the new Irish Free State culminated in the Aonach Tailteann art exhibition and competition, sponsored by the Cumann na nGaedheal government under William T. Cosgrave. Initially proposed in 1919 and planned for 1922, Aonach Week had to be postponed due to the Civil War. Part of a two-week

festival from August 2–17 1924 that included art, music, dance, a literary prize, and sporting events at a renovated Croke Park, the Aonach Tailteann was as much ideological as it was a celebration of Irish culture. English-speaking countries with large immigrant populations – particularly the United States, Canada, and England – took part in the festival. The festival claimed roots extending back to the seventh century BCE, when King Lughaidh Lamhfáda created a celebration in honour of Queen Tailté.[34]

The question to be explored by the art exhibit was whether there was a definable Irish national style of arts and design. Art historian John Turpin has pointed out that Irish art instruction had grown stale and conservative after the First World War; the Dublin Metropolitan School of Art had never embraced the avant garde. William Orpen, the influential painting teacher, would not recognize any modern art beyond Impressionism, by then an innovation in painting that was close to forty years old.[35] Under the direction of Seán Keating, the painting school emphasized realism and painting from life.[36] Artists who were interested in new work had to travel to Paris or Antwerp to learn about the vision and styles of the Modernists.

But this question of a national style did not arise in the 1920s. It dated to earlier in the century, even before the First World War, and represented a common concern among intellectuals and artists. For example, in 1906 George Russell (AE) had called for national art that rejected international influences, which he called 'the cosmopolitan spirit'.[37] Russell was adamant that the spiritual home for art that was 'distinctively Irish' in its subject matter was the western Irish Gaeltacht, where the Irish language was the first language and the life of the locals was seen as uncorrupted by colonialism or modernism. Terence Brown has described this as a 'prevailing rural understanding of Irish identity';[38] the problem for the arts was that the subject matter was limited to landscape and details of rural Irish life.

From 1906 through the Fifth Exhibition in 1917 to the Aonach Tailteann in 1924, then, the proper subjects for Irish art and its relationship to what AE called 'national being' were critical to the

organizations to which Harry Clarke belonged. Russell's concerns, and a potential debate about their relevance, were picked up as a point of debate by the ACSI 1917 exhibition, as O'Connell cautioned that no art 'can live on the past alone. It is therefore essential that no slavish reversion to ancient forms, however beautiful, or to traditions, however well-established should hamper – should do more than tend to help – the Irish craftsman of to-day'.[39]

Hosted by the Royal Dublin Society in Ballsbridge, over 1,500 works of art were on display at the Aonach Tailteann. Notable artists of the day such as Jack Yeats and Seán Keating as well as Harry Clarke were represented in the exhibit – with Keating controversially being awarded the majority of the prizes. With a wide circle of Irish friends that included Oliver St John Gogarty and the painters William Orpen and Sir John Lavery, Edwin Lutyens 'spent an enjoyable weekend, staying with Andrew Jameson, in Dublin in August 1924 during the Tailteann games'.[40] Joseph Maunsel Hone, founder of the publishing house Maunsel and Co., recalled the later summer party in his memoir:

> I remember Oliver Gogarty's garden party very well. It was in the August of 1924, towards the close of a wet and cold summer. The visitors from England … – Augustus John, G. K. Chesterton, Compton MacKenzie, Sir Edwin Lutyens – had come to Dublin as guests of the newly established State for the Tailteann Games … If my memory serves me, W. T. Cosgrave, the president of the Dáil, and T. M. Healy, the wily and witty politician who had been appointed Governor of the Free State were also at the party. Gogarty, an athlete as well as a poet and physician, was very much 'in' with the Government. I am sure that he was the hand behind the invitations to John and Lutyens.[41]

While it is tempting to think that because they had met in London in 1919 and because of mutual acquaintances, Lutyens and Clarke shared a moment in Dublin in 1924 discussing the publication of *Ireland's*

Memorial Records, it should be remembered that the commission for the design of the Irish National War Memorial Gardens would not be offered to Lutyens until 1930. With only a few days, and such a wide variety of events and exhibits taking place as part of the Aonach Tailteann, it's possible that Lutyens did not even see the eight volumes of *Ireland's Memorial Records* on display at the exhibition. Many years later, in December 1935, as the Irish National War Memorial Gardens were being completed, Lutyens was puzzled by a reference to 'books' in a communication from the committee. His note to them read, 'Mr Byrne has sent me the size of the books for the Book Room in the National Memorial. In his letter he mentions the word "books" which means there are more than one book. Could you let me know how many books there are?'[42]

The display of *Ireland's Memorial Records* at the Royal Dublin Society did not receive much attention, although the books won the silver medal for black and white engraving. Essentially an Anglo-Irish enterprise in inception and direction, Harry Clarke's engravings for *Ireland's Memorial Records* attempt a rapprochement between the Celtic style, the popular silhouette motifs, and the modern photographic representations of the First World War. By 1924, anxious to move on with their lives, people were forgetting about the war, particularly in the new Irish Free State. In addition to being a reminder of pain and suffering in a European setting, *Ireland's Memorial Records* must have appeared as an artefact from a distant age. In fact, criticizing 'the involvement of the Anglo-Irish elite in the literary and artistic events', Sinn Féin boycotted the festival.[43]

Maunsel & Company, Printing Ireland

Clare Hutton points out that 1905 was 'a key moment in the Irish Literary Revival'.[44] In that year, George Russell (AE) became the editor of the *Irish Homestead* and Maunsel and Co. was founded with three directors: Joseph Maunsel Hone, George Roberts, and Stephen Gwynn. AE was a leader in the Celtic Revival, stressing a return to national subjects and a national style for Irish art. Maunsel's publications would

be a leader in the literary and cultural efforts to 'de-anglicise' Irish culture, to take up a call for Irish writers to be published in Ireland 'on Irish paper,'[45] and to reject 'imported British products and insisting on Irish ones instead'.[46] The publishing firm was distinctive in its record of publishing works on Irish themes by Irish writers. Among their sales list were works by J. M. Synge, Padraig Pearse, Maud Gonne, and Jack Yeats, as well as works by leading political leaders, among them James Connolly, Éamon de Valera, Eva Gore Booth, Alice Stopford Green, Darrell Figgis, and P. S. O'Hegarty. Bowe and Cumming refer to Maunsel and Co. as 'the most important Arts and Crafts publisher of the early Celtic Revival in Dublin'.[47]

The following year, in 1906, the Irish copyright symbol was created, and used to mark printed products of Irish origin. 1906 also marked the surfacing of the radical newspaper *Sinn Féin*, edited by Arthur Griffith. Like his fellow publishers, Griffith insisted on printing the paper in Ireland on Irish paper.[48] During this time period, Sinn Féin acted as both a political and cultural mouthpiece for Irish identity. Until its suppression by the British government in 1914, *Sinn Féin* was issued weekly by the Sinn Féin Printing and Publishing Company. Trained in printing and publishing, Griffith's advocacy of Irish industry extended into his prominent use of graphic design in the newspaper.[49] He hired Clarke's friend Austin Molloy as a cartoonist, preferred bold graphic advertising, and employed strong visual elements to persuade readers of the necessity of linking Irish industrial politics to questions of national identity.[50] In addition, he positioned the copyright symbol *Déanta I nÉirinn* – 'Made in Ireland' – prominently in the masthead of the newspaper. In a bit of self-promoting rhetoric within the newspaper itself, Griffiths explained that *Sinn Féin* was 'the only journal in Ireland entitled to use the Irish Trade Mark'.[51]

> The reason why is that 'Sinn Féin' is the only daily journal in Ireland printed on Irish paper. 'Sinn Féin' is printed with Irish ink. All the materials procurable in Ireland that go to make up a newspaper are used in 'Sinn Féin'. All other daily journals in Ireland import their paper from England,

America, France, or Holland. If they procured their paper and ink at home, at least £100,000 a year would be retained in this country and permanent employment provided for about 2,000 people. 'Sinn Féin' is the only daily paper in Ireland that supports the paper-making and ink-making industries of the country.[52]

Maunsel and Co. shared a similarly nationalist agenda with the Sinn Féin Printing and Publishing Company, although Maunsel and Co. consistently had financial problems and took much of its printing and binding business to England. The publishing output of Maunsel and Co. consisted for the most part of small paperbound books without illustrations, and they usually used inexpensive wood pulp paper rather than linen stock. Their books demonstrated simplicity in design, using a readable typeface and ample white space. Maunsel's books were lightweight and portable, yet, as Hutton maintains, their style of book production set them apart from 'the many cheap and badly printed books that were issued by other Irish publishing houses during this period'.[53]

The Fine Art of Printing

Although Irish paper making was in decline by 1880, after William Morris established the Kelmscott Press in 1890 and published his influential essay on printing in 1893, Ireland saw a resurgence in printing so that by 1895, seventy-three print works were open in Dublin.[54] Morris called for a complete, holistic revolution in the production of books, in which the book design would be fitting to its subject: 'whatever the subject-matter of the book may be ... it can still be a work of art'.[55] His concerns extended from the 'architectural arrangement' – or design of the page – to the materials used in printing.[56] Architecturally, the book required 'proper setting' of type, margins, and spacing of words to be legible and pleasing; ornaments such as border designs had to 'form as much a part of the page as the type itself'.[57] As Morris wrote in his statement on 'The Ideal Book',

'if you want a legible book, the white should be white and the black black'.[58] Materially, the book had to 'be printed on hand-made paper as good as it can be made'.[59] As a contemporary champion commented about Morris, 'His one thought has been quite simple, to make books as beautiful as those which have come down to us from the period which every bibliophile recognises as the golden age of printing.'[60]

Following Morris's influence, 'in the last decades of the nineteenth century, the aesthetics of book covers became a topic of intense interest and sometimes passionate debate. Numerous national and international expositions included bookbinding exhibits and were regularly reviewed in the press'.[61] Among those who stimulated new developments in the art of bookbinding were Thomas James Cobden-Sanderson and his student Douglas Cockerell. Like Morris, Cobden-Sanderson adhered to the philosophy that there could be an 'ideal book,' one in which 'paper, type, font, printing and illustration'[62] worked in harmony to 'embody a single aesthetic vision'.[63]

While Clarke was at work on the commission from the Irish National War Memorial Committee, from 1919 onward the largest organization of war commemorations was considering how to sensitively represent in print and memorial spaces the names of the legions of war dead. With the Director of the British Museum, Frederic Kenyon, as an artistic advisor, the Imperial War Graves Commission (IWGC) hired three architects to design cemeteries in Belgium and France: Reginald Blomfield, Herbert Baker, and Edwin Lutyens. As a student of architecture in England, Lutyens embraced the Arts and Crafts style. His earlier domestic architecture incorporates the romanticized English cottage style, popular with the movement. Evidence of his interest in the legendary past is at Howth Castle County Fingal, where the redesign of 1911 incorporates battlements, oriel windows, and an Elizabethan garden. In his later work, Lutyens incorporated his early romanticism into a more classical refinement, elements which are evident in the Irish National War Memorial.

In addition, early in 1920 the IWGC hired Douglas Cockerell, binder for W. H. Smith and former student of Cobden-Sanderson, as Technical Advisor to oversee the printing and binding of cemetery

THE WAR GRAVES OF
THE BRITISH EMPIRE

The Register of the names of those
who fell in the Great War
and are buried in
Forceville Communal Cemetery AND Extension
Forceville, France

Compiled and Published by order of the Imperial War
Graves Commission, London. 1920

FIGURE 2.3
Douglas Cockerell's design for the cemetery register, Forceville Community Cemetery, France.
Imperial War Graves Commission, 1920. Photo Credit: Maria Choules/Commonwealth War
Graves Commission.

registers for each of the IWGC cemeteries.[64] Cockerell and his brother Sydney were both associated with the Arts and Crafts Movement in England. Sydney had served as William Morris's secretary, while Douglas spent five years at the Doves Bindery, founded by T. J. Cobden-Sanderson and Emery Walker.[65] In 1898, Cockerell opened his own bindery and began teaching at the Central School of Arts and Crafts.[66] We find the tenets of Arts and Crafts in Cockerell's work for the IWGC.

The history of the War Graves Commission, *The Unending Vigil*, notes that 'Cockerell was determined that a register should be more than mere lists of names: the names should have a context.'[67] Each of the registers would contain a map and alphabetical list of graves. In addition, each was to include a description that would present 'a historical note on the origin of the cemetery and the military operations connected with it'.[68] Many IWGC cemeteries began as plots behind field hospitals or casualty clearing stations; their history reveals the history of the war, both in terms of troop and medical movements. Thus, each cemetery has a story. Printing, like all the other work, was, in Kenyon's words, to be carried out by firms of 'high standing, in order that the result may be worthy of the Commission and of the subject'.[69] From 1921 to 1931, the IWGC developed 2,400 cemeteries in Belgium and France as well as Italy, Egypt, and the Dardanelles.[70] The Commission planned to place a bound copy of the specific cemetery registers in a box near the entrance to each of these cemeteries and offer copies for sale to the public. Visitors to First World War cemeteries today will still find bound copies of the cemetery registers near the entrance gates.

By 1920, then, when the IWGC produced the first cemetery registers for Forceville, Louvencourt, and Le Treport in northern France, finely decorated, printed memorial registers were established within the cultural practices of memory and commemoration. Cathedrals, parish churches, towns, businesses, and social organizations also began to create elaborate and handmade local honour rolls. Some, like those on display at the cathedrals of Winchester and Durham in England, take the form of the 'parchment rolls' that the Irish National War Memorial

FIGURE 2.4
The King's Book of York's Fallen Heroes. ©Dean and Chapter of York: Reproduced by kind permission.

Committee envisioned. Large books on heavy paper in which the names of the dead are handwritten in fine calligraphy, these books rest open on a pedestal, typically within a locked glass case. Another unique work from the time should be mentioned, the remembrance book completed by the community of York, England, titled the *King's Book of Heroes*. This massive volume was commissioned in 1920, and today is kept in a locked case at York Minster. The carved covers of the *King's Book of Heroes* are two feet long, made of solid oak and bound in steel. Nine inches thick, and listing over 1,400 names, the book weighs 130 pounds.[71] Each of these examples – Imperial War Graves, Winchester, Durham, York – represents the dead of a battle, a regiment, or a city. None attempts to cover the thousands of names of war dead from a single country.

What makes *Ireland's Memorial Records* unique, then, if Douglas Cockerell was also producing a fine set of memorial records for the IWGC? *Ireland's Memorial Records* are firmly rooted in the Arts and Crafts tradition and belong to a significant postwar genre of international significance. They pay homage to the finest tradition of bookbinding, drawing inspiration from the Honan Chapel Missal and the Kelmscott Press. Finally, nothing could equal the elaborate and fantastic expression of Harry Clarke. The illustrations for *Ireland's Memorial Records* work independently and interdependently with the text. This dialogue between the honour roll at centre of the pages and the illustrated margins suggests a provocative argument about war, nationality, and reconciliation.

Social historian Angela Bourke has commented that 'standardisation and uniformity were hallmarks of nineteenth-century official thinking', including literary works, which 'were published in identical bindings in uniform editions'.[72] As official government documents, the IWGC cemetery registers were also uniform in their concept, design, and printing. The registers and the gravesites were intended to be non-hierarchical, not divided by rank. In the history of the IWGC (*The Unending Vigil*), the communal burial grounds are described as reinforcing the common experience of the trenches.[73] Conversely, although each of the eight books in the set of *Ireland's Memorial Records* are printed following the same pattern, the designs as a whole cast uniformity aside in favour of individualized and thought-provoking imagery.

As the efforts of the IWGC suggest, Harry Clarke's commission to complete the borders for *Ireland's Memorial Records* can be placed in the wider context of memorialization. By 1917, Irish artists were active with war commissions. The *Catalogue for the Fifth Exhibition* of the Irish Arts and Crafts Society was prefaced with the apology that 'It has not been found possible … to include in the exhibition examples of all the varied kinds of work now being done by them [the Irish craftsmen], among which may be mentioned Memorials to those who have fallen in the war – mural tablets in metal, marble, etc.; memorial windows in stained glass, and Mosaics.'[74] Artists taking out special ads that announced availability for memorial

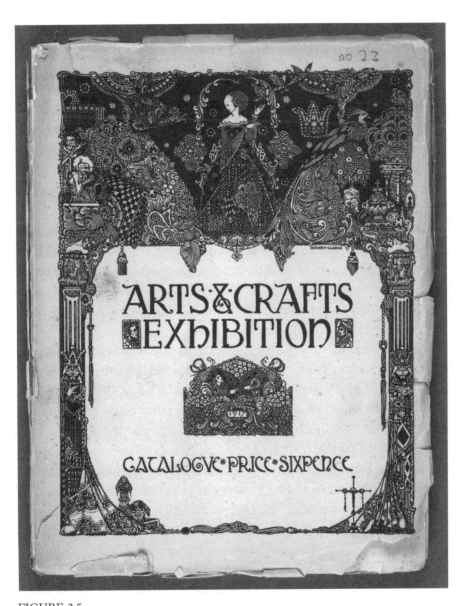

FIGURE 2.5
Catalogue of the fifth exhibition 1917: held in conjunction with the Irish art competition and exhibition, organized by the Department of Agriculture and Technical Instruction for Ireland in Dublin, Belfast, Cork. The Arts and Crafts Society of Ireland and Guild of Irish Art-Workers. Image courtesy of Trinity College, Dublin.

works were Charles Braithwaite and T. H. Drummond, of No. 7 Chichester Street, Belfast, who advertised that they were: 'Craftsmen and Designers, Illuminations, Heraldry, Designs for Book-production, Bookbinding, Ecclesiastical and other Fine Embroideries. Memorials in Bronze, Brass or Copper Designed and Executed.'[75] In addition, Kathleen Quigley, of No. 5 Clareville Road, Rathgar, Dublin offered her services in 'Wood Engraving for illustration, book-plates, etc. Memorial Tablets in brass or copper.'[76]

By 1921, two members of the Arts and Crafts Society of Ireland had created notable memorials for the All Saints Church of Ireland in Grangegorman, North Dublin. Ethel Rhind's extraordinary mosaic of St Michael is located on the exterior south wall of the church. It depicts St Michael in cloak and armour, vanquishing evil, represented as a half-human half-wolf creature. St Michael's wings extend behind him in a blaze of red. The Bible passage is *Judges* 5:21, 'O my soul, thou hast trodden down strength.'

Percy Oswald Reeves's enamelled memorial triptych, the *Allegory of Peace*, is set to the side of the altar within All Saints Church. Its motto 'Their glory shall not be blotted out' (*Ecclesiasticus* 44:13), was used by the IWGC for graves that had been destroyed or disturbed by continuing battles, with many of the remains lost. Reeves draws further on the Imperial War Graves language at the base of the enamelled figure, continuing 'but their name liveth for evermore' (*Ecclesiasticus* 44:14). The angel of mercy holds two laurel leaves, symbols of peace. She is dressed in the blue robes typically associated with the Virgin Mother. Behind her is the crucified Christ. At her feet are two doves of peace, of the same shape and downward turning that Reeves would use in his doublures for the *de luxe* set of *Ireland's Memorial Records*.

The War Memorial Exhibitions in London, 1919

The Victoria and Albert Museum and the Royal Academy War Memorials Committee in London responded to wishes for war memorials by launching two related exhibitions in 1919. The first was

held at the Victoria and Albert Museum in July. Many of the pieces were moved to the Royal Academy on October 20 for an exhibition that extended until November 29. Each of these exhibits was designed to suggest the style and tone of artistic memorial language, setting forward what was appropriate for various media including sculpture, church furniture, mural painting, tapestries, and stained glass. The Victoria and Albert Museum organized its East and West Halls to show items from the permanent museum collections and new designs for memorials by living artists; some of the same contemporary items were transferred to the Royal Academy. The exhibits suggested to artists and the public appropriate taste for memorials, and they encouraged business, as both the Victoria and Albert Museum and the Royal Academy set up a Bureau of Reference with photographs and 'reference lists of artists and architects, and some suggestions for Memorial inscriptions'.[78]

Clarke's domestic stained-glass panel 'Gideon' was among the new works exhibited at the Victoria and Albert Museum exhibit in July 1919. His work was not represented at the Royal Academy exhibition. The Dublin studio An Túr Gloine exhibited at both exhibitions, showing six stained-glass window designs by A. E. Child, Beatrice Elvery, Michael Healy, and Ethel Rhind. Also notable and unique to the Royal Academy exhibition in October was the model of Reginald Blomfield's Great War Cross, designed for the IWGC cemeteries, and dramatically presented alone in the Quadrangle. The Royal Academy displayed a replica of Edwin Lutyens's War Stone, also a significant feature of the IWGC cemeteries, as well as a model of the Cenotaph that was unveiled at the July 1919 Victory Day ceremonies.

Popular suggestions for windows included representations of the warrior saints, St George, St Michael, and St Hubert, as well as the Virgin. Rolls of honour were predominantly represented by tablet designs for bronze, brass, and slate, although illuminated manuscripts appeared at both exhibitions. The Victoria and Albert Museum was concerned with inscriptions, encouraging phrases in Latin.[79] Intriguingly, in its suggestions for stained glass, the Victoria and Albert was also very particular about representation of figures:

As regards themes of decoration for memorial stained glass, heraldry (in which may be included regimental badges), emblematical devices and inscriptions are generally appropriate. Deeds of heroism or sacrifice and the triumph of right over might are perhaps better brought to mind, in church windows at all events, by symbolical parallels from sacred history or legends of the saints … than by an attempt to depict actual occurrences or personalities of the war. Not the only reason for this is that khaki is a colour that does not lend itself readily to good effects in stained glass … Direct representations and figures in contemporary dress may be used with less hesitation in windows made for secular buildings …[80]

In his illustrations for *Ireland's Memorial Records*, Harry Clarke seems to have absorbed these directives and taken the advice as a challenge: he merges heraldry, regimental badges, deeds of heroism, and representations of 'figures in contemporary dress'. Furthermore, he borrows medieval, Renaissance, Celtic and modern artistic languages, blending design and documentary reference. Actual occurrences, such as the attacks on Suvla Bay and the gaining of ground at Chocolate Hill, are represented in vignettes, woven in with allusions to saints and a representation of the Virgin and Child.

In terms of illumination for rolls of honour, the Victoria and Albert also advised restraint and conservatism. The exhibit halls paired medieval illuminated manuscripts with the work of the Kelmscott Press, 'showing how much depends not only on decoration, but on spacing and arrangement in the production of a beautiful page'.[81] In addition to vellum, gilt edges were on display. The Victoria and Albert singled out the contemporary work of the Chiswick Press as exemplary, and also a border design by Fred Richards, which in description alone sounds very similar to what Clarke eventually created: 'Border Design, with the arms and floral emblems of Great Britain and Ireland'.[82]

On Monday 17 November 1919, Clarke travelled to London on a business trip to his publisher George G. Harrap and Company, at

No. 2 and 3 Portsmouth Street, Kingsway, near Lincoln's Inn Field.[83]
The Royal Academy Exhibition was entering its last two weeks. It
is very possible that he visited the exhibit when it transferred to the
Royal Academy at Burlington House. London was in the midst of a
cold and blustery November in 1919. We can imagine Clarke bundled
against the wind, boarding the London Electric Railway's Piccadilly
Line at Holborn to travel to the Dover St exit near Green Park, then
walking a few blocks east along the wide streets of Piccadilly, ducking
under the stone arches of the Ritz Hotel arcade. At the double golden
gates of Burlington House, he would pass through the long and dimly
lit narrow side stone arch, where in the open air of the wide, paved
courtyard, the stunning war cross by Blomfield would impress upon
him the sanctity with which the Royal Academy was presenting the
exhibit. If he visited the exhibit, he was most likely dashing through
in haste, as he had to gather a painting from the National Gallery,
and travel to Sussex and Cheshire on the same trip, which would have
sent him across the city to catch trains at Victoria and Euston. He
didn't pause at the National Gallery, writing to Bodkin that he was in
a 'dreadful rush'.[84] Perhaps inspired, perhaps wearied, he could have
made a mental note; Blomfield's Great War Cross of Sacrifice appears
at the head and at the end of each volume of *Ireland's Memorial Records*.

Film Arts of the War Years

This chapter opened by considering the arts of the early twentieth
century, those high arts with which Clarke had contact, including the
Ballets Russes and the publications *Mir iskusstva* and *The Studio*. Yet it is
also important to consider the full visual cultural experience, including
popular culture. Just as today we cannot help but notice advertising
in shop windows, Clarke could not have avoided product and event
advertising, recruiting posters, and the pages of the illustrated press.
For example, Dublin, like many cities in the Empire, ran a recruiting
tram, decked with bunting and posters.[85] Two prominent and familiar
posters are 'Kitchener Wants You' and Lawrence Oakley's silhouetted
figure in his popular poster 'Think!'

Dublin contained seventy-three print works at the turn of the
century, and by 1915 Dublin also was home to twenty-seven picture
houses.[86] As Denis Condon has documented, from 1910 onward,
Ireland experienced a picture house building boom. Many are familiar
with James Joyce's Volta Theatre, which opened in Mary Street in
December 1909. Harry Clarke would only have taken a few steps
outside his studio at North Frederick Street before coming to the
door of the Cosy Corner in Parnell Square, just opposite the Rotunda:

> So, on or close to O'Connell Street could be found the
> Sackville and Grand Cinema on Lower O'Connell Street;
> the soon-to-open Pillar Picture House close to Nelson's
> Column at the midpoint of the street; and the Round
> Room of the Rotunda at the northern extremity of
> O'Connell Street, where it almost faced the Cosy Cinema
> in Parnell Street. The picture houses also pushed further
> east and west of O'Connell Street: the stroller toward the
> Volta on Mary Street would first encounter the World's
> Fair on Henry Street, and passing the Volta, see the Mary
> Street Picture House before continuing into Capel Street
> at the edge of the shopping district to visit the Irish
> Cinema. Walking east from Nelson's Column down North
> Earl Street and into Talbot Street, an amusement seeker
> would first see the Masterpiece Theatre and would almost
> have reached Amiens Street Station before coming upon
> the Electric Theatre.[87]

As Condon comments, 'it would be hard to exaggerate how much of
an explosion in the easy availability of visual images this represented'.[88]
In addition, the picture house made it possible for all classes to
experience entertainment in a formal venue. Picture houses were open
all day; the spectators could enter at any time. A typical afternoon or
evening at the picture house included short films, dramas, Westerns,
slapstick, travelogues, and a newsreel. The screenings were interspersed
with entertainments from singers, a pianist, and a small orchestra.[89]

During the First World War, a war feature such as Geoffrey Malins and John McDowell's 1916 *Battle of the Somme* might be shown. Newsreels produced by Pathé and Gaumont provided the public with 'moving images of battle sites and the people who fought in the war'.[90] Condon describes a theatre as this:

> Because a film performance in a cinema during the silent period combined recorded visuals with the live sound produced by musicians and, sometimes, a lecturer or cicerone who explained, or invented, the narrative, considerable local variations in the experience of a particular film were possible. At the Queen's, the film show was punctuated by vocal acts singing to magic lantern slides and by an interval that allowed spectators to socialise, smoke, and drink nonalcoholic beverages, the last because of restriction on the building's lease.[91]

Furthermore, as Michael Hammond points out, cinema owners allied 'themselves with the war effort. Special screenings for soldiers, reduced rates for servicemen, the use of the cinema for patriotic concerts and talks were all part of a strategy to attract audiences and at the same time demonstrate that the cinema had an important social and patriotic function.'[92] They also screened 'Roll of Honour films as part of their programmes, photographs of local men who were serving or had been wounded or killed.'[93] These films consisted of a series of still photographs of combatants, interspersed with title slides.

Among the pictures at the show house were Charlie Chaplin comedies. We know that Harry Clarke enjoyed Chaplin because of an aside in a letter to Bodkin, in which he laments that his time in London was busy and he couldn't even take in a Chaplin film.[94] What was it about Chaplin that Clarke would have admired? Chaplin was a master of physical gesture and expression. He used his body flexibly, yes, but also brought in the cane and bowler hats to signal sexual interest. The hat, almost prophylactic, rises on and off, while the cane rises and falls, often presumptuously lifting women's skirts. Tom Gunning

notes that part of Chaplin's popularity was that he could be seen in a sentimental way or as vulgar and boorish. Noting that Chaplin shares a tradition of carnival clowns, who purposefully satirized the bourgeois, the clean, and the proper, Chaplin drew attention to the way that 'authority is inverted'.[95] His emphasis on the body and his phallic pliancy of cane and hat reminded viewers of their own bodies and impulses, no matter how discomfiting that reminder might be. Given Clarke's interests in the visual pun and double entendre, he would have noticed with delight Chaplin's combination of innocence and innuendo. Chaplin's 1914 release *The Property Man*, for example, is engagingly self-reflexive. Chaplin is backstage at the theatre, among the props and costumes. In a twist of identity, he is performing a non-performing role. At one point, his property man passes some writing on the wall, which includes a sketch of Chaplin himself. Clarke must have enjoyed Chaplin's self-referential theatricality, the disguise and double-meaning.

FIGURE 2.6
The Property Man (1914), directed by Charlie Chaplin, Keystone Film Company.

It's possible, as well, that Clarke and the members of the Waldon circle saw something insatiably Irish about Chaplin's tramp character. The tramp was always able to evade the authorities; he was a swinging door away from being fired or arrested. Critics have noted that Chaplin's humour could constitute an expression of 'rebellion against authority' and a 'strategy of cultural resistance and agency committed to a community's survival'.[96] With his use of costuming and disguise, he was able to transform into anyone or anything – an Everyman. T. S. Eliot called him a 'universal figure'.[97] Michael Hammond points out that 'Charlie in his comedies is often a character with no name, simply identified as "the waiter", "the tramp", and "the reveler", or – as he is named in the credits to the First World War film *Shoulder Arms* – "the recruit".'[98] Libby Murphy confirms that Chaplin 'was received with wild enthusiasm in wartime and postwar Britain, where he was identified with the British infantry soldier or Tommy'.[99]

Film historian Susan McCabe writes, 'When Chaplin screened in Paris, "the little tramp", or "Charlot", as he was called, emerged as "the new hero of the literary avant-garde", the very "embodiment of modernity" in his "resistance to meaning".'[100] Chaplin was an influence on a host of writers and artists in the teens and early twenties, including Gertrude Stein, Man Ray, Fernand Léger, Guillaume Apollinaire, Jean Cocteau, Blaise Cendrars, Hart Crane, Berthold Brecht, Osip Mandelstam, and Anna Akhmatova. On Chaplin's popularity in mass and intellectual culture, Michael North commented, if there was 'one thing that every human being living in 1922 – from Evelyn Waugh to Walter Benjamin – could have agreed upon, it would probably be Charlie Chaplin'.[101] Alexandra Harrington extends the influence on the arts even further, citing 'Cinema was integral to the inception and development of Modernism's more avant-garde incarnations' and, as one critic remarks, 'it might easily be argued that every avant-garde movement since 1900 owes something to the new visions afforded by the movies'.[102]

Among the avant-garde who were intrigued not only by Chaplin, but by film, was the Parisian artist Fernand Léger. His *Ballet Mécanique*

introduced a 'Charlot', drawing attention to the dichotomy of the mechanical film and the flexible, human body. Léger was aware of the mechanics of film, which divides actions – and consequently a body performing those actions – into frames per second, so that the audience watches a reconstructed body from fragments. Eadward Muybridge's studies of motion demonstrated to the public the curious problem and wonder of film: hundreds of still shots that made up a whole moving narrative meant that cinema effectively 'made visible a body never visible before – one that is at once whole and in pieces'.[103] Linked to the frame-by-frame motion of cinema, Eadward Muybridge's publications about paths of motion in books such as *Animals in Motion* (1899) and *The Human Figure in Motion* (1901), were likely seen by Clarke. Certain illustrated scenes in *Ireland's Memorial Records* appear to echo Muybridge's work, patterns of men and horses that can be read narratively.

In December 1918, Chaplin released *Shoulder Arms*, his only film to deal directly with the First World War. The film is structured as a fantasy sequence in which Chaplin's character, named simply 'the recruit' falls asleep in his tent and dreams that he captures the Kaiser and wins the war. Again playing with fragmentation and variation, Chaplin wears many disguises and costumes in the film, including a scene in which he completely loses his humanness while masquerading undercover as an observation tree. Murphy comments that this scene in particular delighted Jean Cocteau, who saw it 'as an apt "fable of the war"'.[104] Far from being received as inappropriately irreverent for its time, the film was hailed as a much-needed respite to the continuous news of war, deaths, and reparations that dominated the news.

Soldiers on leave saw Chaplin's films repeatedly during the war, writes Hammond. 'The official war films, and in particular *The Battle of the Somme* ... had drawn considerable audiences and were instrumental in bringing a middle-class audience to the pictures. Perhaps even more critical in this regard were the newsreels that brought to the screen footage of the front, and these remained an attraction to audiences throughout the war, supplanting both the

feature-length official war films and the fictionalised representations of the war.'[105]

Chaplin's fashioning of the body was similar to the illustrations of Léon Bakst and the sensational dances choreographed by Nijinsky. Each envisioned the body moving in new ways. In addition, the innovation of film, which divided a body so that it was 'at once whole and in pieces' also influenced Clarke. His work made note of these innovations, and in his illustrations, we see a body in flux, as Gunning notes:

> Rather than simply summoning up images of the body subject to the demands of production, the idea of taking performance rhythms from the modern realm of work, the factory, or the everyday encounters of the urban crowds – shoving onto subways, crossing busy streets – inspired modernist artists, and Chaplin seemed to supply one of the first examples available on film to avant-gardists around the world.[106]

These 'everyday encounters of the urban crowds' concern Harry Clarke. They are evident in several of his drawings from the early 1920s. One in particular shows the artist himself amidst the cables and boulevards of the modern world. It is the final image in *The Year's at the Spring*, which he was working on in 1919, along with *Ireland's Memorial Records*. Bowe identifies the man in the image as Harry himself, waiting for a tram along an empty windswept highway.[107]

This image of a man with 'a cold white face', was inspired by lines from H. H. Abbott's poem 'Black and White'.[108] It is an ambivalent image, both frank and dissembling. A man crosses a road, collar turned up against the chill air, feet half way between the old and the new, like 1919 itself. Overhead are 'gaunt poles with shrilling wires', the wires that E. M. Forster called a world of 'telegrams and anger'.[109] It is a bleak December. An early darkness descends on the traveller. The winds are raw. A single raven, foretelling the future, swirls in the eddying winds by the side of the traveller. It is tempting

"MIDST OF ALL WAS A COLD WHITE FACE" 126

FIGURE 2.7
The Year's at the Spring: An Anthology of Recent Poetry, compiled by L. D'O. Walters and illustrated by Harry Clarke, with an introduction by Harold Monro (1921). Image courtesy of Trinity College Dublin.

to think that rather than speaking 'Nevermore', as in Poe's poetry, this raven utters a foreboding 'forevermore'.

NOTES

1. E. Gallatin, *Art and the Great War* (New York: E.P. Dutton & Co., 1919).
2. G. Hartcup, *Camouflage: A History of Concealment and Deception in War* (New York: Scribner, 1980); E. Kahn, *The Neglected Majority: "Les Camoufleurs," Art History and World War* (London: UP of America, 1984).
3. M. Helmers, 'Iconic Images of Wounded Soldiers by Henry Tonks', *Journal of War and Culture Studies*, 3, 2 (2010), pp.181–199.
4. On Diaghilev's admiration for Beardsley, see G. deVries, D.B. Johnson, L. Ashenden, *Vladimir Nabokov and the Art of Painting* (Amsterdam: Amsterdam University Press, 2006), p.63; and S. Weintraub, *Beardsley* (New York: Penguin, 1972), p.246.
5. *Catalogue of an Exhibition of Drawings by Léon Bakst for Ballets, Plays, and Costumes* (London: Fine Art Society, 1913); *Catalogue of Designs for the Ballet 'La Belle au Bois Dormant' by Léon Bakst* (London: Fine Art Society, 1917). The Victoria and Albert Museum, London features an online exhibition of Bakst's work at http://www.vam.ac.uk/page/l/leon-bakst/.
6. White is quoted in N. G. Bowe, *Harry Clarke: The Life and Work* (Dublin: History Press Ireland, 2012), p.13.
7. E. Kahn, 'Art from the Front: Death Imagined and the Neglected Majority,' *Art History*, 8, 2 (June 1985), p. 193.
8. M. Eksteins, *Rites of Spring: The Great War and the Birth of the Modern Age* (Boston: Houghton Mifflin, 1989), p.210.
9. M. Ernst is quoted in S. Rewald, 'Introduction,' *Max Ernst: A Retrospective*, Werner Spies (ed.), (New Haven: Yale, 2005), p.*xiv.*
10. W. S. Peterson, *The Kelmscott Press: A History of William Morris's Typographical Adventure* (New York: Oxford, 1991).
11. N. G. Bowe, *Harry Clarke*, p.28.
12. W. B. Yeats, 'Ireland and the Arts', *The Collected Works of W. B. Yeats: Volume IV, Early Essays* (New York: Scribner, 2007), pp. 150–155.
13. N. G. Bowe, 'Wilhelmina Geddes, Harry Clarke and Their Part in the Arts and Crafts Movement in Ireland', *Journal of Decorative and Propaganda Arts* 8 (1988), p.58.
14. W. Kaplan, 'Traditions Transformed: Romantic Nationalism in Design, 1890–1920', *Designing Modernity: The Arts of Reform and Persuasion, 1895–1945*, W. Kaplan (ed.), (London: Thames and Hudson, 1995), p.20.
15. G. Russell (AE), *The National Being: Some Thoughts on an Irish Polity* (Dublin: Maunsel, 1916). pp.8–9.
16. N. G. Bowe, 'Wilhelmina Geddes, Harry Clarke', p.59.
17. W. Kaplan, 'Traditions Transformed', p.23.

18. W. Kaplan, 'Traditions Transformed', p.44.
19. N. G. Bowe and E. Cumming, *The Arts and Crafts Movements in Dublin and Edinburgh: 1885-1925* (Dublin: Irish Academic Press, 1998). p.9.
20. N. G. Bowe and E. Cumming, *The Arts and Crafts Movements*, p.77.
21. N. G. Bowe, 'The Irish Arts and Crafts Movement (1886–1925)', *Irish Arts Review Yearbook* (1990–1991), p.75.
22. N. G. Bowe, 'Evocative and Symbolic Memorials and Trophies by Percy Oswald Reeves', *Irish Arts Review* 16 (2000), pp.131–138.
23. N. G. Bowe, 'Preserving the Relics of Heroic Time: Visualizing the Celtic Revival in Early Twentieth-Century Ireland', *Synge and Edwardian Ireland*, Brian Cliff, Nicholas Grene (eds), (Oxford: Oxford University Press, 2011), p.72.
24. N. G. Bowe, 'Wilhelmina Geddes, Harry Clarke', p.62.
25. N. G. Bowe, 'The Book in the Irish Arts and Crafts Movement', *The Irish Book in the Twentieth Century*, Claire Hutton (ed.), (Sallins: Irish Academic Press, 2004), p.32.
26. N. G. Bowe, 'The Book in the Irish Arts and Crafts Movement', p.22.
27. N. G. Bowe, 'Preserving the Relics of Heroic Time', p.58.
28. J. O'Connell, *The Arts and Crafts Society of Ireland and Guild of Irish Art Workers Catalogue of The Fifth Exhibition, 1917* (Dublin: George Roberts and Co., 1917), p.16.
29. J. O'Connell, *The Arts and Crafts Society of Ireland*, p.19.
30. J. O'Connell, *The Arts and Crafts Society of Ireland*, p.10.
31. M. Leland, *The Honan Chapel: A Guide* (Cork: Honan Trust, 2004), p. 40
32. *Journal and Proceedings of the Arts and Crafts Society of Ireland*, 1, 3 (1901).
33. N. G. Bowe, 'Ireland's Memorial Records, 1914–1918', *Ireland of the Welcomes*, November/December 2006, pp. 18–23.
34. M. Cronin, 'The State on Display: The 1924 Tailteann Art Competition', *New Hibernia Review / Irish Éireannach Nua* 9, 3 (Autumn 2005), pp.50–71.
35. J. Turpin, 'The Education of Irish Artists, 1877-1975', *Irish Arts Review*, 13 (1997), p.188–193.
36. J. Turpin, 'The Education of Irish Artists', p.191.
37. G. Russell (AE), 'Nationality or Cosmopolitanism', *Irish Writing in the Twentieth Century: A Reader*, David Pierce (ed.), (Cork University Press, 2000), pp. 44–47.
38. Quoted in M. Cronin, 'The State on Display', p.55.
39. J. O'Connell, *The Arts and Crafts Society of Ireland*, p.17.
40. K. Jeffrey, *Ireland and the Great War*,
41. J. M. Hone, *Memories of W. B. Yeats, Lady Gregory, J. M. Synge and Other Essays* (Dublin: Rosemary Hone, 2007), p.73.
42. Letter from Sir Edwin Lutyens, 5 Eaton Gate, London S.W.I to Miss H.G. Wilson, Secretary, Irish National War Memorial Committee, Room No.7, 102 Grafton Street, Dublin, (12 December 1935), Dublin City Archive and Library, RDFA/020/041.
43. M. Cronin, 'The State on Display', p.63.
44. C. Hutton, (ed.), *The Irish Book in the Twentieth Century*. p.36
45. C. Hutton, (ed.), *The Irish Book in the Twentieth Century*. p.36.
46. C. Hutton, (ed.), *The Irish Book in the Twentieth Century*, p.37.

47. N. G. Bowe and E. Cumming, *The Arts and Crafts Movements*, p.96.
48. J. Strachan and C. Nally, *Advertising, Literature and Print Culture in Ireland, 1891–1922*, (Palgrave, 2012), p.41.
49. J. Strachan and C. Nally, *Advertising*, p.80.
50. J. Strachan and C. Nally, *Advertising*, p.46.
51. J. Strachan and C. Nally, *Advertising*, p.46.
52. J. Strachan and C. Nally, *Advertising*, p.46–47.
53. C. Hutton (ed.), *The Irish Book in the Twentieth Century*, p.38.
54. N. G. Bowe, 'The Iconic Book in Ireland, 1891–1930,' *The Oxford History of the Irish Book, Volume V: The Irish Book in English, 1891–2000* (Oxford: Oxford UP, 2011), p. 394.
55. W. Morris, 'The Ideal Book: A Paper by William Morris', Delivered at the Bibliographical Society, London, 19 June 1893, (London: L.C.C. Central School of the Arts and Crafts, 1908), p.2.
56. W. Morris, 'The Ideal Book', p.3.
57. W. Morris, 'The Ideal Book', p.13.
58. W. Morris, 'The Ideal Book', p.5.
59. W. Morris, 'The Ideal Book', p.11.
60. J. M. Bowles, 'William Morris as a Printer: The Kelmscott Press', *Modern Art* 2, 4 (Autumn, 1894).
61. E. M. Thomson, 'Aesthetic Issues in Book Cover Design 1880–1910', *Journal of Design History*, 23, 3 (2010), p.229.
62. E. M. Thomson, 'Aesthetic Issues', p.229.
63. E. M. Thomson, 'Aesthetic Issues', p.243.
64. 'Mr. D. B. Cockerell, An Authority on Bookbinding', Obituary, London: *The Times*, 28 November 1945. Commonwealth War Graves Commission, Catalogue No. 1069, File #23286.
65. 'Mr. D. B. Cockerell, An Authority on Bookbinding'.
66. 'Mr. D. B. Cockerell, An Authority on Bookbinding'.
67. P. Longworth, *The Unending Vigil: The History of the Commonwealth War Graves Commission* (Barnsley: Pen and Sword, 2003), p.40.
68. Letter from F. Ware to Secretary of the Treasury, Whitehall, 11 March 1920, on the appointment of Douglas Cockerell as technical advisor on cemetery registers. CWGC files, Catalogue No. 1069, File #23286.
69. P. Longworth, *Unending Vigil*, p.40.
70. 'First World War', Commonwealth War Graves Commission, http://www.cwgc.org/about-us/history-of-cwgc/first-world-war.aspx.
71. 'The King's Book Of Heroes: The Most Moving and Poignant Memorial to Those Who Died in the First World War', *York Press*, 23 July 2014.
72. A. Bourke, *The Burning of Bridget Cleary* (London: Pimlico, 1999), p.10.
73. P. Longworth, *Unending Vigil*, p.14.
74. ACSI, *Catalogue of The Fifth Exhibition, 1917*.
75. ACSI, *Catalogue of The Fifth Exhibition, 1917*.

76. ACSI, *Catalogue of The Fifth Exhibition, 1917.*

77. C. Malone, 'A Job Fit for Heroes? Disabled Veterans, The Arts and Crafts Movement and Social Reconstruction in Post-World War I Britain', *First World War Studies*, 4, 2, (2013), 201–217.

78. *Catalogue of the War Memorials Exhibition*, 130, Victoria and Albert Museum, London (H. M. Stationery Office, 1919), p.3.

79. *Catalogue of the War Memorials Exhibition*, 130, p.21.

80. *Catalogue of the War Memorials Exhibition*, 130, p.21.

81. *Catalogue of the War Memorials Exhibition*, 130, p.29.

82. *Catalogue of the War Memorials Exhibition*, 130, p.83.

83. N. G. Bowe, *Harry Clarke: The Life and Work*, p.168.

84. Letter from Harry Clarke to Thomas Bodkin, 21 November 1919. Harry Clarke Papers, National Library of Ireland, MS 39,202 /A, I.i (xxvi).

85. M. Corcoran, *Through Streets Broad and Narrow: A History of Dublin Trams* (Shepperton: Ian Allan Publishing, 2008).

86. D. Condon, '"Temples to the Art of Cinematography": The Cinema on the Dublin Streetscape, 1910–1920', In Justin Carville (ed.) *Visualizing Dublin: Visual Culture, Modernity and the Representation of Urban Space* (Bern: Peter Lang: 2013). p.147.

87. D. Condon, '"Temples"', p.148.

88. D. Condon, 'Going to the Pictures in Phibsboro in 1914.' Unpublished manuscript, 2014.

89. D. Condon, 'Going to the Pictures in Phibsboro in 1914.' Unpublished manuscript, 2014.

90. D. Condon, 'Rolls of Honour: Irish Film Businesses and the War, Autumn 1914', *Early Irish Cinema*, https://earlyirishcinema.wordpress.com/2014/10/22/rolls-of-honour-irish-film-businesses-and-the-war-autumn-1914/, 22 October 2014.

91. D. Condon, 'The Volta Myth,' *Film Ireland* 116 (May/June 2007), p.43.

92. M. Hammond, '"So Essentially Human": The Appeal of Charles Chaplin's *Shoulder Arms* in Britain, 1918', *Early Popular Visual Culture*, 8, 3, (August 2010), p.299.

93. M. Hammond, '"So Essentially Human", p.299.

94. N. G. Bowe, *Harry Clarke*, p.

95. T. Gunning, 'Chaplin and the Body of Modernity', *Early Popular Visual Culture*, 8, 3 (August 2010), p.239.

96. A. Harrington, 'Eloquent Silence: Akhmatova, Mandel'shtam, Early Cinema, and Modernism', *Slavonica*, 18, 2, (October 2012) p.124.

97. T. S. Eliot, 'Dramatis Personae', *Criterion*, 1 (April 1923), p.306.

98. M. Hammond, '"So Essentially Human"' p.307.

99. L. Murphy, 'Charlot Francais: Charlie Chaplin, The First World War, and the Construction of a National Hero', *Contemporary French and Francophone Studies* 14, 4, (September 2010), p.422.

100. S. McCabe, 'Delight in Dislocation: The Cinematic Modernism of Stein, Chaplin, and Man Ray', *Modernism / Modernity*, 8, 3 (2001), p.435.

101. Quoted in S. Hanks, 'The Birth of the Tramp: Chaplin, Gesture, and the Rhythms of Modernity', *Postgraduate English*, 26 (March 2013) p.3, n. 5.

102. A. Harrington, 'Eloquent Silence', p.111.
103. A. Harrington, 'Eloquent Silence', p.120.
104. L. Murphy, 'Charlot Francais', p.423.
105. M. Hammond, '"So Essentially Human"', p. 300.
106. T. Gunning. 'Chaplin and the Body of Modernity', p.241.
107. N. G. Bowe, *Harry Clarke: The Life and Work*, p.184.
108. H. H. Abbott, 'Black and White,' in L. D'Oyly Walters (ed.), *The Year's at the Spring: An Anthology of Recent Poetry* (London: Harrap), 1920, pp.126–127.
109. E. M. Forster, *Howards End* (New York: Knopf, 1921), p.33.

The Call

Richard Valentine Williams (Richard Rowley), 1918

Not with the blare of trumpet,
Not with the roll of drum,
In proud imperious summons
The final call shall come –
But on the silent midnight,
The soft, alluring, low,
Irresistible voice shall whisper,
And I shall arise and go.

I shall leave the home that loves me,
Earth's quiet ways and green
For the road that no man knoweth,
And the land that never was seen.
Ah, thy white arms may not hinder,
Thy kisses cannot stay,
For lo! 'tis my fate a-calling!
I must up and away.

III

Art at the Margins: Illustrating
Ireland's Memorial Records

Harry Clarke was commissioned to illustrate the First World War, images that he would know through newspaper reports and photographs from the front. Yet Clarke was living through Irish wars: the Easter Rising of 1916, and the Irish war of independence. He could draw on his own experiences, having confronted death and widespread destruction in Dublin in 1916, and suspicion, fear, and violence that affected the mood of the entire country after 1919.

Like many other artists of the time, Clarke's productivity was not diminished by the Irish wars or the battles in Europe. If anything, the First World War was pushing artists to new modes of expression, calling into question nationalism, traditionalism, and representation. Clarke's illustrations became bolder during the long period of conflict, exaggerating the line of the figure and more frankly representing sexuality. His borders for *Ireland's Memorial Records* are even experimental, reading much like the sequential montage of cinematic storytelling.

From 1914 to 1923, Clarke lived amidst cataclysmic political and artistic upheavals, and therefore it is wise to look to his illustrations for some sign of his sentiments. One of the most striking features of *Ireland's Memorial Records* is the way that the illustrations seem

simultaneously traditional and modern. As memorial records, the illustrations draw on familiar iconography of the cross and resurrection. In spite of that nod to convention, Clarke pulls viewers into a storyworld, creating vignettes of shadowed characters in suspended animation. Within this storyworld, there are no recruiting sergeants, military parades, or girls left behind. A line from Katherine Tynan's poem, 'Joining the Colours' seems to express the imagery in words, 'Out of the mist they stepped--into the mist / Singing they pass.'

Due to his many book illustrations and his preference for creating artistic stained glass based on literary themes, we can infer that Clarke was a literary man, a reader of contemporary literature, and some of the techniques of Modernist literature are evident in the drawings. For example, the vignettes of *Ireland's Memorial Records* may be sequential, but the traditional denouement and resolution are replaced by an open-ended question. The scenes are only fragments of an epic. And like a film, the images repeat in a loop. Recently, the American graphic artist Joe Sacco created something similar, a graphic and panoramic scroll without words depicting the first day on the Somme, 1 July 1916. Reading left to right, the long illustrated panel moves from the soldiers' preparations through combat to retreat. Like Clarke's illustrations of the First World War a century earlier, Sacco's scroll does not have a resolution, even though the images come to an end.

An official commission doesn't offer the freedom of personal exploration. However, Harry Clarke nonetheless infused his drawings with ambivalently heroic scenes. The lithe, balletic, silhouetted figures of soldiers contrast with the knowledge of their tragic corruption in death. The tilting grave markers and decaying trench walls are exuberantly macabre in the style of his illustrations for Poe's tales as they fuse with decorative flowers and marine motifs. Clarke engaged in a dialogue with the names that would be printed within his borders, encircling the lifeless list of the dead with moving, vital, living imagery, all the things that the soldiers whose names were printed in the pages would forever miss.

Artists' Books and Small Presses

One of the distinctive artistic developments in the early twentieth century was the artists' book, which took the form of a pamphlet, broadside, or traditional codex. Created by artists and book craftspeople, the artists' book was printed in a limited edition, with a high attention given to the design and production. Together with the Arts and Crafts Movement, circles of artists and writers in several countries were producing work with small presses that challenged the status of bookmaking and print publication. These avant garde publications included the two issues of the literary magazine *Blast* in England (1915 and 1916), edited by Percy Wyndham Lewis, and a series of Futurist Russian publications titled *A Game In Hell* (1914), *Transrational Boog* (1915), and *Universal War* (1916).

Although the stylistic outcome of artists' books produced by the Arts and Crafts Movement differed markedly from the style of the avant garde, their philosophy of book production was similar. In both cases the creators saw the book as both an object that disseminates information and an art object notable in itself for beauty and fine design. Drawing attention to the latter – the book as art object – the English designer and printer William Morris posited that typography, ink paper, illustrations, and binding were interdependent.[1] It should be impossible to separate the 'substance of the text' from the 'physical form of its presentation'.[2]

Concurring with the philosophy of design, George Roberts personally planned *Ireland's Memorial Records*, selecting the type, organizing the pages, and acquiring the paper. He ordered that the type be hand-cut, and based the font on the Golden Type model of William Morris's Kelmscott Press.[3] Electroplates from Clarke's drawings for the title page and the borders were made by the Irish Photo Engraving Company, Middle Abbey Street, Dublin and the Dublin Illustrating Company, South William Street.

The first volume of each series includes forwarding material composed by the Irish National War Memorial Committee and an invocation by Sir John French, Lord Lieutenant of Ireland. In the preface, the craftspeople are credited for their work:

These records consist of eight volumes of which one hundred copies are being printed for distribution through the principal libraries of the country. ... The work of printing, decoration, and binding the eight volumes of the special edition has been carried out by Irish artists and workers of the highest reputation and efficiency. They have been printed on hand-made paper by Maunsel and Roberts, Ltd., the title page and beautiful symbolical borders have been designed by Harry Clarke, and engraved by the Irish Photo Engraving Co. Ltd., and The Dublin Illustrating Co.; while the binding and tooling has been carried out [by] William Pender, on designs prepared for the cover, and doublures by P. Oswald Reeves, A.R.C.A., Metropolitan School of Art, Dublin.

Each of the eight volumes in the 100 sets measures 12' x 10' and is approximately 3' thick. All volumes include a two-page index to the borders in the final pages. In the spirit of egalitarianism that marked the Imperial War Graves Commission graveyards and cemetery registers, the names of ordinary soldiers and officers appear together within the pages of *Ireland's Memorial Records*. Alphabetically, the volumes are organized as follows:

Volume 1	A to CAR
Volume 2	CAR to DOV
Volume 3	DOV to GYV
Volume 4	H to KER
Volume 5	KER to M'GIL
Volume 6	McGIL to O'HAN
Volume 7	O'HAR to SMA
Volume 8	SMA to ZIG

The equality of the alphabetised list is significant because, in England, the War Office compiled two full lists of the dead in which the rosters were separated by rank: *Soldiers Died in the Great War* and *Officers Died in the Great War*. Ireland made no such distinction; officers and other ranks were listed side by side, in the same volumes.

Contemporary reporters and subsequent scholars have relied on the summary preface written by the Irish National War Memorial Committee to describe the books, and indeed these pages provide valuable clues to the inception of *Ireland's Memorial Records*. Unfortunately, the information provided by the Irish National War Memorial Committee is incomplete and misleading. For example, it appears that only one set of doublures can be verified as the work of Oswald Reeves; these are the purple leather inner covers tooled in gold within the special edition of *Ireland's Memorial Records* presented to King George V. Reading the prefatory material closely once again, it will be noticed that the authors specify that 'printing, decoration, and binding the eight volumes *of the special edition* has been carried out by Irish arts and workers', namely Maunsel, Clarke, Pender, and Reeves. The majority of the books were bound – without doublures – in grey linen. The set at the National War Memorial have blue leather covers embossed with a small harp; the end papers are plain boards marked 'O'Loughlin, Binder, Fleet St., Dublin.'

A laudatory article in the industry magazine, the *Irish Printers Advertiser*, credits Messrs. Brindley and Galwey, Eustace Street, Dublin for their work on 'the binding of the one hundred sets ... in grey paper boards with linen backs'. However, the *Irish Printers Advertiser* further confuses matters by not recognizing some of the 'one hundred sets' that were not bound in linen, namely those sets, such as the set at St Patrick's Cathedral, Dublin, that are bound in blue leather by Galwey and Co. Thus, it is not clear whether the leather-bound sets number *beyond* the 100 identified by the *Irish Printers Advertiser*.

The special edition *de luxe* created for King George V was presented on 23 July 1924 by Sir John French. The set was intended for the library at the British Museum, and today can be found in the British Library, St Pancras. William Pender, of No. 29 Lower Leeson Street,

FIGURE 3.1
Cover of *Ireland's Memorial Records, 1914–1918* presented to King George V. © The British Library Board. C.121.f.1.

FIGURE 3.2
Doublure, inside cover, for *Ireland's Memorial Records, 1914–1918* by Oswald Reeves. © The British Library Board. C.121.f.1.

Dublin bound this set in purple morocco leather and embossed it with a gilded sword. The interior pages are of the uncut rag-based stock, and the upper edge of the deckle-edge binding is gilded with a rich gold. The doublures by Oswald Reeves combine traditional and Celtic imagery, setting the image of a soaring eagle or a dove of peace over the sun of the Fianna. The eagle is symbolic: in the medieval illuminated Gospels, the eagle represents John the Evangelist and signifies the Ascension, as well as Christ's divine nature; however, it is also the symbol of imperialism. The borders also include two laurel leaf wreaths, symbols of peace.

In November 1923, Caroline, Lady Arnott inquired whether Pope Pius XI would receive a copy of *Ireland's Memorial Records* for the Vatican Library, suggesting that 'It would gladden many an Irish mother's heart to hear that these precious records have been seen

FIGURE 3.3
The Menin Gate, Ypres, Belgium. Commonwealth War Graves Commission. Photo credit: Mike Field, 2009. Creative Commons 4.0 Share-Alike License.

and blessed by the Sovereign Pontiff.'[4] His Holiness replied through an emissary that, 'having taken into benevolent consideration the Committee's noble thought, will gladly receive the gracious gift'.[5]

Listing the Names of the Dead

As Chapter One noted, one of the long-standing contentions concerning *Ireland's Memorial Records* has been about the names recorded in the books. One question that has not been asked is why there are books of memorial records at all? From where does the tradition arise, and why would a list of names be the most suitable way to commemorate the dead? Writing about traditions of remembrance in the First World War, Heather Jones associates lists of names of the war dead with the Low Church tradition of Irish Protestantism, in which biblical passages were used as church decoration, rather than images:

> The idea of the divine text is at the heart of the cultural understanding of the sacred space and its creation. In this way, by listing the names of the dead on church walls, contemporaries were actively sacralising them; the dead became a spiritual 'text'.[6]

Given the enormous number of missing in the First World War, a memorial listing a name could serve 'as an intimate substitute grave'.[7] In the decades following the 1918 Armistice, the Imperial War Graves Commission erected extensive stone memorials in France and Belgium to commemorate the names of the missing. The first of these memorials were the Menin Gate in Ypres, Belgium (1927), designed by Sir Reginald Blomfield (55,000 names of the missing) and the Tyne Cot Memorial to the Missing in Zonnebeke, Belgium (1927), designed by Sir Herbert Baker (35,000 names of the missing). These were followed by the Thiepval Memorial to the Missing of the Somme, near Thiepval, Picardy, France (1932), designed by Sir Edwin Lutyens (72,000 names of the missing).

FIGURE 3.4 (top)
Tyne Cot Commonwealth War Graves Commission Cemetery, Belgium. Photo credit: Gary Blakeley, 2014. Creative Commons 3.0 Share-Alike License.

FIGURE 3.5 (bottom)
Memorial at Thiepval, France. Commonwealth War Graves Commission. Photo credit: Martin V. Morris, 2014. Creative Commons 3.0 Share-Alike License.

It might be said that Catholic worship evolved from the orthodox tradition in which iconography plays a strong role; images of the saints and relics of the martyrs are central to the tradition. Protestant faith rejected images as idolatry, favouring instead the iconic text. The genius of *Ireland's Memorial Records* as a document designed to bridge the two faiths thus emerges: the elaborate drawings of martyred soldiers amidst the instruments of their torture and demise speak to the traditions of Catholic iconography, while the list of names of the dead is a canonical feature of Church of Ireland and Church of England remembrance.

As neither Clarke nor any of his immediate circle of friends was a combatant in the war, he had to rely on material provided to him by the Irish National War Memorial Committee for the accuracy of his drawings, as well as his general familiarity with war-related visual images from 1914–18. Bowe notes that Clarke drew some of the scenes from a short-lived propaganda publication titled *The Irish Soldier*, and copies of the publication were found among his papers, although they no longer survive.[8] William Orpen's sketch of a soldier appeared on each cover of *The Irish Soldier*. Within were photographs of battlegrounds and troops. However, these photographs do not correspond directly to any of the drawings in *Ireland's Memorial Records*, although they may have offered Harry Clarke the ideas for theatres of war and war weaponry.

The Irish Soldier was issued by the British Ministry of Information, which had published a prior monthly periodical titled *The War*.[9] The magazine was created at the instigation of the Viceroy, Lord French, who established the Irish Recruiting Council in mid-1918 to enlist 50,000 additional soldiers. Because there was no conscription in Ireland (and, in fact, there was an agitated crisis over the question of whether the draft would be introduced), the government relied on propaganda to recruit, and their aims were more successful than one would imagine in a post-Easter Rising world. They recruited 10,000 in the months before the Armistice, and while this was far short of their aims, it is more than would be predicted given the divided sentiments of the populace. *The Irish Soldier* was issued fortnightly in a print run

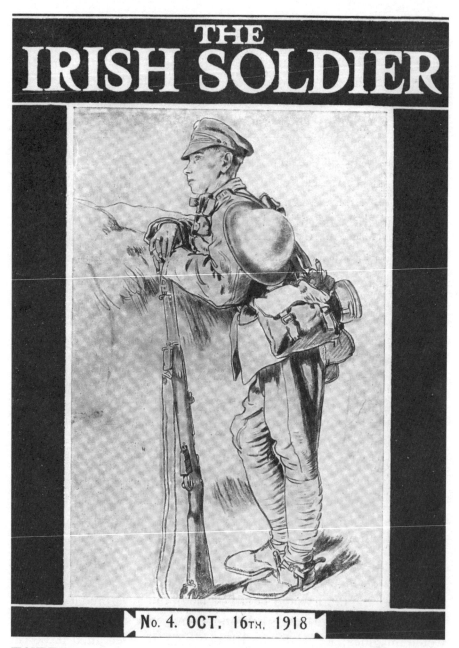

FIGURE 3.6
The Irish Soldier featured this drawing by Irish-born war artist William Orpen on every cover. Image courtesy of Anne S.K. Brown Military Collection, Brown University Library.

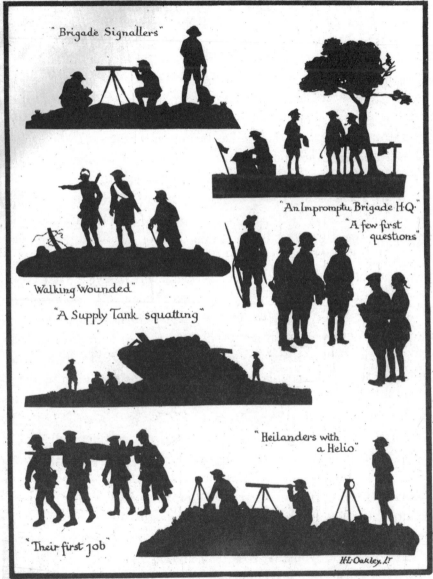

FIGURE 3.7
'Scraps from the Western Front' (16 October 1918) by Harry Lawrence Oakley. Silhouettes cut from sketches taken during the Battle of Amiens. © Illustrated London News Ltd/Mary Evans.

of 35,000; it was distributed to bookstores, railway station kiosks, national school teachers, and clergymen. Predominantly a magazine of news about the war, it also focused on the Irish troops.[10]

Perhaps the most immediately striking visual aspect of the illustrations in *Ireland's Memorial Records* are the soldiers in silhouette. Those approaching *Ireland's Memorial Records* today might deduce that the silhouettes were an innovation of Harry Clarke. However, it's more likely that Clarke was drawing on a convention familiar from an earlier sentimental portrait style, as well as posters and other war propaganda. Silhouette images were popular during the war. They initially appeared on recruiting posters, such as 'Think!'; 'Remember'; 'Lads, you're wanted'; 'Be Ready!'; and 'Enlist Today!' A photograph of an 'enlistment tram' in Dublin shows one of these silhouette posters aside the entrance step.[11] Enlistment trams were used throughout the Commonwealth as moving advertisements. Bedecked in bunting, they took the recruiting office to the people. One of the most popular silhouette artists of the First World War, the British Captain Harry Lawrence Oakley, was responsible for the popular 'Think!' and 'Remember' posters. Oakley's silhouettes of army life were also a regular feature of a magazine called *The Bystander*, published by *The Illustrated London News*.[12] By contrast, Clarke's own illustrated work is recognisable for delicate line and profuse detail, although he incorporated some silhouette figures in 18th century dress into his illustrations for *The Fairy Tales of Charles Perrault* (1922). The swirl of a tunic or the turn of a boot would not go unembellished in Clarke's work, which makes the silhouetted figures of *Ireland's Memorial Records* so startlingly different from his other work.

Ernest Brooks, an official war photographer from England, favoured the motif of a silhouetted figure against the vast and open skies of the Western Front. One of the most popular, even today, is of a soldier standing near the wooden cross of a comrade's grave near Pilckem during the battle of Passchendaele, 1917. He is in profile, looking down, holding his gas mask in front of him, his rifle strapped to his back. The image was adopted by illustrators, including Clarke. An image similar to that of Brooks's photograph is repeated in *Ireland's Memorial Records*.

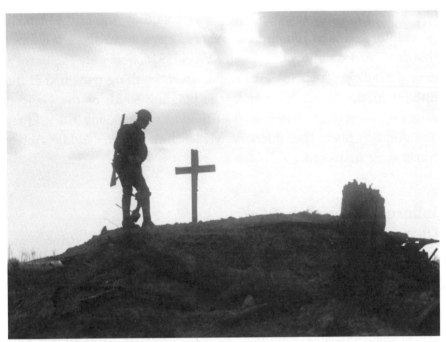

FIGURE 3.8
A British soldier stands besides the grave of a comrade near Pilckem during the Third Battle of Ypres, 22 August 1917. Ernest Brooks, photographer. © Imperial War Museum Q 2756.

As one modern commentator has written, despite illustrated newspapers and war art, the 'momentousness, duration, modernity and horror' of war 'had seemed impossible to grasp, either visually or conceptually'.[13] Nonetheless, there were persistent visual reminders of the world turned upside down by the conflict. Recruiting posters idealized the adventure of combat, while newspapers from 1914–19 listed the names of the dead. There would be the injured and the amputees disembarking from the trains and boats, and the shuttered windows and black crepe on the doorknobs for those homes in mourning. After April 1916, a walk down O'Connell Street would reveal destruction that rivalled that of Ypres or Thiepval, a comparison often made by eyewitnesses in Dublin.

In April 1916, after being trapped by the fighting in his studio on North Frederick Street for several days, Clarke emerged to a scene of

wreckage. Piles of bricks and rubble surrounding the central streets on the north side of Dublin took years to clean away. Those buildings that remained standing after Easter Week 1916 were only shells, their empty windows like blank eyes to the street. Nothing remained of the interior of the Hotel Metropole, the building south of the General Post Office. Very little remained of the businesses along Eden Quay and Abbey Street. The offices of Maunsel at No. 96 Middle Abbey Street were destroyed.

Influence of the *Book of Kells*

Clarke's decorative borders for *Ireland's Memorial Records* are modelled after the traditions of Insular art, well known to Clarke from the *Book of Kells*. As with traditional illumination of the Gospels, Clarke's borders have a denotative aspect that directly references recognizable objects in the world and a connotative aspect that suggests the point of view of the artist. Modern weapons of warfare share space with images that float free of the substance of the illustrations. The dialogue between these two aspects of the illustrations – the representational and the communicative – gives the illustrations their power. Within the interlace of the border designs, Clarke connects the material and ethereal, things of the earth and visions of the afterlife. He also presents ordinary soldiers, not the decorated combat heroes or the generals that were the subjects of much of Orpen's work. His use of the Everyman strengthens the illustrations' persuasive potential, for these silhouettes are any of the brothers, sons, and husbands of the readers, and perhaps more importantly for this period of strife in Ireland, they are of any faith, Protestant, Catholic, or Jewish.

All of the pages use the same format: decorative borders surrounding text. The title page of *Ireland's Memorial Records* makes use of interlaced stylized animal forms – zoomorphic designs – that derive from Insular art, such as the *Book of Kells*. There follow eight designs repeated and reversed over the eight sets of books. The title page of each volume is the only traditionally Celtic design of the

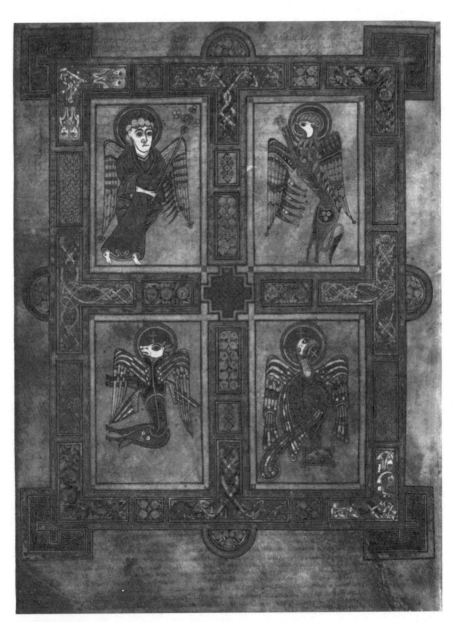

FIGURE 3.9
Book of Kells, Folio 27v, with symbols of the four evangelists.

volumes. The entwined figures twist between female protectors who hold the emblems of the four provinces of Ireland.

Clarke completed nine illustrations in pen and ink, which were then electroplated for the printing process. The drawings were all created as recto pages (right), with a wide decorative margin to the right and a thin margin along the gutter, where the book would be bound. The centre area of the illustrated page would be left blank, as the text was set by George Roberts and printed after the decorative pages were complete. Any correspondence between the text and the engravings, such as the regimental badge of a particular unit being placed next to the name of a soldier from that unit, is coincidental.

In fact, it is reasonable to believe that Clarke had not read or studied the names that would be recorded in the book. Clarke's successes with his illustrations for *Fairy Tales by Hans Christian Andersen* (1916) and Edgar Allan Poe's *Tales of Mystery and Imagination* (1919) depended on his being familiar with the writers' nuances of language and idea. *Ireland's Memorial Records* presented a different situation. For one, of course, *Ireland's Memorial Records* are not a narrative, although the grand narrative of the First World War was being written by the press and poets of the day. At the time he was given the commission for *Ireland's Memorial Records*, the committee had not begun to collect names for the roll of remembrance; when he finished the illustrations that would serve as the borders, the committee had not finished verifying or organizing the list. Clarke may have recognized that the commission was controversial, which may account for the absence of any correspondence, sketches, or diary entries about them. However, Clarke could not forsee that it would be the nationality of names within *Ireland's Memorial Records* that would call into question the entire project, that the *Records* would be contested for including young men born in England and America.

When the books were bound, images were printed in recto and verso, as right and left pages. This means that, as a reader examines each volume of *Ireland's Memorial Records*, some images are printed in reverse. Pages always appear in the same order within the quire, which is a unit of bookbinding, four sheets of paper, folded to make up eight

leaves. To make up each quire, four folio-sized sheets were printed, each with four images front-to-back. Two appear on the front of the paper and two on the back. This system allowed for eight images to be presented (recto) and reversed (verso), ultimately resulting in sixteen print images per quire. Quires were then sewn together by hand and bound into the linen or leather case. The centrepiece of each quire in *Ireland's Memorial Records* is always the double image of cavalry in the woods, with the verso (left) page repeating the right. In addition, there are two other pages requiring that they be presented together; these are the carpet pages, referred to as 'ornamentation' in the index, and distinguished by the image of a broken spur. Within each illustration, Clarke included some distinctive identifying feature worked into the decorative design. I have chosen to describe the plates in their recto versions, which is as Clarke drew them. This will mean that, in the descriptions that follow, the plates are not ordered as they are found in *Ireland's Memorial Records*.

The organization of the engraved borders of *Ireland's Memorial Records* – in the order in which they appear in each quire – is as follows:

1) Always the first image of each quire, this border is distinguished by a disabled tank in the bottom page design. RECTO

2) Page 2 VERSO is the Reverse of Page 11.

3) Depicting grenade throwers in action, the page also is notable for the kangaroo, the emblem of Australia. RECTO

4) Page 4 VERSO is the Reverse of Page 15.

5) Suvla Bay, a maple leaf emblem in remembrance of Canadian comrades, and the image of St Hubert embellish this page. RECTO

6) Page 6 VERSO is the Reverse of Page 1.

7) The dark imagery of this page depicts a transport ship, seaplane, and barbed wire. RECTO

8) Page 8 VERSO is the Reverse of Page 9.

9) At the centre of the printed and bound quire is a military cemetery and silhouetted horses and riders. This page is always printed with its reverse. RECTO

10) Page 10 VERSO is the Reverse of Page 3.

11) At the bottom of the page, a soldier in silhouette stands reverently at a grave. The Madonna and Child are on the left side of the page. RECTO

12) Page 12 VERSO is the reverse of Page 13.

13) Drawn from the Elizabethan 'carpet page' style and always bound together with its reverse, this page is largely ornamentation. A broken spur distinguishes it. RECTO

14) Page 14 VERSO is the reverse of Page 5.

15) Grenade throwers in silhouette and a gas mask are featured in the top border. RECTO

16) Page 16 VERSO is the reverse of Page 7.

Title Page

The title page of each volume is the only traditionally Celtic design of the nine plates. Against a background of interlace and zoomorphic tracing, Clarke inhabits the borders with five female figures. The left border contains angels representing the provinces of Leinster and Connaught. Within the tracery of the right border, the angels represent Munster and Ulster. At the top of the page is the *crux immissa*, the Latin cross based on the design by Reginald Blomfield for the Imperial War Graves cemeteries in France.

Wendy Kaplan writes in her study of romantic nationalism that the iconic Tara brooch – uncovered in 1850 – used interlace with animals and subsequently, it 'became the standard design vocabulary of the Celtic Revival', that period from the middle nineteenth century onward when artists and intellectuals looked to the distant Irish past for inspiration.[14] Of course, Clarke most likely studied the *Book of Kells* in the library at Trinity College, which had been opened to the public for viewing in 1853. Several books that Clarke could consult for ideas on Celtic patterning dated from the nineteenth century, including *The Grammar of Ornament* by Owen Jones (1856); *Facsimiles of National Manuscripts of Ireland*, edited by Edward Sullivan, John Gilbert, and H. James (1874, 4 vols.); *Celtic Illuminative Art in the Gospel Books of Durrow, Lindisfarne and Kells*, by Stanford Robinson

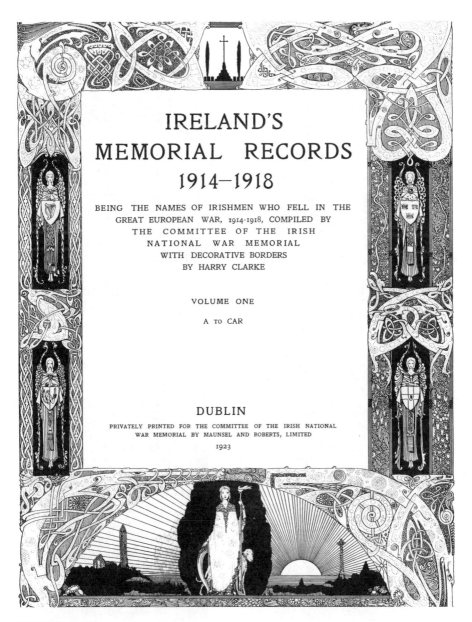

FIGURE 3.10
Ireland's Memorial Records 1914–1918. Harry Clarke, illustrator. Dublin: Maunsel and Roberts, 1923. Image courtesy of Eneclann.

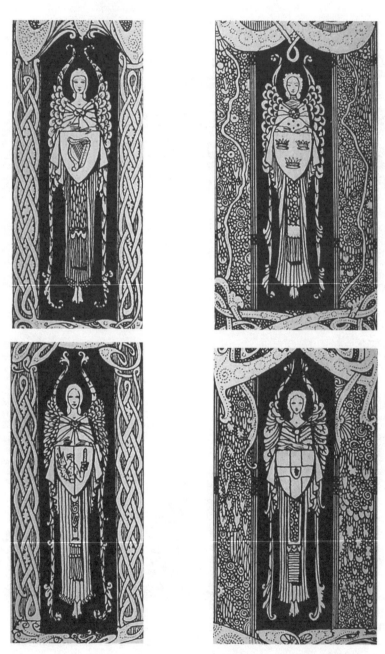

FIGURE 3.11 (top left), 3.12 (top right), 3.13 (bottom left), 3.14 (bottom right)
Angel with the shield of Munster. Detail from *Ireland's Memorial Records 1914–1918*. Harry
Clarke, illustrator. Dublin: Maunsel and Roberts, 1923. Image courtesy of the Royal Irish
Academy.

(1908), and Sir Edward Sullivan's study of *The Book of Kells*, published in 1914. He describes four aspects of the ornamentation of the Kells gospel: geometrical and interlaced patterns; zoomorphic animal forms; phyllomorphic leaf and plant forms; and figure representations.[15] Sullivan labels the human figures 'heraldic', noting that, rather than drawing from life, they derive from theological and artistic traditions.[16] Harry Clarke's own designs for *Ireland's Memorial Records* reflect such tradition: the evangelical figures in the *Book of Kells* are four in number, appearing in the manuscript in four quadrants, and Clarke borrows this motif to represent the four provinces of Ireland. While each saint in the *Kells* manuscript holds a book, each of the angels in the *Records* holds a shield. The consequence of his artistry is that he brings an ancient visual vocabulary to a new subject.

Clarke had used a similar motif of the four provincial emblems in letterhead for the Irish National Assurance Company in 1919. In fact, that insurance company letterhead looks remarkably like *Ireland's Memorial Records*, as Clarke chose to create visual vignettes of potential disasters that might befall the public and against which they might want to be insured: a young wanderer struck by lightning on a mountain top, a burning Big House, a speeding car striking a stone wall, and a rather romantic looking burglar creeping through a darkened home. As Bowe notes, the pen and ink drawing is 'composed of variations on the usual themes of floral motifs, jellyfish, overlapping leaves, hair-like coils and swirling tendrils'.[17]

The dominant figure of *Ireland's Memorial Records'* title page is Hibernia (or Erin), the female representation of Ireland. Just as the saints in Insular manuscripts were represented by 'attributes', or objects that identify them, Erin is surrounded by emblems of Irish nationalist significance: a harp, a wolfhound, a round tower, and a Celtic cross. Her 'attribute' is the uncrowned harp, which 'represented the heritage of the Gaelic past and the nationalist ideals of political and cultural separatism'.[19] Eileen Reilly notes,

> From a nationalist perspective the round tower was a suitable image for portraying the antiquity of Ireland's

civilisation and a period of Irish history which preceded English conquest. As an image which signified durability as well as accomplishment it was an apt representation of characteristics which were central to nationalist views of the past.[20]

Like the round tower, the Celtic high cross represented antiquity, accomplishment in art, and religion. It is juxtaposed – or perhaps

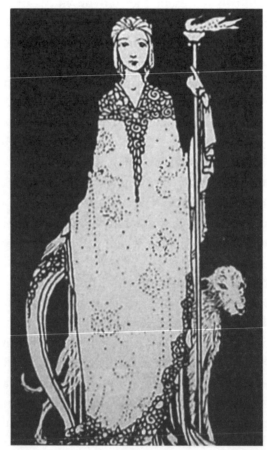

FIGURE 3.15
Hibernia surrounded by emblems of Irish nationalist significance. Detail from *Ireland's Memorial Records 1914–1918*. Harry Clarke, illustrator. Dublin: Maunsel and Roberts, 1923. Image courtesy of the Royal Irish Academy.

unified – with the Anglican cross at the top of the page. The sun alludes to the Fianna, the semi-mythological original warrior people of Ireland. Art historian Jeanne Sheehy offers an insight into the nationalist conventions of design that inform Clarke's engravings,

FIGURE 3.16
O'Connell Statue, Dublin. Photo credit: Laura Bittner, 2009. Creative Commons Share-Alike license 2.0.

noting that 'the most obvious way in which nationality could be expressed was by the use of emblems. There were many of these, but the most commonly used were the shamrock, the harp, the Irish wolfhound, and the round tower.'[21] The iconography is evident in the statue of Daniel O'Connell that fronts the wide thoroughfare of O'Connell Street in Dublin. Emblems of the four provinces are placed around the four sides of the statue's base. One of the winged maidens guarding the pedestal is Hibernia, with wolfhound. Here the elements that would recur in *Ireland's Memorial Records* are present: four winged guardians, national symbols, and the insignia of the four provinces. Sheehy's point is amplified by Sean Farrell Moran, who studied the prevalence of Celtic design amidst nineteenth-century political campaigns and writes that 'artists standardised such images as the Celtic cross, the harp, and the wolfhound, as well as allegorical figures that combined Christian and Celtic motifs. Erin came to be a "Virgin Erin", used in commemorative statues honouring the Manchester Martyrs and to commemorate the dead of [the rebellion for independence of] 1798'.[22] The sun was used in nationalist iconography from the nineteenth century, and Clarke used a similar image on the cover of the memorial book for Michael Collins and Arthur Griffith. This book was published by Martin Lester, Ltd., Dublin, to commemorate the deaths of the two Free State supporters in 1922. A mourning woman, suggesting the legendary and tragic Irish heroine Deirdre, kneels by a vast lake, a ruined monastery behind her and the rising sun ahead.

However, Clarke also includes a visual allusion to the *Book of Revelation*, a theme that runs throughout his illustrations for *Ireland's Memorial Records*:

> And after these things I saw four angels standing on the four corners of the earth, holding the four winds of the earth, that the wind should not blow on the earth, nor on the sea, nor on any tree. (7:1) … These are they which came out of great tribulation (7:14) … They shall hunger no more, neither thirst any more; neither shall the sun light on them, nor any heat. For the Lamb which is in the

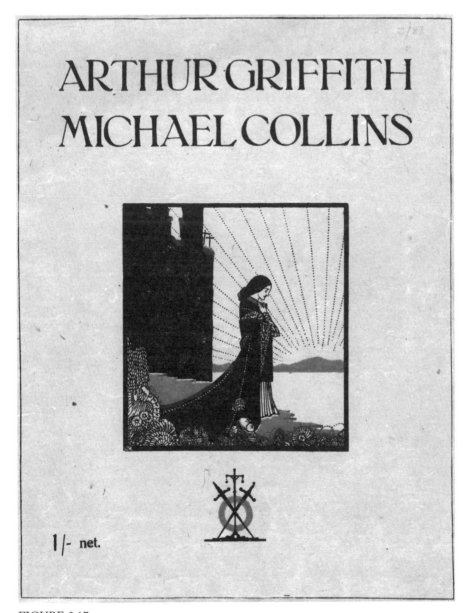

FIGURE 3.17
Harry Clarke's cover for *Arthur Griffith, Michael Collins*. Martin Lester Ltd, Dublin, 1922.
Image courtesy of Trinity College, Dublin, SamuelsBox2pt13_001.

midst of the throne shall feed them, and shall lead them
unto living fountains of waters: and God shall wipe away
all tears from their eyes. (7:16-17)

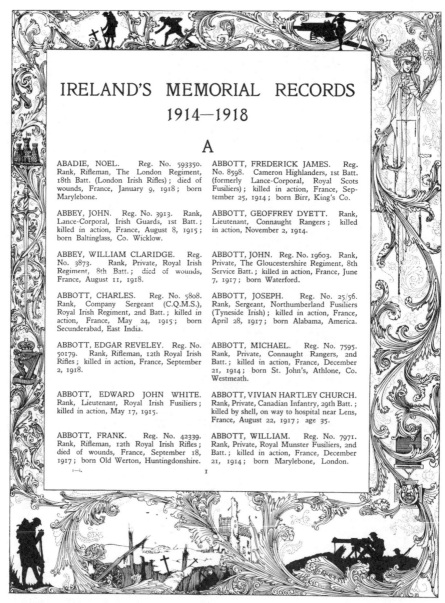

IRELAND'S MEMORIAL RECORDS
1914—1918

A

ABADIE, NOEL. Reg. No. 593350. Rank, Rifleman, The London Regiment, 18th Batt. (London Irish Rifles); died of wounds, France, January 9, 1918; born Marylebone.

ABBEY, JOHN. Reg. No. 3913. Rank, Lance-Corporal, Irish Guards, 1st Batt.; killed in action, France, August 8, 1915; born Baltinglass, Co. Wicklow.

ABBEY, WILLIAM CLARIDGE. Reg. No. 3873. Rank, Private, Royal Irish Regiment, 8th Batt.; died of wounds, France, August 11, 1918.

ABBOTT, CHARLES. Reg. No. 5808. Rank, Company Sergeant (C.Q.M.S.), Royal Irish Regiment, 2nd Batt.; killed in action, France, May 24, 1915; born Secunderabad, East India.

ABBOTT, EDGAR REVELEY. Reg. No. 50179. Rank, Rifleman, 12th Royal Irish Rifles; killed in action, France, September 2, 1918.

ABBOTT, EDWARD JOHN WHITE. Rank, Lieutenant, Royal Irish Fusiliers; killed in action, May 17, 1915.

ABBOTT, FRANK. Reg. No. 42339. Rank, Rifleman, 12th Royal Irish Rifles; died of wounds, France, September 18, 1917; born Old Werton, Huntingdonshire.

ABBOTT, FREDERICK JAMES. Reg. No. 8598. Cameron Highlanders, 1st Batt. (formerly Lance-Corporal, Royal Scots Fusiliers); killed in action, France, September 25, 1914; born Birr, King's Co.

ABBOTT, GEOFFREY DYETT. Rank, Lieutenant, Connaught Rangers; killed in action, November 2, 1914.

ABBOTT, JOHN. Reg. No. 19603. Rank, Private, The Gloucestershire Regiment, 8th Service Batt.; killed in action, France, June 7, 1917; born Waterford.

ABBOTT, JOSEPH. Reg. No. 25/56. Rank, Sergeant, Northumberland Fusiliers (Tyneside Irish); killed in action, France, April 28, 1917; born Alabama, America.

ABBOTT, MICHAEL. Reg. No. 7595. Rank, Private, Connaught Rangers, 2nd Batt.; killed in action, France, December 21, 1914; born St. John's, Athlone, Co. Westmeath.

ABBOTT, VIVIAN HARTLEY CHURCH. Rank, Private, Canadian Infantry, 29th Batt.; killed by shell, on way to hospital near Lens, France, August 22, 1917; age 35.

ABBOTT, WILLIAM. Reg. No. 7971. Rank, Private, Royal Munster Fusiliers, 2nd Batt.; killed in action, France, December 21, 1914; born Marylebone, London.

FIGURE 3.18
Ireland's Memorial Records 1914–1918. Harry Clarke, illustrator. Dublin: Maunsel and Roberts, 1923. Image courtesy of Eneclann.

Plate One

As I noted earlier, a Roll of Honour is not a narrative. Yet each name on a memorial list points to an individual's story of war, and together, these tales of combat form a broader narrative of the First World War. In *Ireland's Memorial Records*, Harry Clarke creates his own visual narrative of war that encircles the 49,435 names of the dead. Influenced by lantern-slide entertainments and the cinema, he is able to piece together a bold story of combined military effort and singular sacrifice. The effect is to see the names as actors within the great landscapes and ongoing tragedies of war. To locate a name on a page is also to refer to the margins, where readers can visualize what the soldiers may have experienced in battle. In other words, the images are not purely decorative. Harry Clarke astutely creates a graphic narrative of war and its aftermath that emotionally affects the reader.

The first image of each quire is always that which features a ruined chateau and leaning crosses by a sinking trench. At the top of the page, three vignettes depict silhouetted soldiers. Reading from left to right, a soldier remarkably resembling Ernest Brooks's young man at Passchendaele with steel helmet, backpack, and rifle stands over

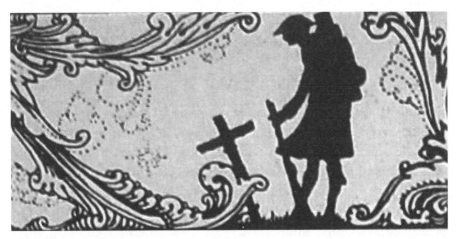

FIGURE 3.19
Soldier at grave. Detail from *Ireland's Memorial Records 1914–1918*. Harry Clarke, illustrator. Dublin: Maunsel and Roberts, 1923. Image courtesy of the Royal Irish Academy.

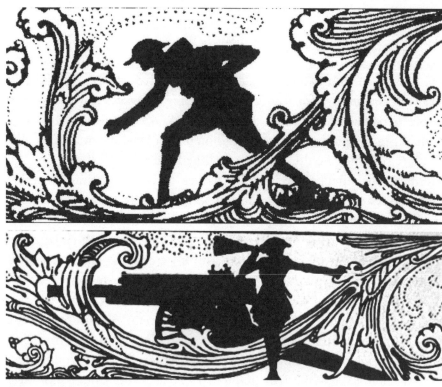

FIGURE 3.20 (top)
Crossing No Man's Land. Detail from *Ireland's Memorial Records 1914–1918*. Harry Clarke, illustrator. Dublin: Maunsel and Roberts, 1923. Image courtesy of the Royal Irish Academy.

FIGURE 3.21 (bottom)
Soldier with a megaphone. Detail from *Ireland's Memorial Records 1914–1918*. Harry Clarke, illustrator. Dublin: Maunsel and Roberts, 1923. Image courtesy of the Royal Irish Academy.

a tilting cross that marks a grave. At the centre, another soldier, in helmet, breeches, and boots, crouches low as he crosses over a roll of barbed wire in No Man's Land. The right corner depicts a soldier with a megaphone, presumably shouting orders to the gunners at the heavy artillery, for a cannon is behind him (known as a thirteen- or eighteen-pounder). It's possible to read the images from left to right as discrete vignettes from the tradition of lantern slides and early silent film. However, at a certain point in the printing and binding of *Ireland's Memorial Records*, this page is reversed in the quire so that a

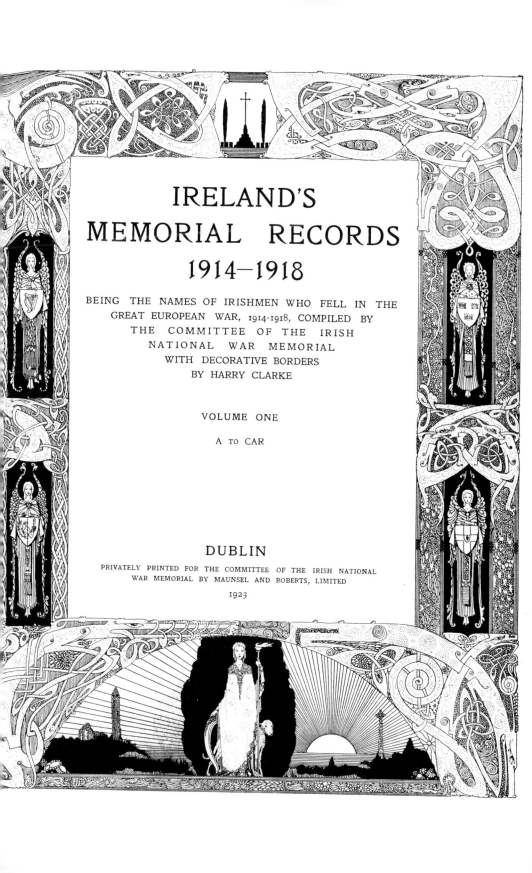

IRELAND'S
MEMORIAL RECORDS
1914–1918

BEING THE NAMES OF IRISHMEN WHO FELL IN THE
GREAT EUROPEAN WAR, 1914-1918, COMPILED BY
THE COMMITTEE OF THE IRISH
NATIONAL WAR MEMORIAL
WITH DECORATIVE BORDERS
BY HARRY CLARKE

VOLUME ONE

A TO CAR

DUBLIN

PRIVATELY PRINTED FOR THE COMMITTEE OF THE IRISH NATIONAL
WAR MEMORIAL BY MAUNSEL AND ROBERTS, LIMITED
1923

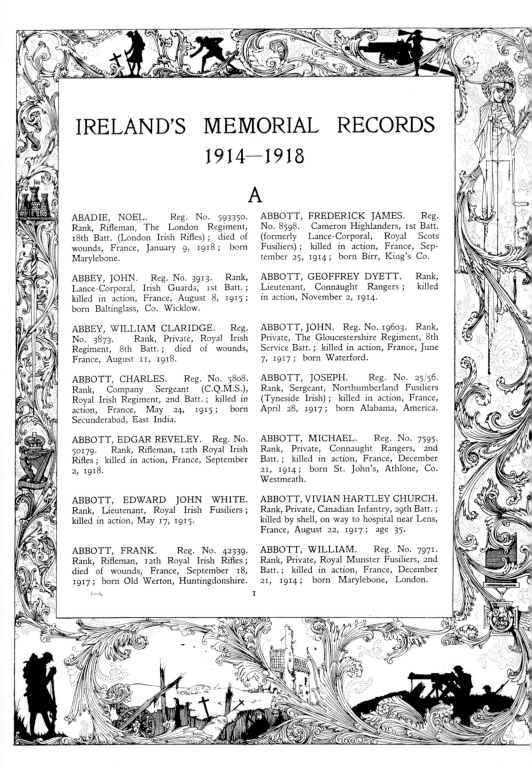

IRELAND'S MEMORIAL RECORDS
1914—1918

A

ABADIE, NOEL. Reg. No. 593350. Rank, Rifleman, The London Regiment, 18th Batt. (London Irish Rifles); died of wounds, France, January 9, 1918; born Marylebone.

ABBEY, JOHN. Reg. No. 3913. Rank, Lance-Corporal, Irish Guards, 1st Batt.; killed in action, France, August 8, 1915; born Baltinglass, Co. Wicklow.

ABBEY, WILLIAM CLARIDGE. Reg. No. 3873. Rank, Private, Royal Irish Regiment, 8th Batt.; died of wounds, France, August 11, 1918.

ABBOTT, CHARLES. Reg. No. 5808. Rank, Company Sergeant (C.Q.M.S.), Royal Irish Regiment, 2nd Batt.; killed in action, France, May 24, 1915; born Secunderabad, East India.

ABBOTT, EDGAR REVELEY. Reg. No. 50179. Rank, Rifleman, 12th Royal Irish Rifles; killed in action, France, September 2, 1918.

ABBOTT, EDWARD JOHN WHITE. Rank, Lieutenant, Royal Irish Fusiliers; killed in action, May 17, 1915.

ABBOTT, FRANK. Reg. No. 42339. Rank, Rifleman, 12th Royal Irish Rifles; died of wounds, France, September 18, 1917; born Old Werton, Huntingdonshire.

ABBOTT, FREDERICK JAMES. Reg. No. 8598. Cameron Highlanders, 1st Batt. (formerly Lance-Corporal, Royal Scots Fusiliers); killed in action, France, September 25, 1914; born Birr, King's Co.

ABBOTT, GEOFFREY DYETT. Rank, Lieutenant, Connaught Rangers; killed in action, November 2, 1914.

ABBOTT, JOHN. Reg. No. 19603. Rank, Private, The Gloucestershire Regiment, 8th Service Batt.; killed in action, France, June 7, 1917; born Waterford.

ABBOTT, JOSEPH. Reg. No. 25/56. Rank, Sergeant, Northumberland Fusiliers (Tyneside Irish); killed in action, France, April 28, 1917; born Alabama, America.

ABBOTT, MICHAEL. Reg. No. 7595. Rank, Private, Connaught Rangers, 2nd Batt.; killed in action, France, December 21, 1914; born St. John's, Athlone, Co. Westmeath.

ABBOTT, VIVIAN HARTLEY CHURCH. Rank, Private, Canadian Infantry, 29th Batt.; killed by shell, on way to hospital near Lens, France, August 22, 1917; age 35.

ABBOTT, WILLIAM. Reg. No. 7971. Rank, Private, Royal Munster Fusiliers, 2nd Batt.; killed in action, France, December 21, 1914; born Marylebone, London.

1—1. I

ABRAHAM, WILLIAM. Reg. No. 27369. Rank, Private, 9th Royal Inniskilling Fusiliers; killed in action, France, July 1, 1916; born Ballinamallard, Co. Fermanagh.

ABRAHAM, WILLIAM GEORGE. Reg. No. 18119. Rank, Lance-Corporal, Machine Gun Corps (Infantry), 1st Batt. (formerly Royal Irish Rifles); killed in action, France, May 21, 1916; born Collon, Co. Louth.

ABRAMS, FREDERICK GEORGE. LEONARD. Reg. No. 9505. Rank, Lance-Corporal, Duke of Cornwall's Light Infantry; killed in action, France, April 23, 1915; born Landport, Hants; age 23.

ABRAMS, HAROLD JAMES. Rank, A.B., Royal Navy, H.M.S. Good Hope; killed in Naval action off Chili, November 1, 1914; age 25.

ABREY, JAMES. Reg. No. 42772. Rank, Rifleman, 12th Royal Irish Rifles; died of wounds, France, August 18, 1917; born Rochford, Essex.

ABSALOM, MATTHEW. Reg. No. 21/1182. Rank, Private, Northumberland Fusiliers (Tyneside Irish); killed in action, France, July 1, 1916; born Bedlington, Northumberland.

ABSOLOM, HARRIS LEE. Reg. No. 17117. Rank, Lance-Corporal, 13th Royal Irish Rifles; killed in action, France, July 1, 1916; born Bangor, Co. Down.

ABSOM, CHARLES STEWART. Reg. No. 305102. Rank, Gunner, Tank Corps; killed in action, France, September 27, 1918; born St. Giles, Edinburgh; decoration, M.M.

ACHESON, JOSEPH. Rank, 2nd Lieutenant, South Lancashire Regiment; died of wounds received in action, June 13, 1918.

ACHESON, THOMAS. Reg. No. 42610. Rank, Private, Machine Gun Corps (Infantry), 1st Batt. (formerly Royal Irish Fusiliers; died of wounds, France, August 19, 1916; born Mitchelstown, Co. Donegal.

ACHESON, VINCENT ANDREWS. Rank, Captain (Temporary), The Royal Inniskilling Fusiliers, 6th Batt. (attached 7th); killed in action, September 10, 1916.

ACHESON, PERCEVAL HAVELOCK. Rank, Major, Army Service Corps; died, April 29, 1916.

ACKERLEY, HAROLD OWEN. Reg. No. 45596. Rank, Rifleman, 1/8th London Regiment (Royal Irish Rifles); killed in action, France, October 3, 1918.

ACKERLEY, JOSEPH. Reg. No. 21810. Rank, Private, 1st Royal Dublin Fusiliers; died of wounds, France, July 2, 1916; born Timperley, Cheshire.

ACKERMAN, THOMAS. Reg. No. 43609. Rank, Private, Royal Inniskilling Fusiliers, 11th Batt.; killed in action, France, August 16, 1917; born Moreton, Inmarsh, Gloucester.

ACKINSON, ROBERT. Reg. No. 40201. Rank, Rifleman, Royal Irish Rifles, 2nd Batt.; killed in action, France, October 22, 1918; born Belfast.

ADAIR, J. T. Rank, Lieutenant, Bedfordshire Regiment, 10th Batt.; died of wounds, Dardanelles, August 22, 1915.

ADAIR, JAMES. Reg. No. 16149. Rank, Rifleman, 13th Royal Irish Rifles; killed in action, France, July 1, 1916; born Banbridge, Co. Down.

ADAIR, JAMES. Reg. No. 71659. Rank, Private, North Irish Horse; died, British Expeditionary Force, November 14, 1918.

ADAIR, JOHN. Reg. No. 765. Rank, Lance-Corporal, 10th Royal Irish Rifles; died of wounds, France, November 14, 1916; born Ballywalter, Co. Down.

ADAIR, JAMES B. Rank, Private, Co. A., 6th Engineers, American Expeditionary Force; killed in action, October 22, 1918.

ADAIR, JOHN. Reg. No. 14849. Rank, Private, Royal Inniskilling Fusiliers, 11th Batt.; killed in action, France, July 1, 1916; born Omagh, Co. Tyrone.

ADAIR, ROBERT. Reg. No. 9204. Rank, Sergeant, Royal Irish Rifles, 2nd Batt.; killed in action, France, October 25, 1914; born Shankhill, Co. Antrim.

ADAIR, ROBERT. Reg. No. 24/1660. Rank, Private, Northumberland Fusiliers (Tyneside Irish); killed in action, France, April 9, 1917; born Maryport, Cumberland.

ADAIR, ROBERT HUGH. Reg. No. 5818. Rank, Rifleman, Royal Irish Rifles, 2nd Batt.; killed in action, France, July 7, 1915; born Monkstown, Co. Antrim.

ADAIR, ROBERT JAMES. Reg. No. 8955. Rank, Rifleman, Royal Irish Rifles, 2nd Batt.; killed in action, France, November 11, 1914; born Donagheady, Co. Tyrone.

ADAIR, ROBERT MOORE. Reg. No. 509. Rank, Rifleman, 8th Royal Irish Rifles; killed in action, France, June 7, 1917; born Dromore, Co. Down.

ADAIR, THOMAS. Reg. No. 43291. Rank, Private, Machine Gun Corps (Infantry), 1st Batt. (formerly Royal Irish Regiment); killed in action, France, February 20, 1917; born Roscrea, Co. Tipperary.

ADAIR, WILLIAM. Reg. No. 5481. Rank, Rifleman, 7th Royal Irish Rifles; died of wounds, France, September 9, 1916; born Belfast.

ADAMS, ADOLPHUS. Reg. No. 13945. Rank, Rifleman, Royal Irish Rifles, 15th Batt.; died of wounds, France, May 2, 1918; born Belfast.

ADAMS, ALAN. Rank, Engineer Lieutenant, Royal Navy; killed in action, H.M.S. Indefatigable, May 31, 1916; age 34.

ADAMS, ALBERT. Reg. No. 13030. Rank, Private, 6th Royal Irish Fusiliers; killed in action, Gallipoli, August 9, 1915; born Lurgan, Co. Armagh.

ADAMS, EDWARD. Reg. No. 16158. Rank, Rifleman, 14th Royal Irish Rifles; killed in action, France, May 6, 1916; born Shankhill, Belfast.

ADAMS, GEORGE GORDON CRYMBLE. Rank, Lieutenant, Royal Army Medical Corps; died of Fever contracted on active service, East Africa, March 9, 1918.

ADAMS, ERNEST. Reg. No. 22623. Rank, Private, 9th Royal Inniskilling Fusiliers; killed in action, France, July 1, 1916; born Belfast, Co. Antrim.

ADAMS, GEORGE PERRINS. Reg. No. 59207. Rank, Private, Northumberland Fusiliers (Tyneside Irish), formerly A.O.C.; died, France, March 23, 1918; born Shipston, Worcester.

ADAMS, FERGUS EUSTACE. Rank, Captain, Lancers; died, Nursing Home, Edinburgh, 30th January, 1917.

ADAMS, HENRY. Regimental No. 8555. Rank, Private, Irish Guards, 1st Batt; killed in action, France, August 2, 1917; born Ballymoney, Co. Antrim.

ADAMS, FRANK GEORGE. Reg. No. 608400. Rank, Rifleman, The London Regiment, 18th Batt., London Irish Rifles (formerly 5th London Regiment); killed in action, France, March 26, 1918; born Herne Hill.

ADAMS, HENRY ARTHUR. Reg. No. 9825. Rank, Lance-Corporal, Royal Inniskilling Fusiliers, 8th Batt.; killed in action, France, July 15, 1916; born Glendermott, Co. Derry.

ADAMS, FREDERICK JAMES. Reg. No. 2582. Rank, Rifleman, The London Regiment, 18th Batt. (London Irish Rifles); killed in action, France, September 25, 1915;

ADAMS, HENRY GEORGE. Reg. No. 593891. Rank, Rifleman, The London Regiment, 18th Batt. (London Irish Rifles); killed in action, France, April 7, 1917; born Rotherhithe.

ADAMS, GEOFREY JULIAN BAL-COMBE. Rank, 2nd Lieutenant, London Rifle Brigade; killed in action, September 27, 1918; age 24.

ADAMS, HENRY RICHARD. Reg. No. 8583. Rank, Acting Sergeant, The Royal Berkshire Regiment, 1st Batt.; died of wounds France, May 17, 1915; born Kildare.

ADAMS, GEORGE. Reg. No. 12497. Rank, Rifleman, 8th Royal Irish Rifles; killed in action, France, July 2, 1916; born Ballymacarrett, Co. Down.

ADAMS, JAMES. Regimental No. 586. Rank, Rifleman, 9th Royal Irish Rifles; killed in action, France, June 22, 1917; born Mullinhill, Co. Antrim.

ADAMS, GEORGE. Reg. No. 40124. Rank, Gunner, Royal Garrison Artillery, 10th T.M.B.; died of wounds received in action, Hospital, Abbeville, France, July 23, 1915; born Keady, Co. Armagh; age 20

ADAMS, JAMES. Regimental No. 16150. Rank, Corporal, 11th Royal Irish Rifles; killed in action, France, August 16, 1917; born Dunadry, Co. Antrim.

7

ADAMS, JAMES. Regimental No. 23519. Rank, Lance-Corporal, Highland Light Infantry, 14th (Service) Batt.; killed in action, France, April 9, 1918; born Larne, Co. Antrim.

ADAMS, JAMES. Regimental No. 59790. Rank, Private, Royal Army Medical Corps; died of wounds, France, August 30, 1918; born Ballymacarrett, Co. Down.

ADAMS, JAMES ALEXANDER. Reg. No. 3694. Rank, Lance-Corporal, Royal Inniskilling Fusiliers, 1st Batt.; died of wounds, France, June 11, 1916; born Belfast.

ADAMS, JAMES WILLIAM. . Reg. No. 9554. Rank, Sergeant, 1st Royal Irish Rifles; killed in action, France, December 2, 1917; born Portglennone, Co. Antrim.

ADAMS, JOHN. Regimental No. 9249. Rank, Rifleman, 1st Royal Irish Rifles; killed in action, France, May 9, 1915; born Shankhill, Co. Antrim.

ADAMS, JOHN GOULD. Rank, Captain, Leinster Regiment; killed in action, May 5, 1915.

ADAMS, JOHN. Regimental No. 119855. Rank, Driver, Royal Regiment of Artillery (Royal Horse and Royal Field Artillery); killed in action, France, August 11, 1917; born Belfast.

ADAMS, JOHN. Regimental No. 24710. Rank, Private, Royal Inniskilling Fusiliers, 1st Batt.; died of wounds, France, August 2, 1917; born Spennymoor, Co. Durham.

ADAMS, JOHN EDWARD. Reg. No. 41008. Rank, Acting Corporal, Northumberland Fusiliers (Tyneside Irish), formerly West Riding Regiment; died of wounds, France, October 6, 1916; born Gateshead-on-Tyne.

ADAMS, JOHN HANNA. Rank, 2nd Lieutenant, Prince of Wales Own North Staffordshires, 8th Batt.; killed in action, November 18, 1916; born Whitehead, Co. Antrim.

ADAMS, JOSEPH. Reg. No. 10025. Rank, Rifleman, Royal Irish Rifles, 2nd Batt.; killed in action, France, September 6, 1918; born Shankhill, Co. Antrim.

ADAMS, JOSEPH. Reg. No. 49597. Rank, Private, Royal Inniskilling Fusiliers, 1st Batt.; died of wounds, France, October 1, 1918; born Oxton, Cheshire.

ADAMS, JOSEPH GEORGE. Reg. No. 17097. Rank, Private, Royal Warwickshire Regiment, 2nd Batt.; killed in action, France, September 3, 1916; born Killarney, Co. Kerry.

ADAMS, MARK. Reg. No. 10593. Rank, Corporal, 1st Royal Dublin Fusiliers; died November 26, 1914; born Kirkdale.

ADAMS, MAURICE. Rank, Driver, New Zealand Artillery; killed in action, Messines, May ·27, 1917; born Ireland; age 33.

ADAMS, PERCY LIONEL. Rank, Lieutenant, 18th London Regiment, London Irish Rifles (M.G.C.); died of wounds October 3, 1918

ADAMS, PETER. Regimental No. 3284. Rank, Private, 1st Leinster Regiment : killed in action, France, April 8, 1915 ; born Dublin.

ADAMS, RALPH. Reg. No. 17121. Rank, Rifleman, 13th Royal Irish Rifles ; killed in action, France, July 1, 1916 ; born Lisburn, Co. Antrim.

ADAMS, RICHARD. Reg. No. 10555. Rank, Acting Sergeant, Yorkshire Light Infantry, 2nd Batt. ; killed in action, France, May 7, 1915 ; born Limerick.

ADAMS, RICHARD. Reg. No. 11463. Rank, Private, Royal Dublin Fusiliers, 2nd Batt. ; died of wounds, France, January 16, 1915 ; born Dublin.

ADAMS, RICHARD A. A. (PHIL). Canadian Cameron Highlanders ; killed in action, Vimy Ridge, France, April 11, 1918.

ADAMS, ROBERT. Reg. No. S/3813. Rank, Lance-Corporal, Argyll and Sutherland Highlanders, 11th Batt. ; died of wounds, France, May 19, 1917 ; born Barony, Lanarkshire ; age 31.

ADAMS, ROBERT. Reg. No. 19371. Rank, Rifleman, Royal Irish Rifles, 15th Batt. ; killed in action, France, October 20, 1918 ; born Crumlin, Co. Antrim.

ADAMS, ROBERT. Reg. No. 47991. Rank, Private, Northumberland Fusiliers, 14th Batt. (formerly A.O.C.) ; died of wounds, France, April 17, 1918 ; born Dublin.

ADAMS, ROBERT McFERRAN. Reg. No. 17119. Rank, Rifleman, 12th Royal Irish Rifles ; died of wounds, France, June 4, 1916 ; born Larne, Co. Antrim ; age 20.

ADAMS, STANLEY. Reg. No. 523. Rank, Private, Royal Irish Regiment, 5th Batt. ; killed in action, Gallipoli, August 16, 1915 ; born Wedmore, Somerset.

ADAMS, THOMAS. Reg. No. 5730. Rank, Corporal, 2nd Royal Inniskilling Fusiliers ; killed in action, France, May 16, 1915 ; born Westminster, Middlesex.

ADAMS, THOMAS. Reg. No. S/14324. Rank, Lance-Corporal, Gordon Highlanders, 7th Batt. ; died of wounds, France, April 28, 1917 ; born Londonderry.

ADAMS, THOMAS. Reg. No. 20035. Rank, Private, Royal Irish Fusiliers, 9th Batt. ; died, France, July 15, 1918 ; born Newry, Co. Down.

ADAMS, THOMAS. Reg. No. 24104. Rank, Acting Sergeant, Royal Dublin Fusiliers, 7th Batt. ; killed in action, Balkans, October 3, 1916 ; born Malden, Surrey.

ADAMS, WILLIAM. Reg. No. 3364. Rank, Rifleman, 1st Royal Irish Rifles ; killed in action, France, May 9, 1915 ; born Dalston, Surrey.

ADAMS, WILLIAM. Reg. No. 47457. Rank, Rifleman, 1st Royal Irish Rifles ; killed in action, France, March 28, 1918 ; born, Leamington, Warwick.

ADDERLY, LEE. Rank, Gunner, Royal Garrison Artillery; died from sickness contracted on active service, May 25, 1918.

ADDIE, WILLIAM. Reg. No. 6875. Rank, Private, Royal Army Medical Corps; died of wounds, France, March 17, 1918; born St. James's, Dublin.

ADDINGTON, ARTHUR P. Reg. No. 8353. Rank, Private, Royal Irish Regiment, 2nd Batt.; died, home, August 22, 1918; born Camberwell, London.

ADDIS, HENRY. Reg. No. 17126. Rank, Rifleman, 11th Royal Irish Rifles; died of wounds, France, June 8, 1917; born Derriaghy, Co. Antrim.

ADDIS, ROBERT. Reg. No. 13972. Rank, Private, Royal Irish Fusiliers, 9th Batt.; killed in action, France, July 1, 1916; born Kilmore, Co. Down.

ADDIS, THOMAS HENRY LIDDON. Rank, Lieutenant, Royal Dublin Fusiliers, 4th Batt.; killed in action, March 21, 1918.

ADDISON, ARTHUR JOSEPH BERKELEY. Rank, Lieutenant-Colonel, York and Lancaster Regiment, 9th Batt.; killed in action, July 1, 1916.

ADDISON, EDWARD. Reg. No. 26/15. Rank, Private, Northumberland Fusiliers (Tyneside Irish); killed in action, France, July 1, 1916; born Rainton, Durham.

ADDISON, ROBERT. Reg. No. 50842. Rank, Private, Royal Army Medical Corps; killed in action, France, June 7, 1917; born Ballymacarrett, Co. Down.

ADDLEY, WILLIAM JAMES. Reg. No. 64342. Rank, Lance-Corporal, Royal Engineers (122nd Field Co., R.E.); died, home, November 1, 1917; born Shankhill, Co. Antrim.

ADRAIN, ANDREW. Reg. No. 17128. Rank, Rifleman, 12th Royal Irish Rifles; killed in action, France, March 25, 1918; born Ballynure, Co. Antrim.

ADRIAN, WILLIAM KEARNS. Rank, 2nd Lieutenant, Royal Irish Regiment, 5th Batt. (attached 1st Irish Rifles); killed in action, August 24, 1916; born Belfast.

AGAR, ARTHUR. Reg. No. 45677. Rank, Private, Northumberland Fusiliers (Tyneside Irish); died, France, September 10, 1917; born Tynemouth, Northumberland.

AGAR, JAMES. Regimental No. 16549. Rank, Private, Royal Dublin Fusiliers, 6th Batt.; killed in action, Gallipoli, August 12, 1915; born Whitly, Yorks.

AGAR, JOHN. Reg. No. 789. Rank, Rifleman, Royal Irish Rifles, 15th Batt.; killed in action, France, October 1, 1918; born Shankhill, Co. Antrim.

AGATE, NORMAN STANFORD. Rank, 2nd Lieutenant, 18th London Regiment (London Irish Rifles); died of wounds, March 23, 1918.

11

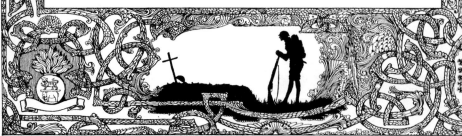

AHERN, RODNEY. Reg. No. 11298. Rank, Driver, 1st Royal Dublin Fusiliers; died of wounds, Gallipoli, August 8, 1915; born High Leas, Portsmouth.

AHERN, THOMAS. Reg. No. 9379. Rank, Private, Royal Dublin Fusiliers, 2nd Batt.; killed in action, France, March 21, 1918; born Newbridge, Co. Kildare.

AHERN, TIMOTHY. Reg. No. 4729. Rank, Private, Royal Munster Fusiliers, 9th Batt.; died of wounds, France, April 3, 1916; born Newcastle West, Co. Limerick.

AHERN, WILLIAM. Rank, Petty Officer, H.M.S. Indefatigable; died, May 31, 1916.

AHERN, WILLIAM. Reg. No. 6045. Rank, Private, Irish Guards, 1st Batt.; killed in action, France, June 18, 1916.

AHERNE, WILLIAM. Reg. No. 10354. Rank, Rifleman, Royal Irish Rifles, 2nd Batt.; killed in action, France, March 31, 1915; born Cork.

AICKEN, JAMES. Reg. No. 1040. Rank, Rifleman, 11th Royal Irish Rifles; killed in action, France, September 1, 1916; born Larne, Co. Antrim.

AIKEN, JAMES. Reg. No. 12504. Rank, Rifleman, Royal Irish Rifles, 15th Batt.; killed in action, France, January 20, 1916; born Shankhill, Co. Antrim.

AIKEN, JOHN. Reg. No. 4464. Rank, Private, Connaught Rangers, 5th Batt.; killed in action, Gallipoli, August 21, 1915; born Aughnish, Ramelton, Co. Donegal.

AIKEN, MAXWELL. Reg. No. 30133. Rank, Private, The Border Regiment, 11th Batt.; died, France, April 23, 1918; born Donaghadee, Co. Down.

AIKEN, WALTER EDMOND. Reg. No. 3396. Rank, Private, 7th Royal Inniskilling Fusiliers; killed in action, France, September 9, 1916; born Ballymacarrett, Co. Down.

AINSCOW, GEORGE ALFRED. Reg. No. 49712. Rank, Private, The Royal Fusiliers, 9th Batt. (formerly 31st (R) Batt., Royal Fusiliers); killed in action, France, September 18, 1918; born Dublin; age 21.

AINSLIE, JOHN ELLIOTT. Rank, 2nd Lieutenant, Royal Scots, 12th Batt.; killed in action, September 28, 1915.

AINSWORTH, HENRY. Reg. No. 4465. Rank, Private, Connaught Rangers, 5th Batt.; killed in action, Gallipoli, August 28, 1915; born Chorley, Lancashire.

AINSWORTH, HERBERT. Reg. No. 29798. Rank, Private, Royal Dublin Fusiliers, 2nd Batt.; killed in action, France, March 21, 1918; born Darwen.

AINSWORTH, JOHN. Reg. No. 40901. Rank, Private, Northumberland Fusiliers (Tyneside Irish), formerly West Yorks Regiment; killed in action, France, October 23, 1917; born East Ardsley, Yorks.

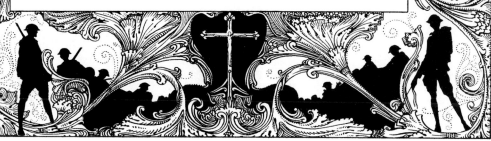

AGATES, REGINALD. Reg. No. 43721. Rank, Lance-Corporal, 1st Royal Irish Rifles; died of wounds, Home, June 1, 1917.

AGER, SIDNEY JOHN. Reg. No. 592013. Rank, Rifleman, The London Regiment, 18th Batt. (London Irish Rifles); killed in action, France, September 1, 1918; born Kelvedon.

AGGAS, ROBERT GEORGE. Reg. No. 41394. Rank, Rifleman, 9th Royal Irish Rifles; killed in action, France, June 7, 1917.

AGNEW, ANDREW. Reg. No. 6122. Rank, Rifleman, 12th Royal Irish Rifles; killed in action, France, July 1, 1916; born Ballyhinton, Co. Antrim.

AGNEW, ANDREW ERIC HAMILTON. Rank, Captain, Royal Dublin Fusiliers; died, November 3, 1918.

AGNEW, CHARLES. Reg. No. 7890. Rank, Private, Irish Guards, 2nd Batt.; killed in action, France, September 13, 1916; born Larne, Co. Antrim.

AGNEW, GEORGE. Reg. No. 1372. Rank, Rifleman, 10th Royal Irish Rifles; killed in action, France, November 22, 1917; born Ballyclare, Co. Antrim.

AGNEW, JACK. Reg. No. 238859. Rank, Gunner, Royal Regiment of Artillery (Royal Horse and Royal Field Artillery); killed in action, France, April 4. 1918; born Bangor.

AGNEW, JAMES. Reg. No. 5037. Rank, Rifleman, 7th Royal Irish Rifles; killed in action, France, August 16, 1917; born Belfast.

AGNEW, JAMES. Reg. No. 42470. Rank, Rifleman, 14th Royal Irish Rifles; killed in action, France, August 16, 1917; born Ballymacarrett, Co. Down.

AGNEW, JAMES. Reg. No. 43149. Rank, Private, 7th Royal Irish Fusiliers; killed in action, France, September 9, 1916; Larne, Co. Antrim.

AGNEW, JOHN. Rank, Sergeant American Expeditionary Force (339th Infantry); killed in action, 1918.

AGNEW, JOHN. Reg. No. 587. Rank, Rifleman, 9th Royal Irish Rifles; killed in action, France, July 1, 1916; born Shankhill, Belfast.

AGNEW, JOHN. Reg. No. 7285. Rank, Private, 2nd Leinster Regiment; killed in action, France, March 13, 1916; born Consett, Durham.

AGNEW, JOHN. Regimental No. 42593. Rank, Private, 12th (Service Batt.) Highland Light Infantry (formerly Royal Scots Fusiliers); killed in action, France, April 11, 1917; born Crumlin, Co. Antrim.

AGNEW, JOSEPH. Reg. No. 16. Rank, Rifleman, 10th Royal Irish Rifles; killed in action, France, July 1, 1916; born Belfast.

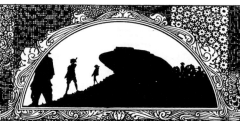

AGNEW, JOSEPH. Reg. No. 7516. Rank, Private, Royal Munster Fusiliers, 2nd Batt.; killed in action, France, November 15, 1914; born Larne, Co. Antrim.

AGNEW, KENNETH MALCOLM. Reg. No. 20459. Rank, Rifleman, 1st Royal Irish Rifles; died of wounds, France, June 25, 1918; born Belfast.

AGNEW, MICHAEL. Reg. No. 27/792. Rank, Private, Northumberland Fusiliers (Tyneside Irish); killed in action, France, July 1, 1916; born Consett, Durham.

AGNEW, MYLES. Reg. No. 4863. Rank, Private, Connaught Rangers (Depot); died, home, April 4, 1915; born Larne, Co. Antrim.

AGNEW, NATHANIEL. H.M.S. Hawke; loss of ship, October 15, 1914.

AGNEW, SAMUEL. Reg. No. 817. Rank, Rifleman, 12th Royal Irish Rifles; killed in action, France, November 22, 1917; born Antrim.

AGNEW, THOMAS. Reg. No. 12285. Rank, Private, 6th Royal Irish Fusiliers; died, Gallipoli, October 25, 1915; born Newtownbutler, Co. Fermanagh.

AGNEW, THOMAS R. Rank, Stoker, H.M.S. Vanguard; killed by explosion, July 9, 1917.

AGNEW, WILLIAM. Reg. No. 903. Rank, Rifleman, Royal Irish Rifles, 15th Batt.; died, France, August 5, 1918; born Ballymacarrett, Co. Down.

AGNEW, WILLIAM. Reg. No. 4150. Rank, Private, Seaforth Highlanders, 5th Batt.; killed in action, France, August 2, 1916.

AGNEW, WILLIAM. Reg. No. 8204. Rank, Rifleman, Royal Irish Rifles, 2nd Batt.; died, France, November 19, 1914; born Belfast.

AGNEW, WILLIAM. Reg. No. 19372. Rank, Rifleman, 14th Royal Irish Rifles; killed in action, France, July 1, 1916; born Liverpool.

AHEARN, JOHN EDWARD. Reg. No. 7901. Rank, Private, Royal Inniskilling Fusiliers, 1st Batt.; died of wounds, France, July 4, 1916; born St. Heliers, Jersey.

AHEARNE, MICHAEL. Reg. No. 897. Rank, Gunner, Machine Gun Corps (Motor Branch); killed in action, France, March 11, 1916; born St. Mary's, Tipperary.

AHEM, JAMES. Reg. No. 7265. Rank, Private, The Oxfordshire and Buckinghamshire Light Infantry; died, Mesopotamia, November 22, 1917; born Cork.

AHEM, JOSEPH. Reg. No. Spts/3570. Rank, Private, The Royal Fusiliers, 24th Batt.; killed in action, France, November 13, 1916; born Cork.

13

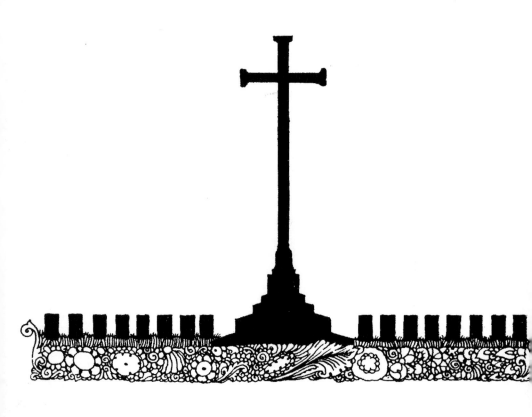

new narrative emerges in action-to-action frames: the order is given, the cannon fires, the soldier is injured and falls forward from the blast, and he is later buried near the battlefield.

Along the right side of this same page, a virtually transparent, helmeted angel mourns with downcast eyes. An elaborate crown of laurel leaves ascends beyond his head. He holds a very fine draped cross, symbolizing the burial shroud of Christ, and establishing the sombre note of mourning. The dichotomy between the laurel leaves of victory and the shrouded cross points to a victory that was achieved at a great price.

The delicately stippled pattern around this angel depicts a rose, which in Christian iconography represents Christ and the Virgin Mother, the 'Rosa Mystica'. The angel gazes directly down upon the Victoria Cross medal, the highest honour for acts of valour in battle. The medal is shaped as a cross pattée over which the crown of St Edward is placed, the crown worn at the coronation of British monarchs. The crown is surmounted by a lion.

Keeping in mind, once again, that we are examining the recto version of the plate, opposite the angel, on the left border at the inner margins, are two coats of arms: the badges of the Royal Inniskilling Dragoon Guards at the top and the harp and crown insignia of the Royal Irish Rifles at the bottom. Between them a long sword with a cross-shaped hilt is woven into the vines.

The vine motif used throughout the illustrations can be traced to Anglo Saxon and Celtic stonework and illuminated manuscripts, in which the vine was a non-representational image of Christ. Following the passage from the Last Supper in which Jesus tells his disciples, 'I am the true vine', the grape vine represents the blood of Christ, the wine of the Holy Communion. Michael W. Herren and Shirley Ann Brown describe the vine as a symbol for 'the living Christ and the Eucharist: salvation and redemption are to be achieved through the agency of Christ's willing self-sacrifice and the sacrament which reenacts it'.[23]

Clarke makes use of *bas-de-page* narrative scenes that are found in traditional European illumination. The bottom of the page mirrors

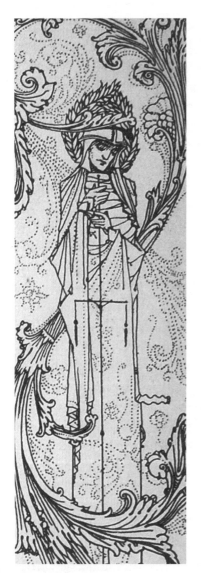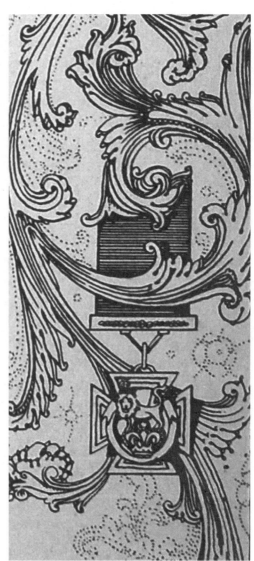

FIGURE 3.22 (left)
Angel with laurel leaves. Detail from *Ireland's Memorial Records 1914–1918*. Harry Clarke, illustrator. Dublin: Maunsel and Roberts, 1923. Image courtesy of the Royal Irish Academy.

FIGURE 3.23 (right)
Victoria Cross medal. Detail from *Ireland's Memorial Records 1914–1918*. Harry Clarke, illustrator. Dublin: Maunsel and Roberts, 1923. Image courtesy of the Royal Irish Academy.

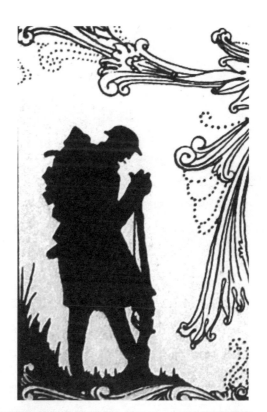

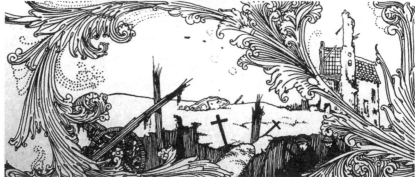

FIGURE 3.24 (left)
Badges of the Royal Inniskilling Dragoon Guards and the Royal Irish Rifles. Detail from *Ireland's Memorial Records 1914–1918*. Harry Clarke, illustrator. Dublin: Maunsel and Roberts, 1923. Image courtesy of the Royal Irish Academy.

FIGURE 3.25 (top center)
Mourning soldier. Detail from *Ireland's Memorial Records 1914–1918*. Harry Clarke, illustrator. Dublin: Maunsel and Roberts, 1923. Image courtesy of the Royal Irish Academy.

FIGURE 3.26 (bottom)
No Man's Land. Detail from *Ireland's Memorial Records 1914–1918*. Harry Clarke, illustrator. Dublin: Maunsel and Roberts, 1923. Image courtesy of the Royal Irish Academy.

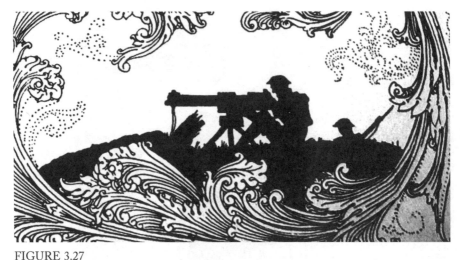

FIGURE 3.27
Lewis gun. Detail from *Ireland's Memorial Records 1914-1918*. Harry Clarke, illustrator. Dublin: Maunsel and Roberts, 1923. Image courtesy of the Royal Irish Academy.

the top. Again reading left to right, a soldier mourns at a grave, a pipe from his gas mask protruding from his pack; an extended scene of No Man's Land stretches over half of the page; and a man fires a Lewis gun. Thus, we have the repetition of the mourning soldiers coupled with the heavy artillery firing upon an absent and anonymous enemy. Because the scenes are partial and the soldiers are in silhouette, the viewers must use their imaginations to fill in the targets of the guns. In each case there is some visual question being asked. For instance, at the bottom of the page, the Lewis gun might have been the one to knock the windows from the house and blast the branches from the trees. The power of Clarke's illustration is that it asks viewers questions about responsibility, consequences, and culpability. Rhetorically, Clarke is employing visual anaphora and epistrophe, the repetition of identical or similar figures at the beginning and ends of lines to amplify the illustration and the message behind it.

This page is one of a group that strongly suggests a visual rhetoric of ensnarement, as the vines that twist around the page link the figures and encircle them. At times, the soldiers are partially covered by the heavy foliage, as if a heavy wreath of memory threatens to

obscure the reality of the fighting. For example, the juxtaposition of the winding foliage rinceau and trench at the foot of the page is startling. The elegant lines and swirls of the stems and leaves contrast with the macabre, leaning grave markers. Those crosses, in turn, imply that the living men in the trench are already in a grave. Everything else in the scene is disabled or dead: the trees, the limber, the disabled tank. Looking again, it is clear that the soldier in his Burberry, who mirrors the mourning posture of the soldier at the top of the page, is not looking at a cross; he looks down upon the men in the trench, whose pale, ghostly faces look out at the viewer. Clarke here may have been astutely representing conventions of documentary photography and film from the time. For example, in the 1916 British documentary *The Battle of the Somme*, the soldiers

FIGURE 3.28
Official cameramen were present at the front. Members of Photo Unit G.H.Q. Chaumont. Left to right: Cpl. J.S. Schlick; Pvt. L.S. Pauley; Capt. C. Christie; Sgt. H.A. Nash; Pvt. Jack Estes; Lt. L.J. Rode. Photo credit: US Army Signal Corps, 38524.

IRELAND'S MEMORIAL RECORDS 1914-1918

ABRAHAM, WILLIAM. Reg. No. 27369. Rank, Private, 9th Royal Inniskilling Fusiliers; killed in action, France, July 1, 1916; born Ballinamallard, Co. Fermanagh.

ABRAHAM, WILLIAM GEORGE. Reg. No. 18119. Rank, Lance-Corporal, Machine Gun Corps (Infantry), 1st Batt. (formerly Royal Irish Rifles); killed in action, France, May 21, 1916; born Collon, Co. Louth.

ABRAMS, FREDERICK GEORGE. LEONARD. Reg. No. 9505. Rank, Lance-Corporal, Duke of Cornwall's Light Infantry; killed in action, France, April 23, 1915; born Landport, Hants; age 23.

ABRAMS, HAROLD JAMES. Rank, A.B., Royal Navy, H.M.S. Good Hope; killed in Naval action off Chili, November 1, 1914; age 25.

ABREY, JAMES. Reg. No. 42772. Rank, Rifleman, 12th Royal Irish Rifles; died of wounds, France, August 18, 1917; born Rochford, Essex.

ABSALOM, MATTHEW. Reg. No. 21/1182. Rank, Private, Northumberland Fusiliers (Tyneside Irish); killed in action, France, July 1, 1916; born Bedlington, Northumberland.

ABSOLOM, HARRIS LEE. Reg. No. 17117. Rank, Lance-Corporal, 13th Royal Irish Rifles; killed in action, France, July 1, 1916; born Bangor, Co. Down.

ABSOM, CHARLES STEWART. Reg. No. 305102. Rank, Gunner, Tank Corps; killed in action, France, September 27, 1918; born St. Giles, Edinburgh; decoration, M.M.

ACHESON, JOSEPH. Rank, 2nd Lieutenant, South Lancashire Regiment; died of wounds received in action, June 13, 1918.

ACHESON, THOMAS. Reg. No. 42610. Rank, Private, Machine Gun Corps (Infantry), 1st Batt. (formerly Royal Irish Fusiliers; died of wounds, France, August 19, 1916; born Mitchelstown, Co. Donegal.

ACHESON, VINCENT ANDREWS. Rank, Captain (Temporary), The Royal Inniskilling Fusiliers, 6th Batt. (attached 7th); killed in action, September 10, 1916.

ACHESON, PERCEVAL HAVELOCK. Rank, Major, Army Service Corps; died, April 29, 1916.

ACKERLEY, HAROLD OWEN. Reg. No. 45596. Rank, Rifleman, 1/8th London Regiment (Royal Irish Rifles); killed in action, France, October 3, 1918.

ACKERLEY, JOSEPH. Reg. No. 21810. Rank, Private, 1st Royal Dublin Fusiliers; died of wounds, France, July 2, 1916; born Timperley, Cheshire.

ACKERMAN, THOMAS. Reg. No. 43609. Rank, Private, Royal Inniskilling Fusiliers, 11th Batt.; killed in action, France, August 16, 1917; born Moreton, Inmarsh, Gloucester.

ACKINSON, ROBERT. Reg. No. 40201. Rank, Rifleman, Royal Irish Rifles, 2nd Batt.; killed in action, France, October 22, 1918; born Belfast.

3

FIGURE 3.29

Ireland's Memorial Records 1914–1918. Harry Clarke, illustrator. Dublin: Maunsel and Roberts, 1923. Image courtesy of Eneclann.

on the front lines are aware of the camera. On parade, they cheer and wave. In their daily activities, they crowd to be in the scene. Even German prisoners of war look at the cameraman in wonderment as they are escorted behind the lines.

Plate Two

The second recto plate symbolizes a trinity of technology: camouflage netting, searchlights, and grenades. The central image within the top border presents the field artillery in action. The index to the volumes notes that the eighteen-pounder gun is 'camouflaged with bushes'. Yet, rather than display the artillery in a screen of brush, Clarke chose to illustrate the inventive 'camouflage netting', a technical innovation developed by the French army in 1915. An officer with a megaphone shouts orders, while two soldiers crouch in the undergrowth to the far left, emerging from the interlace foliage. Although a single frame amidst the much larger page, the relationship between the figures offers the viewers the opportunity to read in a series of actions. The sequence suggests that an advance is imminent. Readers must imagine the soldiers moving into the deafening sound of the big guns and the hoarse calls of the commanding officer.

The right border introduces the badge of the 5th (Royal Irish) Lancers; the medal of the French Legion of Honour; and the coats of arms of the four Irish provinces: Ulster, Munster, Leinster, and

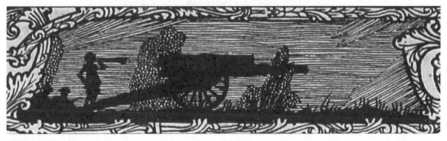

FIGURE 3.30
Camouflage netting. Detail from *Ireland's Memorial Records 1914–1918*. Harry Clarke, illustrator. Dublin: Maunsel and Roberts, 1923. Image courtesy of the Royal Irish Academy.

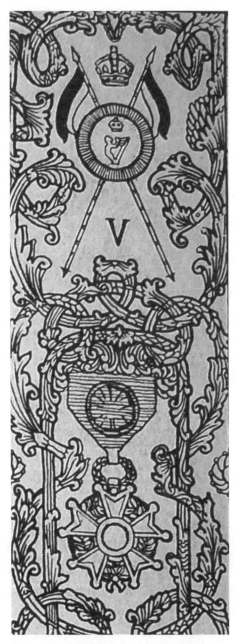

FIGURE 3.31
Badge of the 5th (Royal Irish) Lancers and medal of the French Legion of Honour. Detail from *Ireland's Memorial Records 1914–1918*. Harry Clarke, illustrator. Dublin: Maunsel and Roberts, 1923. Image courtesy of the Royal Irish Academy.

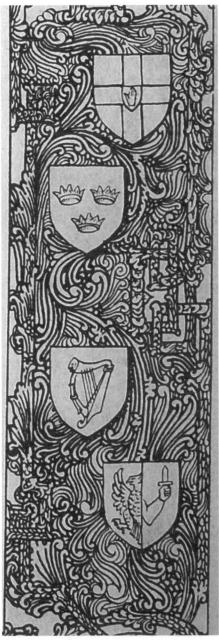

FIGURE 3.32

Coats of arms of Irish provinces. Detail from *Ireland's Memorial Records 1914–1918*. Harry Clarke, illustrator. Dublin: Maunsel and Roberts, 1923. Image courtesy of the Royal Irish Academy.

FIGURE 3.33
Insignia of the Royal Irish Dragoon Guards. Detail from *Ireland's Memorial Records 1914–1918*. Harry Clarke, illustrator. Dublin: Maunsel and Roberts, 1923. Image courtesy of the Royal Irish Academy.

Connaught. Along the left border is the insignia of the Royal Irish Dragoon Guards.

The bottom of the page presents the greatest visual curiosity for its juxtaposition of references and imaginative artistry. A large kangaroo in a circular medallion represents the connection to Australia, particularly an acknowledgement to the shared experiences at Gallipoli. Three grenade throwers in the centre of the page are in a field, searchlights

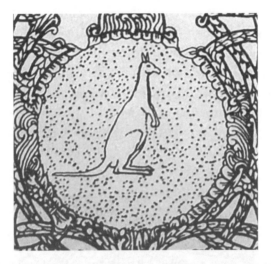

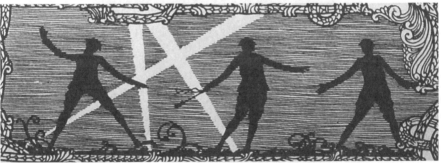

FIGURE 3.34 (top)
Kangaroo. Detail from *Ireland's Memorial Records 1914–1918*. Harry Clarke, illustrator. Dublin: Maunsel and Roberts, 1923. Image courtesy of the Royal Irish Academy.

FIGURE 3.35 (bottom)
Grenade throwers amidst searchlights. Detail from *Ireland's Memorial Records 1914–1918*. Harry Clarke, illustrator. Dublin: Maunsel and Roberts, 1923. Image courtesy of the Royal Irish Academy.

behind them. At the right corner of the page is the badge of the Royal Inniskilling Fusiliers. On this page, the vines have become a thicket, closing in around the four provincial shields. The twisting vines contain four flowers, unifying the idea of four represented by the four provinces. Although stylized, the flowers appear to be two chrysanthemums and two roses.

The three soldiers at the foot of the page may reference the Trinity. Three searchlights behind the soldiers form four crosses, which repeat the concept of four evangelists, four cardinal directions, and four provinces. However, the soldiers are also noticeably like dancers, their poses surprisingly full of life and movement. Similar figures to these three are found in Clarke's window *The Eve of Saint Agnes*, completed in 1922. It's possible that he consulted copies of the army manuals for the correct way of throwing stick and 'cricket ball' grenades. As one manual notes, soldiers were taught to throw as if they were bowling a cricket ball.

FIGURE 3.36
Badge of the Royal Inniskilling Fusiliers. Detail from *Ireland's Memorial Records 1914–1918*. Harry Clarke, illustrator. Dublin: Maunsel and Roberts, 1923. Image courtesy of the Royal Irish Academy.

FIGURE 3.37
Flowers amidst the vines. Detail from *Ireland's Memorial Records 1914–1918*. Harry Clarke, illustrator. Dublin: Maunsel and Roberts, 1923. Image courtesy of the Royal Irish Academy.

It's also likely that Clarke was further exploiting the influences of Leon Bakst and Charlie Chaplin in his art. Chaplin's agile and fanciful 1916 film *The Rink* was shown continually from its release. In it, Chaplin's waiter, fumbling and clumsy at his job in a restaurant, reveals an easy balletic grace on roller skates. The long skating scene in the middle of the film is a virtuoso performance for Chaplin, revealing his ability to sinuously bend and twist while those around him slide and tumble.

The searchlights are another inventive addition to Clarke's catalogue of modern technologies, for they were among the many new electrical technologies used in the First World War, such as the radio. They were important for signalling and navigation; they enabled search parties to find their way across the craters of No Man's Land and revealed opposing forces hidden amidst the obstacles of the battlefield. They can be interpreted Biblically, as well, for at several points in the *Book of Revelations*, 'lightnings and thunderings and voices' (*Revelations* 4:5, King James) add to the foreboding aura of the end of days.

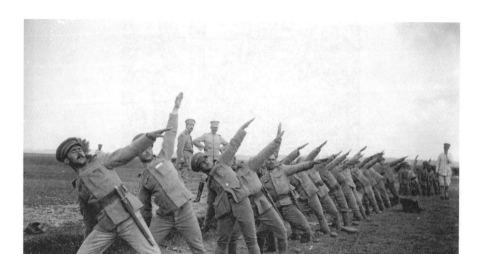

FIGURE 3.38 (top)
Portuguese troops at grenade throwing practice at the Infantry Training School. Marthes, 23 June 1917, photograph by John Warwick Brooke. ©Imperial War Museum Q5557.

FIGURE 3.39 (bottom)
The Rink (1916), directed by Charlie Chaplin, Lone Star Studio, California.

FIGURE 3.40
A German star shell bursting at night at Ploegsteert, March 1916, photograph by Ernest Brooks. © Imperial War Museum Q 445.

Plate Three

Perhaps the most complex plate of the series is that which features the plumed and helmeted soldier. This page incorporates a myriad of scenes and symbols, including two battlefields, a watchful knight, regimental badges, cavalry, and soldiers in the trenches. The densely drawn interlace of this page uses a zoomorphic peacock motif.

The top border of the page depicts an oddly empty and calm V Beach at Suvla Bay. Devoid of ships but with two small silhouettes peering above the parapets, the illustration expresses the mutability of time, a literary motif that dominated war writing. Writers feared and anticipated that at some point the great doings of humans and machines would be forgotten. The poet laureate John Masefield expressed this anxiety in *The Old Front Line*, his book about the battlefields of the Somme in 1916:

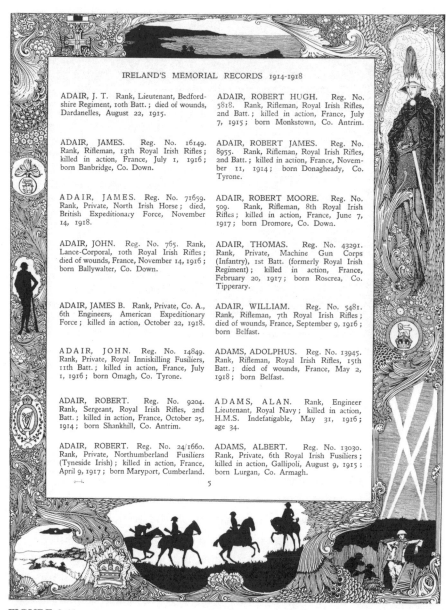

IRELAND'S MEMORIAL RECORDS 1914-1918

ADAIR, J. T. Rank, Lieutenant, Bedford-shire Regiment, 10th Batt.; died of wounds, Dardanelles, August 22, 1915.

ADAIR, JAMES. Reg. No. 16149. Rank, Rifleman, 13th Royal Irish Rifles; killed in action, France, July 1, 1916; born Banbridge, Co. Down.

ADAIR, JAMES. Reg. No. 71659. Rank, Private, North Irish Horse; died, British Expeditionary Force, November 14, 1918.

ADAIR, JOHN. Reg. No. 765. Rank, Lance-Corporal, 10th Royal Irish Rifles; died of wounds, France, November 14, 1916; born Ballywalter, Co. Down.

ADAIR, JAMES B. Rank, Private, Co. A., 6th Engineers, American Expeditionary Force; killed in action, October 22, 1918.

ADAIR, JOHN. Reg. No. 14849. Rank, Private, Royal Inniskilling Fusiliers, 11th Batt.; killed in action, France, July 1, 1916; born Omagh, Co. Tyrone.

ADAIR, ROBERT. Reg. No. 9204. Rank, Sergeant, Royal Irish Rifles, 2nd Batt.; killed in action, France, October 25, 1914; born Shankhill, Co. Antrim.

ADAIR, ROBERT. Reg. No. 24/1660. Rank, Private, Northumberland Fusiliers (Tyneside Irish); killed in action, France, April 9, 1917; born Maryport, Cumberland.

ADAIR, ROBERT HUGH. Reg. No. 5818. Rank, Rifleman, Royal Irish Rifles, 2nd Batt.; killed in action, France, July 7, 1915; born Monkstown, Co. Antrim.

ADAIR, ROBERT JAMES. Reg. No. 8955. Rank, Rifleman, Royal Irish Rifles, 2nd Batt.; killed in action, France, November 11, 1914; born Donagheady, Co. Tyrone.

ADAIR, ROBERT MOORE. Reg. No. 509. Rank, Rifleman, 8th Royal Irish Rifles; killed in action, France, June 7, 1917; born Dromore, Co. Down.

ADAIR, THOMAS. Reg. No. 43291. Rank, Private, Machine Gun Corps (Infantry), 1st Batt. (formerly Royal Irish Regiment); killed in action, France, February 20, 1917; born Roscrea, Co. Tipperary.

ADAIR, WILLIAM. Reg. No. 5481. Rank, Rifleman, 7th Royal Irish Rifles; died of wounds, France, September 9, 1916; born Belfast.

ADAMS, ADOLPHUS. Reg. No. 13945. Rank, Rifleman, Royal Irish Rifles, 15th Batt.; died of wounds, France, May 2, 1918; born Belfast.

ADAMS, ALAN. Rank, Engineer Lieutenant, Royal Navy; killed in action, H.M.S. Indefatigable, May 31, 1916; age 34.

ADAMS, ALBERT. Reg. No. 13030. Rank, Private, 6th Royal Irish Fusiliers; killed in action, Gallipoli, August 9, 1915; born Lurgan, Co. Armagh.

5

FIGURE 3.41
Ireland's Memorial Records 1914–1918. Harry Clarke, illustrator. Dublin: Maunsel and Roberts, 1923. Image courtesy of Eneclann.

FIGURE 3.42
Suvla Bay. Detail from *Ireland's Memorial Records 1914–1918*. Harry Clarke, illustrator.
Dublin: Maunsel and Roberts, 1923. Image courtesy of the Royal Irish Academy.

All wars end; even this war will some day end, and the ruins will be rebuilt and the field full of death will grow food, and all this frontier of trouble will be forgotten. When the trenches are filled in, and the plough has gone over them, the ground will not long keep the look of war. … In a few years' time, when this war is a romance in memory, the soldier looking for his battlefield will find his marks gone.[24]

This page is guarded by a knight who wears what appears to be the parade helmet of the Life Guards, who were part of the Household Cavalry. From other images by Harry Clarke completed at around the same time, the knight appears to be St Hubert, the patron saint of huntsmen. Clarke used St Hubert in the La Touche memorial window in St Patrick's Church, Harristown, County Kildare.[25] The resemblance between the attitude and attributes of the figure in the La Touche window and the *Records* is strong. He may also be St Martin, the patron saint of soldiers and a favourite among French Catholics. His feast day is November 11; this day corresponds to the signing of the Armistice. Both figures wear the same wide-brimmed and plumed helmet. The saint is enclosed by a luxurious swirl of peacock feathers, the symbol of immortality and resurrection, which at some point in the tracery become indistinguishable from the decorative flowers that fall through the page. Most importantly for many viewers of this image, the knight is holding the Papal ferula, the staff particular to the Catholic Church. As his crozier, or shepherd's staff, it amplifies the hunting and flock-tending aspects of this scene, while the eyes of

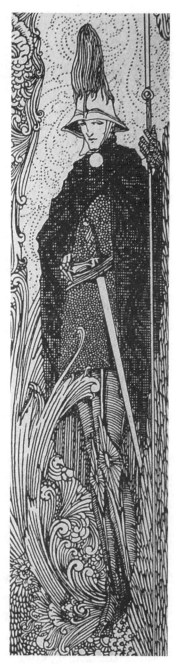

FIGURE 3.43
Helmeted knight. Detail from *Ireland's Memorial Records 1914–1918*. Harry Clarke, illustrator.
Dublin: Maunsel and Roberts, 1923. Image courtesy of the Royal Irish Academy.

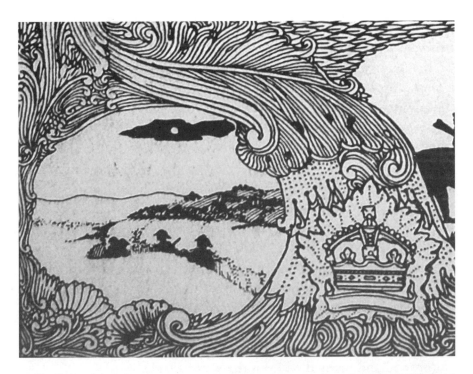

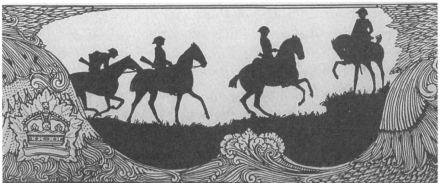

FIGURE 3.44 (top)
Chocolate Hill. Detail from *Ireland's Memorial Records 1914–1918*. Harry Clarke, illustrator.
Dublin: Maunsel and Roberts, 1923. Image courtesy of the Royal Irish Academy.

FIGURE 3.45 (bottom)
Cavalry. Detail from *Ireland's Memorial Records 1914–1918*. Harry Clarke, illustrator. Dublin:
Maunsel and Roberts, 1923. Image courtesy of the Royal Irish Academy.

the peacock's tail feathers represent the omnipotence of God and the benevolence of the Church.

The bottom frieze of this page features three scenes. At the left is a landscape – Clarke's representation of Chocolate Hill, the target of the advance on 5 August 1915 in the Dardanelles Peninsula. Soldiers are shown emerging from a shallow trench. The centre image on the page is of four horses of the cavalry, most likely a direct reference to the 15th Hussars who served at Suvla Bay with the Royal Irish Fusiliers and the Royal Dublin Fusiliers. The figures likely point, as well, to the Four Horsemen of the Apocalypse, as told to St John the Divine and recorded in the *Book of Revelations*: conquest, war, famine, and death. *Revelation* 6: 7-8 reads, 'And power was given unto them over the fourth part of the earth, to kill with sword, and with hunger, and with death, and with the beasts of the earth.' The sword of the passage is given to St Hubert adorned with his cavalry plume. The trials of Gallipoli found parallel in further verses from *Revelations*: 'A third of the sea became blood' (8:9) and 'a third of the waters become wormwood and many died from the water' (8:11).

The five regimental badges on this page include the Military Cross in the top border; the badge of the cavalry troops of the 15th Hussars on the right; the badges of the Royal Dublin Fusiliers (at Suvla Bay with the 16th (Irish) and losing 3,160 in the war) and the Royal Irish Regiment at left; and the badge of the Canadian forces within a maple leaf at the bottom of the page, replicated from a general Canadian Expeditionary Force Army cap badge.

The very detailed trench scene in the lower-right corner of the page is notable for the full view of the soldier, who leans against a trench wall, the dark opening of a dugout behind him. To his right, two shadows crouch under the overhang. He wears a thick scarf, probably knitted by someone at home. The darkened No Man's Land stretches before them, four searchlights are on the horizon. Woven into the interlace is a laddered board that stretches from the trench wall to the viewer. Ladders were used to send soldiers from the front line trenches into No Man's Land, the process known as going 'over the top'. This ladder seems to invite the viewer into the scene, an invitation that is amplified by the face of the soldier looking out at us.

FIGURE 3.46 (top left)
Badge of the 15th Hussars. Detail from *Ireland's Memorial Records 1914–1918*. Harry Clarke, illustrator. Dublin: Maunsel and Roberts, 1923. Image courtesy of the Royal Irish Academy.

FIGURE 3.47 (top right)
Badge of the Royal Dublin Fusiliers. Detail from *Ireland's Memorial Records 1914–1918*. Harry Clarke, illustrator. Dublin: Maunsel and Roberts, 1923. Image courtesy of the Royal Irish Academy.

FIGURE 3.48 (bottom left)
Military Cross. Detail from *Ireland's Memorial Records 1914–1918*. Harry Clarke, illustrator. Dublin: Maunsel and Roberts, 1923. Image courtesy of the Royal Irish Academy.

FIGURE 3.49 (bottom right)
Badge of the Royal Irish Regiment. Detail from *Ireland's Memorial Records 1914–1918*. Harry Clarke, illustrator. Dublin: Maunsel and Roberts, 1923. Image courtesy of the Royal Irish Academy.

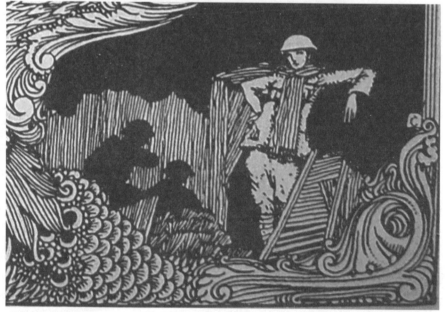

FIGURE 3.50 (top)
Badge of the Canadian forces.Detail from *Ireland's Memorial Records 1914–1918*. Harry Clarke, illustrator. Dublin: Maunsel and Roberts, 1923. Image courtesy of the Royal Irish Academy.

FIGURE 3.51 (bottom)
Soldier leaning against trench wall. Detail from *Ireland's Memorial Records 1914–1918*. Harry Clarke, illustrator. Dublin: Maunsel and Roberts, 1923. Image courtesy of the Royal Irish Academy.

In fact, that soldier is distinctive, for he is the only representation of an infantryman to be depicted in full within Clarke's illustrations for *Ireland's Memorial Records*. Not only are we aware of his full uniform, but he is somewhat insouciant and casual in his pose. Who is he? If we return to Chaplin's 1918 film *Shoulder Arms*, we find three suggestions that perhaps this small figure is based on Chaplin himself, for midway through *Shoulder Arms*, an officer appears wearing an identical thick, hand-knit scarf. After he leaves, Chaplin lounges against the trench wall, calm and unconcerned. Finally, when orders are called to go

FIGURE 3.52
Shoulder Arms (1918), directed by Charlie Chaplin, Chaplin Studios.

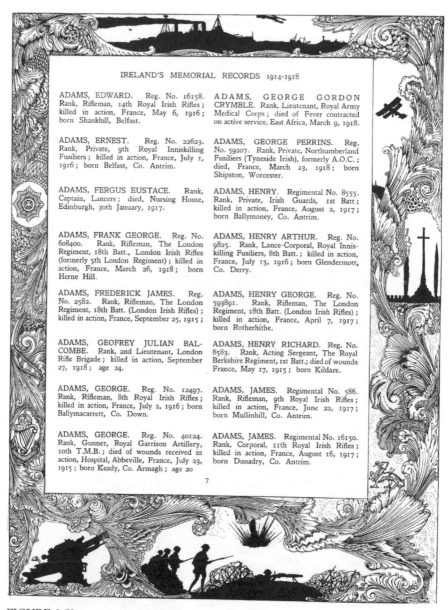

IRELAND'S MEMORIAL RECORDS 1914-1918

ADAMS, EDWARD. Reg. No. 16158. Rank, Rifleman, 14th Royal Irish Rifles; killed in action, France, May 6, 1916; born Shankhill, Belfast.

ADAMS, ERNEST. Reg. No. 22623. Rank, Private, 9th Royal Inniskilling Fusiliers; killed in action, France, July 1, 1916; born Belfast, Co. Antrim.

ADAMS, FERGUS EUSTACE. Rank, Captain, Lancers; died, Nursing Home, Edinburgh, 30th January, 1917.

ADAMS, FRANK GEORGE. Reg. No. 608400. Rank, Rifleman, The London Regiment, 18th Batt., London Irish Rifles (formerly 5th London Regiment); killed in action, France, March 26, 1918; born Herne Hill.

ADAMS, FREDERICK JAMES. Reg. No. 2582. Rank, Rifleman, The London Regiment, 18th Batt. (London Irish Rifles); killed in action, France, September 25, 1915;

ADAMS, GEOFREY JULIAN BAL-COMBE. Rank, 2nd Lieutenant, London Rifle Brigade; killed in action, September 27, 1918; age 24.

ADAMS, GEORGE. Reg. No. 12497. Rank, Rifleman, 8th Royal Irish Rifles; killed in action, France, July 2, 1916; born Ballymacarrett, Co. Down.

ADAMS, GEORGE. Reg. No. 40124. Rank, Gunner, Royal Garrison Artillery, 10th T.M.B.; died of wounds received in action, Hospital, Abbeville, France, July 23, 1915; born Keady, Co. Armagh; age 20

ADAMS, GEORGE GORDON CRYMBLE. Rank, Lieutenant, Royal Army Medical Corps; died of Fever contracted on active service, East Africa, March 9, 1918.

ADAMS, GEORGE PERRINS. Reg. No. 59207. Rank, Private, Northumberland Fusiliers (Tyneside Irish), formerly A.O.C.; died, France, March 23, 1918; born Shipston, Worcester.

ADAMS, HENRY. Regimental No. 8555. Rank, Private, Irish Guards, 1st Batt; killed in action, France, August 2, 1917; born Ballymoney, Co. Antrim.

ADAMS, HENRY ARTHUR. Reg. No. 9825. Rank, Lance-Corporal, Royal Inniskilling Fusiliers, 8th Batt.; killed in action, France, July 15, 1916; born Glendermott, Co. Derry.

ADAMS, HENRY GEORGE. Reg. No. 593891. Rank, Rifleman, The London Regiment, 18th Batt. (London Irish Rifles); killed in action, France, April 7, 1917; born Rotherhithe.

ADAMS, HENRY RICHARD. Reg. No. 8583. Rank, Acting Sergeant, The Royal Berkshire Regiment, 1st Batt.; died of wounds France, May 17, 1915; born Kildare.

ADAMS, JAMES. Regimental No. 586. Rank, Rifleman, 9th Royal Irish Rifles; killed in action, France, June 22, 1917; born Mullinhill, Co. Antrim.

ADAMS, JAMES. Regimental No. 16150. Rank, Corporal, 11th Royal Irish Rifles; killed in action, France, August 16, 1917; born Dunadry, Co. Antrim.

7

FIGURE 3.53

Ireland's Memorial Records 1914–1918. Harry Clarke, illustrator. Dublin: Maunsel and Roberts, 1923. Image courtesy of Eneclann.

over the top, Chaplin bungles with the ladder. Ultimately, Chaplin's recruit crosses into No Man's Land and, through a series of mistaken identities, captures the Kaiser and wins the war.

Plate Four

While the technologies of destruction are evident on other pages, they were often paired with humans, soldiers who hold the guns or throw the grenades. By contrast, this particular plate minimizes the humans and emphasizes the machines: ships, planes, heavy guns, barbed wire, rifles and exploding shells. The planes and ships reference the members of the forces outside of the foot soldiers and cavalry whose names were intended for *Ireland's Memorial Records*. However, due to money and time, the names of those who served in air and sea forces were not listed in full.

At the top of the page, amid stormy seas, a large silhouetted transport ship belches black smoke. The barrels of three heavy guns are visible to the front and the rear. The decorative lines that surround the images on the page are like waves that swirl, froth, and engulf. At the far right of the scene, other vessels crowd toward the shore. Two bi-planes fly low over the fleet.

The right panel is dominated by a silhouette of Sir Reginald Blomfield's Cross of Sacrifice, designed for the Imperial War Graves Commission. This image is identified in the index as 'French military cemetery'. Given the design, however, a more proper appellation would be 'military cemetery, France', for the gravestones are the rounded type used by the Imperial War Graves Commission after

FIGURE 3.54
Transport ship. Detail from *Ireland's Memorial Records 1914–1918*. Harry Clarke, illustrator. Dublin: Maunsel and Roberts, 1923. Image courtesy of the Royal Irish Academy.

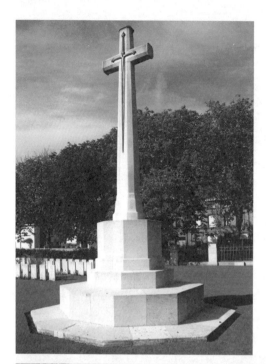

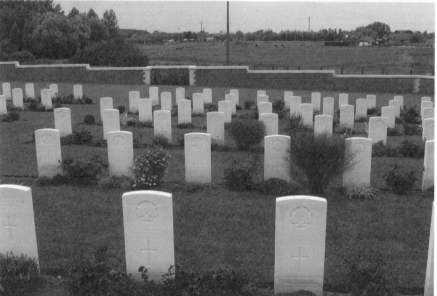

FIGURE 3.55 (top left)
Sir Reginald Blomfield's Cross of Sacrifice, designed for the Imperial War Graves Commission. Ypres Reservoir cemetery. Photo credit: R/DV/RS, 2008. Creative Commons Share-Alike license 2.0.

FIGURE 3.56 (top right)
Cross of Sacrifice. Detail from *Ireland's Memorial Records 1914–1918*. Harry Clarke, illustrator. Dublin: Maunsel and Roberts, 1923. Image courtesy of the Royal Irish Academy.

FIGURE 3.57 (bottom)
Graves at Fromelles (Pheasant Wood) Military Cemetery, Fromelles, France. Commonwealth War Graves Commission.

FIGURE 3.58 (left)
Insignia of the Royal Berkshire Regiment. Detail from *Ireland's Memorial Records 1914–1918*. Harry Clarke, illustrator. Dublin: Maunsel and Roberts, 1923. Image courtesy of the Royal Irish Academy.

FIGURE 3.59 (right)
Airplane flying over a village. Detail from *Ireland's Memorial Records 1914–1918*. Harry Clarke, illustrator. Dublin: Maunsel and Roberts, 1923. Image courtesy of the Royal Irish Academy.

1919. This page also contains a small dragon passant, marked in the index as the insignia of the Royal Berkshire Regiment. No records exist to explain why the Berkshires are included in *Ireland's Memorial Records*.[26] The 3rd (Reserve) Battalion moved to Dublin in 1917, where it was stationed as a training battalion. It's also possible that the Irish National War Memorial Committee received a substantial gift as long as the medallion was included.

FIGURE 3.60
Insignia of the Irish Guards (top) and the Connaught Rangers (bottom). Detail from *Ireland's Memorial Records 1914–1918*. Harry Clarke, illustrator. Dublin: Maunsel and Roberts, 1923. Image courtesy of the Royal Irish Academy.

FIGURE 3.61 (top)
Howitzer. Detail from *Ireland's Memorial Records 1914–1918*. Harry Clarke, illustrator. Dublin: Maunsel and Roberts, 1923. Image courtesy of the Royal Irish Academy.

FIGURE 3.62 (bottom)
Four soldiers cross into a plane covered in large coils of barbed wire. Detail from *Ireland's Memorial Records 1914–1918*. Harry Clarke, illustrator. Dublin: Maunsel and Roberts, 1923. Image courtesy of the Royal Irish Academy.

The inner, left border contains two badges: the insignia of the Irish Guards at the top, and the crowned harp of the Connaught Rangers at the bottom.

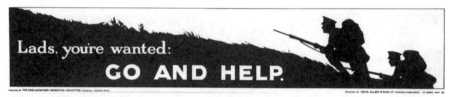

FIGURE 3.63
Lads, You're Wanted: Go and Help. Published by the Parliamentary Recruiting Committee, London. Poster No. 78. Printed by David Allen and Sons Ltd. Harrow. (1915) © Imperial War Museum ART.IWM PST 11714.

The bottom scene is a consistent scroll, in an action-to-action sequence that also suggests an unfolding story. An unmanned howitzer at the left points to the right of the page. Following the trajectory of the floral tracery, which emerges from the barrel of the howitzer as a cloud of smoke, the viewer's eye is led to an exploding shell on the far horizon. Under the barrage, four soldiers cross into a plane covered in large coils of barbed wire. A machine gunner provides covering fire. Clarke is here depicting the method of attack known as the creeping barrage, in which the heavy artillery laid down a carpet of advanced fire to destroy the opposing trenches and keep the combatants under cover. These silhouettes are familiar from the recruiting poster 'Lads, You're Wanted: Go and Help'.

Plate Five

The sombre tone of this page is established by the image of the military cemetery at the top of the page. Like the other military cemetery illustrations, this one mirrors the style of the Imperial War Graves Commission cemeteries in France, Belgium, and other theatres of war.

The right border of the page is given to the display of war medals: the British War Medal of 1914–20 (referred to as the 'Victory Medal' in the index), and the Allied Victory Medal (the 'Allies medal' of the index). From the top, the medals are as follows: the reverse of the British War Medal, showing St George on horseback, trampling on

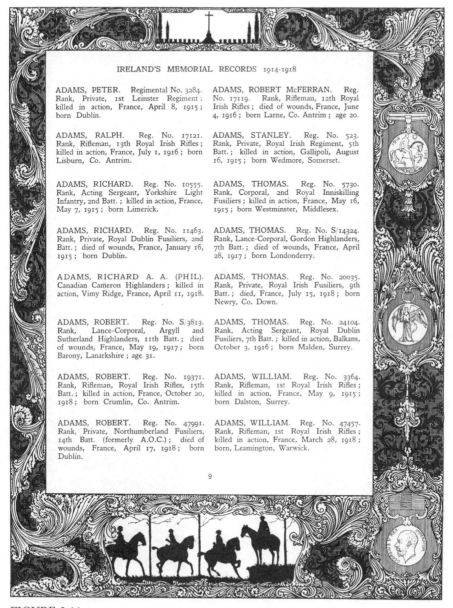

IRELAND'S MEMORIAL RECORDS 1914-1918

ADAMS, PETER. Regimental No. 3284. Rank, Private, 1st Leinster Regiment : killed in action, France, April 8, 1915 ; born Dublin.

ADAMS, ROBERT McFERRAN. Reg. No. 17119. Rank, Rifleman, 12th Royal Irish Rifles ; died of wounds, France, June 4, 1916 ; born Larne, Co. Antrim ; age 20.

ADAMS, RALPH. Reg. No. 17121. Rank, Rifleman, 13th Royal Irish Rifles ; killed in action, France, July 1, 1916 ; born Lisburn, Co. Antrim.

ADAMS, STANLEY. Reg. No. 523. Rank, Private, Royal Irish Regiment, 5th Batt. ; killed in action, Gallipoli, August 16, 1915 ; born Wedmore, Somerset.

ADAMS, RICHARD. Reg. No. 10555. Rank, Acting Sergeant, Yorkshire Light Infantry, 2nd Batt. ; killed in action, France, May 7, 1915 ; born Limerick.

ADAMS, THOMAS. Reg. No. 5730. Rank, Corporal, 2nd Royal Inniskilling Fusiliers ; killed in action, France, May 16, 1915 ; born Westminster, Middlesex.

ADAMS, RICHARD. Reg. No. 11463. Rank, Private, Royal Dublin Fusiliers, 2nd Batt. ; died of wounds, France, January 16, 1915 ; born Dublin.

ADAMS, THOMAS. Reg. No. S/14324. Rank, Lance-Corporal, Gordon Highlanders, 7th Batt. ; died of wounds, France, April 28, 1917 ; born Londonderry.

ADAMS, RICHARD A. A. (PHIL). Canadian Cameron Highlanders ; killed in action, Vimy Ridge, France, April 11, 1918.

ADAMS, THOMAS. Reg. No. 20035. Rank, Private, Royal Irish Fusiliers, 9th Batt. ; died, France, July 15, 1918 ; born Newry, Co. Down.

ADAMS, ROBERT. Reg. No. S/3813. Rank, Lance-Corporal, Argyll and Sutherland Highlanders, 11th Batt. ; died of wounds, France, May 19, 1917 ; born Barony, Lanarkshire ; age 31.

ADAMS, THOMAS. Reg. No. 24104. Rank, Acting Sergeant, Royal Dublin Fusiliers, 7th Batt. ; killed in action, Balkans, October 3, 1916 ; born Malden, Surrey.

ADAMS, ROBERT. Reg. No. 19371. Rank, Rifleman, Royal Irish Rifles, 15th Batt. ; killed in action, France, October 20, 1918 ; born Crumlin, Co. Antrim.

ADAMS, WILLIAM. Reg. No. 3364. Rank, Rifleman, 1st Royal Irish Rifles ; killed in action, France, May 9, 1915 ; born Dalston, Surrey.

ADAMS, ROBERT. Reg. No. 47991. Rank, Private, Northumberland Fusiliers, 14th Batt. (formerly A.O.C.) ; died of wounds, France, April 17, 1918 ; born Dublin.

ADAMS, WILLIAM. Reg. No. 47457. Rank, Rifleman, 1st Royal Irish Rifles ; killed in action, France, March 28, 1918 ; born, Leamington, Warwick.

9

FIGURE 3.64
Ireland's Memorial Records 1914–1918. Harry Clarke, illustrator. Dublin: Maunsel and Roberts, 1923. Image courtesy of Eneclann.

FIGURE 3.65 (top left)
British War Medal (back). Detail from *Ireland's Memorial Records 1914–1918*. Harry Clarke, illustrator. Dublin: Maunsel and Roberts, 1923. Image courtesy of the Royal Irish Academy.

FIGURE 3.66 (right)
British War Medal (front). Detail from *Ireland's Memorial Records 1914–1918*. Harry Clarke, illustrator. Dublin: Maunsel and Roberts, 1923. Image courtesy of the Royal Irish Academy.

FIGURE 3.67 (bottom left)
Allied Victory Medal. Detail from *Ireland's Memorial Records 1914–1918*. Harry Clarke, illustrator. Dublin: Maunsel and Roberts, 1923. Image courtesy of the Royal Irish Academy.

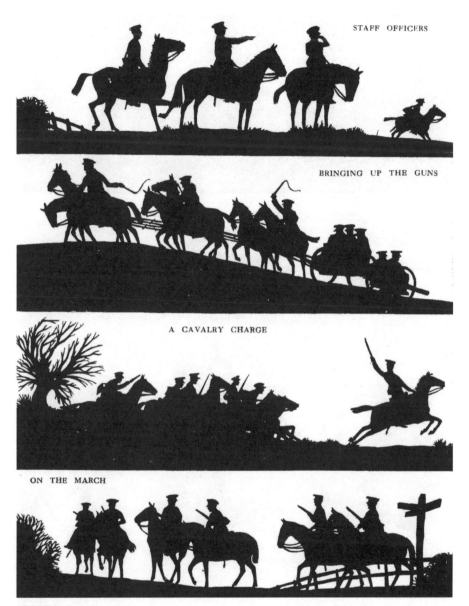

FIGURE 3.68
'Silhouettes of Horses and Men in Wartime' (1916) by Harry Lawrence Oakley. © H. L. Oakley/Mary Evans.

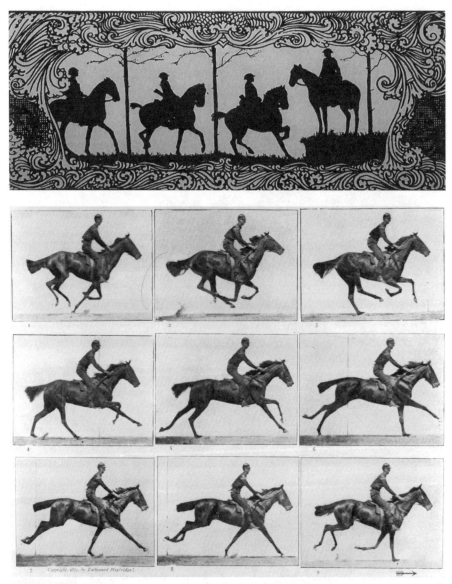

FIGURE 3.69 (top)
Cavalry. Detail from *Ireland's Memorial Records 1914–1918*. Harry Clarke, illustrator. Dublin: Maunsel and Roberts, 1923. Image courtesy of the Royal Irish Academy.

FIGURE 3.70 (bottom)
Eadward Muybridge motion study, demonstrating Clarke's indebtedness to the frame-by-frame analysis of motion. Transverse-Gallop, photograph 1887, from *Animals in Motion*. ART 160193. Photo Credit: Image Select / Art Resource, NY.

the shield of the Central Powers; the front of the Allied Victory Medal; and the front facing of the British War Medal, the full inscription of which should read: GEORGIVS BRITT: OMN: REX: ET: IND: IMP (George V, Omnipotent King of Great Britain and Emperor of India). Clarke has shortened this to Georgius V Rex Imperator – King George V, King-Emperor.

The four horsemen of Plate Three appear again on this page, one of whom mirrors closely the impression of St George on the British War Medal. At this point, the influence of H. L. Oakley is visible once again. This page is always printed with its reverse, giving the parade of cavalry the maximum impact.

With the pairing of the two pages of Plate Five, viewers see clearly the influence of Eadward Muybridge's motion study photography. Clarke's horses adopt different poses; together they offer a sequence of actions in a medium where motion cannot be portrayed. Several horses crossing the plain in different attitudes from different directions allow readers to imagine the movement and sound of the horses, even the confusion of the smoke and dust-filled battlefields.

Plate Six

The twin themes of sacrifice and resurrection are reflected in Plate Six. The Madonna and Child are prominently featured in the right margin. The left margin reproduces, in silhouette, Reginald Blomfield's Cross of Sacrifice. At the bottom of the page, a soldier in breeches and boots stands in silhouette by a graveside. Leaning on the tilted battlefield cross is the tin hat of his comrade.

Insignia appearing at the top of the page are, from the right, the badge of the Tank Corps; the Distinguished Service Order medal, awarded to higher ranks; and the regimental insignia of the Royal Field Artillery. The wide border at the bottom of the page contains the badges of the 8th (Royal Irish) Hussars at the right and the Royal Dublin Fusiliers at the left. While the vignette of the soldier at a graveside can refer to any and all of the dead, it is also possible to trace his line of site over the top of the grave specifically to the badge of the Royal Dublin Fusiliers who suffered so heavily at Gallipoli.

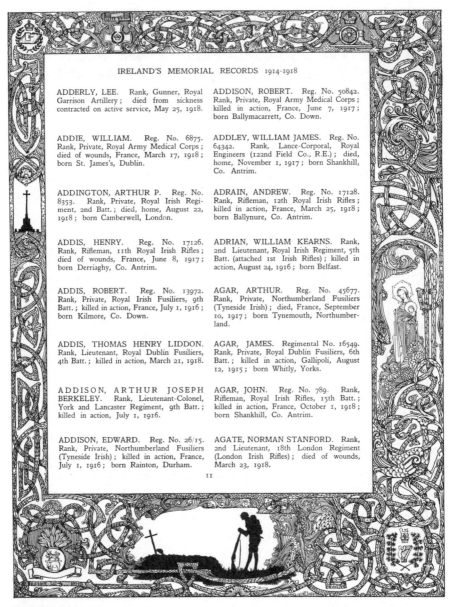

IRELAND'S MEMORIAL RECORDS 1914-1918

ADDERLY, LEE. Rank, Gunner, Royal Garrison Artillery; died from sickness contracted on active service, May 25, 1918.

ADDIE, WILLIAM. Reg. No. 6875. Rank, Private, Royal Army Medical Corps; died of wounds, France, March 17, 1918; born St. James's, Dublin.

ADDINGTON, ARTHUR P. Reg. No. 8353. Rank, Private, Royal Irish Regiment, 2nd Batt.; died, home, August 22, 1918; born Camberwell, London.

ADDIS, HENRY. Reg. No. 17126. Rank, Rifleman, 11th Royal Irish Rifles; died of wounds, France, June 8, 1917; born Derriaghy, Co. Antrim.

ADDIS, ROBERT. Reg. No. 13972. Rank, Private, Royal Irish Fusiliers, 9th Batt.; killed in action, France, July 1, 1916; born Kilmore, Co. Down.

ADDIS, THOMAS HENRY LIDDON. Rank, Lieutenant, Royal Dublin Fusiliers, 4th Batt.; killed in action, March 21, 1918.

ADDISON, ARTHUR JOSEPH BERKELEY. Rank, Lieutenant-Colonel, York and Lancaster Regiment, 9th Batt.; killed in action, July 1, 1916.

ADDISON, EDWARD. Reg. No. 26/15. Rank, Private, Northumberland Fusiliers (Tyneside Irish); killed in action, France, July 1, 1916; born Rainton, Durham.

ADDISON, ROBERT. Reg. No. 50842. Rank, Private, Royal Army Medical Corps; killed in action, France, June 7, 1917; born Ballymacarrett, Co. Down.

ADDLEY, WILLIAM JAMES. Reg. No. 64342. Rank, Lance-Corporal, Royal Engineers (122nd Field Co., R.E.); died, home, November 1, 1917; born Shankhill, Co. Antrim.

ADRAIN, ANDREW. Reg. No. 17128. Rank, Rifleman, 12th Royal Irish Rifles; killed in action, France, March 25, 1918; born Ballynure, Co. Antrim.

ADRIAN, WILLIAM KEARNS. Rank, 2nd Lieutenant, Royal Irish Regiment, 5th Batt. (attached 1st Irish Rifles); killed in action, August 24, 1916; born Belfast.

AGAR, ARTHUR. Reg. No. 45677. Rank, Private, Northumberland Fusiliers (Tyneside Irish); died, France, September 10, 1917; born Tynemouth, Northumberland.

AGAR, JAMES. Regimental No. 16549. Rank, Private, Royal Dublin Fusiliers, 6th Batt.; killed in action, Gallipoli, August 12, 1915; born Whitly, Yorks.

AGAR, JOHN. Reg. No. 789. Rank, Rifleman, Royal Irish Rifles, 15th Batt.; killed in action, France, October 1, 1918; born Shankhill, Co. Antrim.

AGATE, NORMAN STANFORD. Rank, 2nd Lieutenant, 18th London Regiment (London Irish Rifles); died of wounds, March 23, 1918.

11

FIGURE 3.71
Ireland's Memorial Records 1914–1918. Harry Clarke, illustrator. Dublin: Maunsel and Roberts, 1923. Image courtesy of Eneclann.

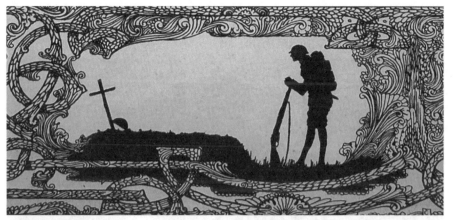

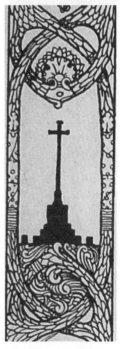

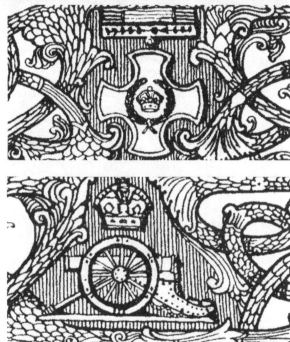

FIGURE 3.72 (top)
Soldier by graveside. Detail from *Ireland's Memorial Records 1914–1918*. Harry Clarke, illustrator. Dublin: Maunsel and Roberts, 1923. Image courtesy of the Royal Irish Academy.

FIGURE 3.73 (bottom left)
Cross of Sacrifice. Detail from *Ireland's Memorial Records 1914–1918*. Harry Clarke, illustrator. Dublin: Maunsel and Roberts, 1923. Image courtesy of the Royal Irish Academy.

FIGURE 3.74 (center right)
Distinguished Service Order medal. Detail from *Ireland's Memorial Records 1914–1918*. Harry Clarke, illustrator. Dublin: Maunsel and Roberts, 1923. Image courtesy of the Royal Irish Academy.

FIGURE 3.75 (bottom right)
Insignia of the Tank Corps. Detail from *Ireland's Memorial Records 1914–1918*. Harry Clarke, illustrator. Dublin: Maunsel and Roberts, 1923. Image courtesy of the Royal Irish Academy.

FIGURE 3.76 (top left)
Insignia of the Royal Field Artillery. Detail from *Ireland's Memorial Records 1914–1918*. Harry Clarke, illustrator. Dublin: Maunsel and Roberts, 1923. Image courtesy of the Royal Irish Academy.

FIGURE 3.77 (top right)
Badge of the 8th (Royal Irish) Hussars. Detail from *Ireland's Memorial Records 1914–1918*. Harry Clarke, illustrator. Dublin: Maunsel and Roberts, 1923. Image courtesy of the Royal Irish Academy.

FIGURE 3.78 (bottom)
Badge of the Royal Dublin Fusiliers. Detail from *Ireland's Memorial Records 1914–1918*. Harry Clarke, illustrator. Dublin: Maunsel and Roberts, 1923. Image courtesy of the Royal Irish Academy.

The interlace pattern is dense. The lines are heavier, with the detail suggesting scales or feathers. There is less white space. The effect is labyrinthine, but a labyrinth without an entrance or a clear path, suggesting disorientation. Yet a labyrinth is not always an ensnarement. In its Christian connotation, such as the labyrinth at the Cathedral of Chartres, the labyrinth represents the passage to divine knowledge and understanding, to the centre where the soul is at one with God. Decorative interlace replicates this patterning on the page of a book, cautioning readers that life may ensnare them with temptation and vice, but that there is ultimate salvation through Christ.

This page is very controlled, the margins being ordered by the centre and the pairing of the Virgin with the cross. As the Mother of God, the Virgin represents all mothers whose sons were sacrificed. This motif of sacrifice is amplified, of course, by Christ's cross on the opposite side of the page. The viewer's eye must travel from Mary to the cross; the names of the dead lie between the two figures as symbolic tombstones. Clarke not only appeals to the Catholic veneration of the Virgin, but to the women of Ireland who, like Mary, once held a child – or knitted a scarf for a loved one in the trenches.

Vines entwine two peacocks, whose feathers trail down the right border. In heraldry, the peacock symbolized resurrection and eternal life. Because the flesh of the peacock was believed to be incorruptible, it was often linked to the Virgin, whose body was incorrupt. Both of the birds are shown in profile. At the top of the page, above the Virgin, the peacock is regardant, looking over its shoulder. Below the Virgin, the peacock passant walks forward. Their attitudes suggest looking to the past and walking into the future.

Finally, looking closely at the descending vine above the cross, we can detect a worm or chrysalis along its inner leaves. There are several possible interpretations of this worm, the first of which is represented by the parable of the gourd in the *Book of Jonah*. Jonah has left the city of Nineveh, the site of present-day Iraq, where he has delivered a warning that the city will be destroyed unless the Ninevites repent. He rests upon a hill above the city:

FIGURE 3.79
Virgin and Child. Detail from *Ireland's Memorial Records 1914–1918*. Harry Clarke, illustrator. Dublin: Maunsel and Roberts, 1923. Image courtesy of the Royal Irish Academy.

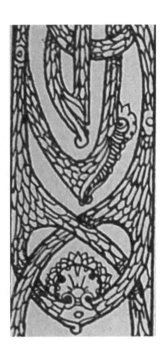

FIGURE 3.80 (left)
Peacock regardant. Detail from *Ireland's Memorial Records 1914–1918*. Harry Clarke, illustrator. Dublin: Maunsel and Roberts, 1923. Image courtesy of the Royal Irish Academy.

FIGURE 3.81 (right)
Chrysalis. Detail from *Ireland's Memorial Records 1914–1918*. Harry Clarke, illustrator. Dublin: Maunsel and Roberts, 1923. Image courtesy of the Royal Irish Academy.

And the LORD God prepared a gourd, and made it to come up over Jonah, that it might be a shadow over his head, to deliver him from his grief. So Jonah was exceeding glad of the gourd. But God prepared a worm when the morning rose the next day, and it smote the gourd that it withered. And it came to pass, when the sun did arise, that God prepared a vehement east wind; and the sun beat upon the head of Jonah, that he fainted, and wished in himself to die, and said, It is better for me to die than to live. (Jonah 4:6-8, King James Version)

The fact that the battles of the Mesopotamian campaign of the First World War were fought on this same ground would not

have escaped Harry Clarke. We see in this parable that God may be benevolent, but also retributive. Just as He is willing to save Nineveh, He is also capable of destroying it; the gourd and the worm reflect this process in microcosm. Jonah, who is buffeted by the torments of the desert winds, wishes to die from his misery, but is reminded that it is God's decision whether he should live or die. Just as he needed to endure the hardship of this trial, the soldiers in Mesopotamia had to suffer the trials of the desert war. Readers of *Ireland's Memorial Records* would understand this reference to mean that life on earth is suffering and the deaths of the soldiers were God's will. The worm reflects the insignificance of humans in the face of the divine.

Yet it is also possible that this small figure might also be a chrysalis, the representation of Christ in his tomb, from which He will rise again. As the *Book of Jonah* also contains the story of Jonah in the belly of the whale – prefiguring Jesus's death and resurrection – the chrysalis amplifies this motif: 'For as Jonah was three days and three nights in the whale's belly; so shall the Son of man be three days and three nights in the heart of the earth' (Matthew 12:40, King James Version). Should it be the chrysalis, it is another symbol of resurrection and eternal life woven into the pattern of this page.

Plate Seven

In the history of illuminated manuscripts, a carpet page was one that contained very little text and was dominated by design. The *Book of Durrow* and the *Lindisfarne Gospels* contain well-known carpet pages with symmetrical, squared designs. The page from *Ireland's Memorial Records* that is largely design is always printed with its reverse, so the pattern covers two pages. Although there are several military-inspired representational images on this page, Clarke largely gives the page over to floral designs, including flowers in his signature style, swirling lines that look like seaweed, and the hint of insects among the vines. They are an ironic juxtaposition with the war scenes, merging nature with the machine.

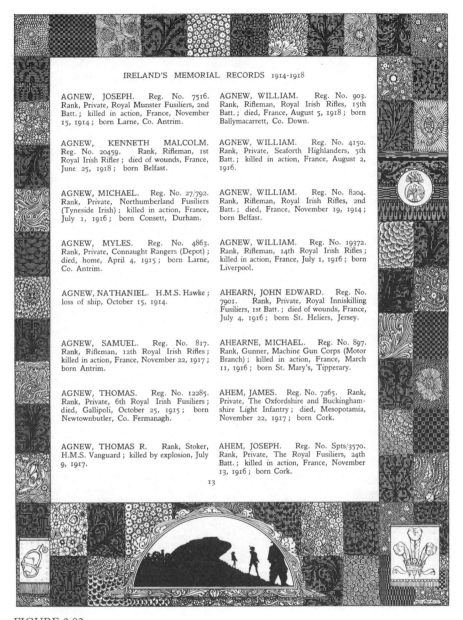

IRELAND'S MEMORIAL RECORDS 1914-1918

AGNEW, JOSEPH. Reg. No. 7516. Rank, Private, Royal Munster Fusiliers, 2nd Batt.; killed in action, France, November 15, 1914; born Larne, Co. Antrim.

AGNEW, KENNETH MALCOLM. Reg. No. 20459. Rank, Rifleman, 1st Royal Irish Rifles; died of wounds, France, June 25, 1918; born Belfast.

AGNEW, MICHAEL. Reg. No. 27/792. Rank, Private, Northumberland Fusiliers (Tyneside Irish); killed in action, France, July 1, 1916; born Consett, Durham.

AGNEW, MYLES. Reg. No. 4863. Rank, Private, Connaught Rangers (Depot); died, home, April 4, 1915; born Larne, Co. Antrim.

AGNEW, NATHANIEL. H.M.S. Hawke; loss of ship, October 15, 1914.

AGNEW, SAMUEL. Reg. No. 817. Rank, Rifleman, 12th Royal Irish Rifles; killed in action, France, November 22, 1917; born Antrim.

AGNEW, THOMAS. Reg. No. 12285. Rank, Private, 6th Royal Irish Fusiliers; died, Gallipoli, October 25, 1915; born Newtownbutler, Co. Fermanagh.

AGNEW, THOMAS R. Rank, Stoker, H.M.S. Vanguard; killed by explosion, July 9, 1917.

AGNEW, WILLIAM. Reg. No. 903. Rank, Rifleman, Royal Irish Rifles, 15th Batt.; died, France, August 5, 1918; born Ballymacarrett, Co. Down.

AGNEW, WILLIAM. Reg. No. 4150. Rank, Private, Seaforth Highlanders, 5th Batt.; killed in action, France, August 2, 1916.

AGNEW, WILLIAM. Reg. No. 8204. Rank, Rifleman, Royal Irish Rifles, 2nd Batt.; died, France, November 19, 1914; born Belfast.

AGNEW, WILLIAM. Reg. No. 19372. Rank, Rifleman, 14th Royal Irish Rifles; killed in action, France, July 1, 1916; born Liverpool.

AHEARN, JOHN EDWARD. Reg. No. 7901. Rank, Private, Royal Inniskilling Fusiliers, 1st Batt.; died of wounds, France, July 4, 1916; born St. Heliers, Jersey.

AHEARNE, MICHAEL. Reg. No. 897. Rank, Gunner, Machine Gun Corps (Motor Branch); killed in action, France, March 11, 1916; born St. Mary's, Tipperary.

AHEM, JAMES. Reg. No. 7265. Rank, Private, The Oxfordshire and Buckinghamshire Light Infantry; died, Mesopotamia, November 22, 1917; born Cork.

AHEM, JOSEPH. Reg. No. Spts/3570. Rank, Private, The Royal Fusiliers, 24th Batt.; killed in action, France, November 13, 1916; born Cork.

13

FIGURE 3.82
Ireland's Memorial Records 1914–1918. Harry Clarke, illustrator. Dublin: Maunsel and Roberts, 1923. Image courtesy of Eneclann.

FIGURE 3.83
Book of Kells, Folio 33r, Carpet Page. Creative Commons Attribution-ShareAlike 3.0 license
Full page (portrait)

The right border contains the cap badge insignia of the Royal Irish Fusiliers. The bottom-right corner contains the distinctive three plumed regimental insignia of the Leinster Regiment, designed as if it has been woven into a banner.

The bottom border embodies an interesting juxtaposition between a broken spur and a tank, two images of the cavalry, one old, one new. As the tank rolls forward, the soldier to the far right of the image is only partially represented. He appears to walk out of the frame. This degree of photorealism adds veracity to the illustration, as similar scenes appear in the 1916 documentary film *The Battle of the Somme*. It is also a sad commentary on the soldiers' fate, erased as a casualty of war.

Plate Eight

Silhouetted grenade throwers appear again across the top of the final plate, reinforcing the inclusive theme of four that has been prevalent throughout the pages. From left to right, one soldier turns away from viewers as he moves backward to throw a hand grenade, a second points his revolver, a third readies his grenade, and the fourth has released the grenade, which floats into the following interlace. While the figures show the influences of the images in training manuals, as well H. L. Oakley's silhouettes and Leon Bakst's costumed dancers for the Ballets Russes, the four frames are mimicking the progression of frames of film, particularly the progression of grenade throwing. Clarke once again draws on Muybridge's innovations and reveals his familiarity with the frame-by-fame mechanics of film as a medium. This knowledge of the art of cinema infuses the illustrations with a forward motion and a series of actions and after-effects.

In the upper-left corner of the page is a gas mask, with the respirator box attached under the hose. Irish soldiers were involved in gas attacks at Second Ypres, April and May 1915. To recreate the sense of the surrounding poisonous fog, Clarke has stippled swirling patterns in to the rinceaux. The pipe of the gas mask uses a design similar to that of the twisting vines, particularly the floral leaf pattern

FIGURE 3.84 (top left)
Badge of the Royal Irish Fusiliers. Detail from *Ireland's Memorial Records 1914–1918*. Harry Clarke, illustrator. Dublin: Maunsel and Roberts, 1923. Image courtesy of the Royal Irish Academy.

FIGURE 3.85 (top right)
Insignia of the Leinster Regiment. Detail from *Ireland's Memorial Records 1914–1918*. Harry Clarke, illustrator. Dublin: Maunsel and Roberts, 1923. Image courtesy of the Royal Irish Academy.

FIGURE 3.86 (bottom)
Tank and soldier. Detail from *Ireland's Memorial Records 1914–1918*. Harry Clarke, illustrator. Dublin: Maunsel and Roberts, 1923. Image courtesy of the Royal Irish Academy.

IRELAND'S MEMORIAL RECORDS 1914-1918

AHERN, RODNEY. Reg. No. 11298. Rank, Driver, 1st Royal Dublin Fusiliers; died of wounds, Gallipoli, August 8, 1915; born High Leas, Portsmouth.

AHERN, THOMAS. Reg. No. 9379. Rank, Private, Royal Dublin Fusiliers, 2nd Batt.; killed in action, France, March 21, 1918; born Newbridge, Co. Kildare.

AHERN, TIMOTHY. Reg. No. 4729. Rank, Private, Royal Munster Fusiliers, 9th Batt.; died of wounds, France, April 3, 1916; born Newcastle West, Co. Limerick.

AHERN, WILLIAM. Rank, Petty Officer, H.M.S. Indefatigable; died, May 31, 1916.

AHERN, WILLIAM. Reg. No. 6045. Rank, Private, Irish Guards, 1st Batt.; killed in action, France, June 18, 1916.

AHERNE, WILLIAM. Reg. No. 10354. Rank, Rifleman, Royal Irish Rifles, 2nd Batt.; killed in action, France, March 31, 1915; born Cork.

AICKEN, JAMES. Reg. No. 1040. Rank, Rifleman, 11th Royal Irish Rifles; killed in action, France, September 1, 1916; born Larne, Co. Antrim.

AIKEN, JAMES. Reg. No. 12504. Rank, Rifleman, Royal Irish Rifles, 15th Batt.; killed in action, France, January 20, 1916; born Shankhill, Co. Antrim.

AIKEN, JOHN. Reg. No. 4464. Rank, Private, Connaught Rangers, 5th Batt.; killed in action, Gallipoli, August 21, 1915; born Aughnish, Ramelton, Co. Donegal.

AIKEN, MAXWELL. Reg. No. 30133. Rank, Private, The Border Regiment, 11th Batt.; died, France, April 23, 1918; born Donaghadee, Co. Down.

AIKEN, WALTER EDMOND. Reg. No. 3396. Rank, Private, 7th Royal Inniskilling Fusiliers; killed in action, France, September 9, 1916; born Ballymacarrett, Co. Down.

AINSCOW, GEORGE ALFRED. Reg. No. 49712. Rank, Private, The Royal Fusiliers, 9th Batt. (formerly 31st (R) Batt., Royal Fusiliers); killed in action, France, September 18, 1918; born Dublin; age 21.

AINSLIE, JOHN ELLIOTT. Rank, 2nd Lieutenant, Royal Scots, 12th Batt.; killed in action, September 28, 1915.

AINSWORTH, HENRY. Reg. No. 4465. Rank, Private, Connaught Rangers, 5th Batt.; killed in action, Gallipoli, August 28, 1915; born Chorley, Lancashire.

AINSWORTH, HERBERT. Reg. No. 29798. Rank, Private, Royal Dublin Fusiliers, 2nd Batt.; killed in action, France, March 21, 1918; born Darwen.

AINSWORTH, JOHN. Reg. No. 40901. Rank, Private, Northumberland Fusiliers (Tyneside Irish), formerly West Yorks Regiment; killed in action, France, October 23, 1917; born East Ardsley, Yorks.

15

FIGURE 3.87

Ireland's Memorial Records 1914–1918. Harry Clarke, illustrator. Dublin: Maunsel and Roberts, 1923. Image courtesy of Eneclann.

FIGURE 3.88
Silhouetted grenade throwers. Detail from *Ireland's Memorial Records 1914–1918*. Harry Clarke, illustrator. Dublin: Maunsel and Roberts, 1923. Image courtesy of the Royal Irish Academy.

just beneath it. Continuing this motif – which we might label 'terrible beauty' after a line from Yeats – some of the leaves and vines have small claws or thorns at the tip.

The right margin contains the insignia of the Royal Munster Fusiliers and an image of an angel holding a laurel wreath, the symbol of victory. Her headdress, wings, and cloak are of peacock feathers, the symbol of royalty. Looking closely, it appears that her necklace is made of shell casings. The left margin includes the regimental insignia for the 5th (Royal Irish) Lancers, repeating it from an earlier plate. Beneath this badge is the Mons Star, which was awarded for service in France or Belgium between 5 August 1914 and 23 November 1914.

FIGURE 3.89
Gas mask. Detail from *Ireland's Memorial Records 1914–1918*. Harry Clarke, illustrator. Dublin: Maunsel and Roberts, 1923. Image courtesy of the Royal Irish Academy.

FIGURE 3.90
Insignia of the Royal Munster Fusiliers. Detail from *Ireland's Memorial Records 1914–1918*. Harry Clarke, illustrator. Dublin: Maunsel and Roberts, 1923. Image courtesy of the Royal Irish Academy.

The bottom frieze is identified in the index as 'silhouette of troops awaiting attack'. The soldier at the right stands with a stick grenade at the ready. His posture suggests that his back is to the viewer. Only one sketch among Clarke's papers might be an early drawing for *Ireland's Memorial Records*. Now in the prints and drawing archive of the National Library of Ireland, this small pencil sketch shows a soldier with a similar pose. In the finished plate, a sentinel emerges from the mist and foliage. The silhouettes of over half a dozen men wait along a ridge or the edge of a copse, perhaps for what Vera Brittain called 'the Last Advance'. A cross divides the scene.

Borderlands

If, as the art historian Michael Camille argues, the margins in illuminated manuscripts are sites of confrontation,[27] where the order of the centre vies for attention with the encircling designs, then the margins of *Ireland's Memorial Records* exploit this idea fully. The centre is the mark of the official record, the list of combatants' names, ranks, places of birth, enlistment numbers, and dates of death. The two columns of text are set with notable order and conformity, using William Morris's Golden Type, celebrated for its clarity and harmony.

FIGURE 3.91
Angel with wreath of victory. Detail from *Ireland's Memorial Records 1914–1918*. Harry Clarke, illustrator. Dublin: Maunsel and Roberts, 1923. Image courtesy of the Royal Irish Academy.

FIGURE 3.92
Insignia for the 5th (Royal Irish) Lancers and the Mons Star. Detail from *Ireland's Memorial Records 1914–1918*. Harry Clarke, illustrator. Dublin: Maunsel and Roberts, 1923. Image courtesy of the Royal Irish Academy.

FIGURE 3.93
'Silhouette of troops awaiting attack'. Detail from *Ireland's Memorial Records 1914–1918*. Harry Clarke, illustrator. Dublin: Maunsel and Roberts, 1923. Image courtesy of the Royal Irish Academy.

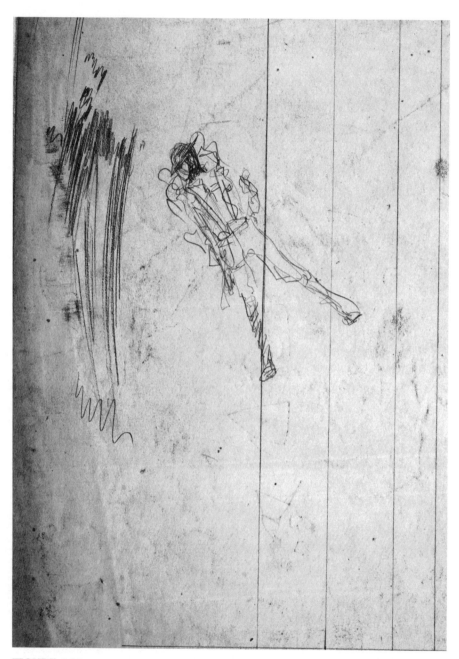

FIGURE 3.94
Pencil drawing of a soldier in uniform (ca. 1919) by Harry Clarke, 33.2 × 47.5 cm. © Image Courtesy of the National Library of Ireland PD 3046 TX 2 (B).

As the *Irish Printers Advertiser* commented, as well, Roberts made excellent use of the white space surrounding the text so that the text was not crowded.

Camille conceptualizes the border as a site where margins 'gloss, parody, modernise and problematise a text's authority'.[28] The borders of *Ireland's Memorial Records* are a liminal space, where the order of the text meets the chaos of battle.[29] Confrontation takes many forms. It is the circumstances that necessitated the *Ireland's Memorial Records*, the confrontation of war, armed combat, and death. It is the continued confrontation of the factions struggling for supremacy in post-Treaty Ireland. It is the need to face the reality of death, when so many lives were lost in the wars. It is the argument over styles, over which artistic style would prevail in the new Ireland. This struggle between looking backward toward the artistic influences of medieval and religious Celticism and the nineteenth-century Arts and Crafts Movement and looking forward to international Modernism and Bauhaus were evidently at the forefront of Clarke's mind. He encodes the illustrations with rhetorics of doubling – mixed styles, multiple meanings, and startling juxtapositions. In *Ireland's Memorial Records*, the past styles never become anachronistic; rather, they are reworked, reborn as an invitation to consider the continuities and ruptures between the distant past, the immediate past, the present, and the future.

Some of the hallmarks of Modernism included pirating popular culture such as Chaplin films, incorporating everyday objects into the work of art, or appropriating objects as art. The iconic urinal by Clarke's contemporary, the French conceptualist Marcel Duchamp, upset the relationship between viewer and work by wresting the urinal from its private, low culture situation and placing it on display in a venerated public venue. While Clarke's work is less extreme, and certainly much less of a parody, it nonetheless confronts the viewer with 'the shock of the new'.

The renowned twentieth-century Russian literary theorist Mikhail Bakhtin called the tension between high and low elements, between official culture and the impromptu and unregulated culture of the streets, between centre and margin, 'carnival'. Bakhtin's writing was

based on the concept of dialogism, that high and low cultures were connected centripetally and centrifugally, each influencing the other. In his writing about adventure and the specific characteristics of stories told in an 'adventure-time', Bakhtin references the fact that the adventure is a series of moments unconnected to real time, moments in which 'one day, one hour, even one minute earlier or later have everywhere a decisive and fatal significance'.[30] Several modern film critics have pointed to the degree to which Chaplin's work exemplifies the traditions of Bakhtin's adventure-time and carnival.[31] And while Michael Camille's work on medieval marginalia disputes that there is a *binary* tension – instead seeing the tension as more diffuse and multifaceted – he cites Bakhtin as an important theoretical precursor for interpreting marginalia. What this means for Clarke's work in *Ireland's Memorial Records* is that the drawings not only borrow from the world of cinema and contemporary popular illustration, but encode various forms of time, from Biblical to modern.

The tense lines and the use of black suggest the frantic hatching of the Modernist German artist Otto Dix more than the ancient *Book of Kells*. The illustrations for *Ireland's Memorial Records* close in on the text. The motion of the interlace pattern swirls toward the ordered and linear block of memorial text, but just as quickly turns away. The figures are often wound into the vines and leaves of the rinceaux; some of the zoomorphic figures are ensnared in the vines. Within the phyllomorphic borders, the battle surrounds the men. Death can come from above or below, from the skies or the ground. The abstract imagery suggests water, waves, clouds, soil, and sand.

The absence of colour in the engravings implies its opposite, a verdant world of home. The soldiers are living and working in a world of perpetually dark skies and mud, their landscape is devoid of features other than a few broken trees and houses. These objects of destruction are in sharp contrast to the implied floral profusion and viney verdant borders. The unruly profusion of greenery hints at the untamed growth of late spring.

The beauty and significance of art is that it allows creators autonomy to express their voices and perspectives. Studies of

marginalia in illuminated manuscripts provide us with language for understanding how artistic borders work as expressions of the illustrator's point of view. As Camille has shown, many illuminated books from the medieval period demonstrate the artist's wit; they abound with visual puns, glosses on the text, parodies, and riddles. Harry Clarke's work as a whole relished just such moments of rupture, points where he might disturb the relationship between viewer and text through a carefully plotted visual joke. The sacred iconography of his stained-glass church windows abound with visual cues about the lives of the saints; however, his secular stained glass, such as the Geneva Window, and the Eve of Saint Agnes roil in ribald humor, sexuality, and the macabre. Thus, we recognize Clarke as an adept, one who is skilled in the technical arts, but who is able to transmit knowledge.

Clarke's son recalls that his father grew up in an atmosphere steeped in the religious fears of the afterlife. As James Joyce relates in the *A Portrait of the Artist as a Young Man*, the youth of Dublin were reminded frequently of the perils of hell that awaited them. Michael Clarke surmises that the priests at Belvedere College

> did make an indelible mark on every sensitive child who listened with care: he would have a grim understanding of the quality of hell and an idealised version of an improbable Paradise. Thus Harry Clarke would carry into the world a comforting picture of the glories of salvation joined inevitably to a fascination with terror of damnation which had particular bearing on those matters of sensual indulgence which his masters constantly trumpeted as a major road to eternal fire.[32]

When Clarke was completing his frankly sexual illustrations for Göethe's *Faust*, he discovered that booksellers were flinching at his drawings. Writing to Thomas Bodkin, Clarke said that they found them 'Lewd & stinking', the kind of things sisters and wives wouldn't care to have in the home. Yet, in a subsequent letter, he also noted,

'tis not a bawdy book – Tis as you say pestilential'. Clarke blamed his vision on being educated at Belvedere.[33]

Legends and the Supernatural

In a much wider context of war history and war literature, *Ireland's Memorial Records* appear to visually represent rumours of war that persisted from 1915 onwards. The interplay between the angels and soldiers, the ethereal imagery and the deeds of humans in battle, is very like the stories of angels who appeared at Mons, Belgium. An abridged version of this story is that at the Battle of Mons in 1914, a cloud built up between the front line of British soldiers and the Germans. From this cloud emerged an angel with the aspect of St Michael, who drove the Germans back to their lines. Other versions of the tale tell of spectral bowmen of the 1415 Battle of Agincourt coming to the rescue of the British soldiers. These stories have an intriguingly intricate history that blends eyewitness testimony, fiction, and fable. It's aptly suited to the interest in the occult and the spiritualist circles that had been increasing since the late nineteenth century. As the literary scholar Paul Fussell writes, the Angels of Mons were part of greater cultural condition that promoted 'superstitions ... wonders, miracles, relics, legends' that attempted to counter the horror of battle and the increasing death toll of the trenches.[34]

Mons was the first major battle of the British Expeditionary Force. Along the southern border of Belgium, cavalry and infantry met a greatly superior force of Germans on 23 August 1914, and despite a strong defense, were forced to retreat. The story of the angels appearing during the retreat seems to have derived from a work of fiction published over a month later in *The London Evening News* on 29 September 1914. This short story was Arthur Machen's 'The Bowmen'. In this tale, when the tide of battle looks especially bleak for British soldiers in an unnamed salient, a heavenly host arrives to save them:

> beyond the trench, a long line of shapes, with a shining about them. They were like men who drew the bow, and

with another shout, their cloud of arrows flew singing and tingling through the air towards the German hosts.[35]

In the short story, the saviour is St George, who 'had brought his Agincourt Bowmen to help the English'.[36] After publication, the story sparked the collective imagination; versions of the tale were published in church newspapers and were told from the pulpit. By the spring of 1915, many insisted that the inspiration for Machen's story was a true account of the front lines. As the scholar David Clarke points out in his study of the legend:

> One of the earliest versions of the rumour has been traced to an issue of *Light* published in London on 24 April 1915 under the headline: 'The Invisible Allies: Strange Story from the Front.' The date of publication is significant, as the feast day of St George was 23 April.[37]

One of the more famous imaginings to arise from the story was a drawing by Alfred Pearse, an illustrator for London's *Strand* magazine. Pearse's rendering of the supernatural encounter is in black and white; amidst a ruined city, two armies face each other and the host of angels wards the danger away.

Clarke's illustrations for *Ireland's Memorial Records* show the influence of Arthur Machen's tale, fanciful as it was. First of all, it shouldn't be supposed that stories of angelic intervention arose with Machen's story from 1914, for they were present in folklore and belief for centuries prior.[38] The glory of Agincourt is a brilliantly evocative and nationalist selection on Machen's part, as it represents a significant heroic moment on the fields of northern France when the few overcame the many, due to courage, bravery, and gallantry. Furthermore, if Machen's story spread throughout the trenches and throughout England, it certainly reached Ireland. We can document that Harry Clarke, W. B. Yeats, and Thomas Bodkin were regular visitors to England during the war years, and it can be assumed from their intellectual circle that topics of the day were readily discussed,

among them, the Angels of Mons. While Clarke's illustrations draw on his own Catholic background, his immersion in ecclesiastical windows, and his knowledge of the war from the news media of the time, it also owes something to the emerging fiction and stories of the war, such as 'The Bowmen'. That religiously-minded women, pastors, and churches took up the story as a patriotic inspiration for their people is not surprising, given that already by 1915 the war was such a desperately different, unheroic undertaking. The people needed something to connect the efforts of men with the Crown and the Church; in other words, amidst the news of the front, they required a sense of a greater purpose beyond patriotism.

It is abundantly evident from Harry Clarke's other illustrations and stained glass that he was well acquainted with the nuances of interpreting texts. He was well read and sensitive to the social and political needs of the time. Like his contemporary James Joyce, he thought deeply about the inherent contradictions of the time, but was also sensitive to the sentiments of his public. Furthermore, in 1919 he supervised the completion of a war memorial window for the Presbyterian Church, Clontarf. Some of the details in this window that reference the war appear in the quatrefoil and cinquefoil windows. On the left, a soldier is shown amidst a fiery explosion, which is rendered with homage to the Vorticists, particularly C. R. W. Nevinson's 1916 painting titled simply *Explosion*. In these uppermost windows, an angel tends to a soldier and another holds a laurel wreath. At the base of the window, another angel cares for a wounded soldier. Clarke used the colours of arms of several regiments in the window, as well. From left to right, these are insignia of the Australian Commonwealth forces, the Royal Munsters, the 13th London Regiment, The Royal Irish Horse, the Connaught Rangers, the West Yorkshire Regiment, the Royal Dublin Fusiliers and the Royal Air Force.

After the First World War, bereaved mothers flocked to spiritualist circles, seeking to contact the spirits of their dead sons or husbands. Under the British government's strict rules that denied repatriating bodies from the battlefields, families were deprived of bodies to

bury and gravesites to mourn beside. The medium's parlour, in the company of other bereaved parents, became a place of mourning. Such spiritualism enters Harry Clarke's work in the form of the spectral figures of silhouetted soldiers and ethereal spirits, entwined in the wreaths of memory.

'He is not missing; he is here,' Field Marshal Plumer said at the unveiling of the Menin Gate in 1927, famous lines that offered a successful deflection from the fact that for close to 200,000 British troops, there were no bodies to be found.[39] But in *Ireland's Memorial Records*, the viewer's movement of the eye towards the margins pushes the reader towards the space of divine intervention, fantasy, and possibility. In this borderland, the soldiers are lithe and whole, they move, flex, are in action. As silhouettes, they take on the promise of being Everyman, everyone's son, husband, or brother. They live in a space that is also home to the very angels that may have saved them on the front. The Unknown Soldier gains his power because of possibility: he fulfils the desire that he might be our own. Just as the angels may refer to the Bible and to the popular rumour of Mons, the silhouettes further contain a Biblical allusion to death, as the *Book of Job* often equates death with 'shadow', as in Job 14:2 in which '[Man] cometh forth like a flower, and is cut down: he fleeth also as a shadow, and continueth not.'

The scenes of war in Clarke's borderlands owe their genesis to the fantastic landscape of traveller's tales, particularly the medieval tales of Pliny, Herodotus, Prester John and Mandeville, all of whom described with great detail places of wonder that they had never seen. So it was that Harry Clarke was charged with a task to describe a place that he had only visited in its prewar state, the area north of Paris, France. Once the roads were lined with avenues of tall trees; by 1918, they were reduced to muddied, pitted trackless wastes, the trees broken and burned. Clarke would have recognized the irony of his task: his memories and sketches of France from 1914 would do him little good in producing a battlefield landscape. He would have to reimagine France from photographs in magazines and newspapers and the Pathé films at the cinema. The even more distant battlefields of Suvla Bay

in the Dardanelles would need to be drawn from reports of travellers and the newsreels.

As Mary Campbell so aptly demonstrated in her scholarly study of maps and travellers' tales, the relation between the divine and the material was never far apart.[40] The concept of a 'design' had theological overtones, signifying that which is 'wondrous', made by God. Yet, in New Testament theology, there were also those things that illustrated the work of demons, abominations and hybrids that portended evil or doom. It is not difficult to find such devices at work in Clarke's illustrations, for the recurrent nobility and beauty of the horse demonstrates the perfection of God's wonders. Yet the horses are archaic, a way of doing battle that was consigned to anachronism from the earliest days of the war on the Western Front. The tank, the airplane, and the battleship on the other hand, are the weapons of modern war. They are also vehicles upon which men ride, but they are monsters of human creation, abominations that bear no relationship to the agrarian life of the fields, to the market economy of small towns, or – like the graceful horse – to the pleasures of race day. In Ireland, tanks and Lewis guns were being used by the Black and Tans and Auxies to put down the resistance movement, which Clarke was certainly alluding to when he incorporated them into his designs. The British ship *Helga* was responsible for shelling Liberty Hall in Dublin on Wednesday 26 April 1916, when it sailed up the Liffey and docked at Eden Quay. The tanks entered Croke Park on Sunday 21 November 1920, and opened fire on the crowd assembled to watch the Gaelic football match. Fourteen civilians were killed that afternoon.

The effect of these images is unsettling precisely because of their double-voiced nature. They do not resolve tensions, nor do they place the machines of war in the past. Clarke was well aware of the irony that the very man who commissioned *Ireland's Memorial Records*, Sir John French, brought the guns and tanks to Ireland in order to kill some of the very men who had fought in Flanders Fields. Training the machine guns on the Volunteers were some of the very men whose comrades were memorialized in *Ireland's Memorial Records*. The machines of war were not historically bound to a past, but were

part of a living present during the period when Clarke worked in his studio on the illustrations for the *Records*.

NOTES

1. G. A. Glaister, *Encyclopedia of the Book* (New Castle, Del.: Oak Knoll Press, 1996), p.333.
2. C. Hutton, (ed.). *The Irish Book in the Twentieth Century* (Sallins: Irish Academic Press, 2004), p.38.
3. 'Splendid Example of Dublin Book-Production,' *Irish Printers' Advertiser*, 3, 3 (July 1924), pp.3–6.
4. March 25, 1926 letter from Carolyn Arnott to Cardinal Gasquet. Volume 9 of *Ireland's Memorial Records, 1914–1918*, British Library, General Reference Collection C.121.f.1.
5. November 16, 1923 letter from P. MacToiney of Mashanaglass to Carolyn Arnott. Original letters are contained in Volume 9 of *Ireland's Memorial Records, 1914–1918*, British Library, General Reference Collection C.121.f.1.
6. H. Jones, 'Church of Ireland Great War Remembrance in the South of Ireland: A Personal Reflection', in J. Horne and E. Madigan (eds), *Towards Commemoration: Ireland in War and Revolution, 1912–1923* (Dublin: Royal Irish Academy, 2013), p.79.
7. H. Jones, 'Church of Ireland Great War Remembrance', p.79.
8. N. G. Bowe, personal communication.
9. P. Callan, '*The Irish Soldier*: A Propaganda Paper For Ireland September – December 1918', *The Irish Sword* 15 (1982), p.67.
10. P. Callan, passim.
11. M. Corcoran, *Through Streets Broad and Narrow: A History of Dublin Trams* (Shepperton: Ian Allan Publishing, 2008).
12. J. Rendell, *Profiles of the First World War: The Silhouettes of Captain H.L. Oakley* (Stroud, Gloucestershire: Spellmount, 2013), pp.9–10.
13. M. Levitch, 'Death and Material Culture: The Case of Pictures During the First World War', in N. Saunders (ed.), *Matters of Conflict: Material Culture, Memory and the First World War* (London: Routledge, 2004), p.94.
14. W. Kaplan, 'Traditions Transformed: Romantic Nationalism in Design, 1890–1920', *Designing Modernity: The Arts of Reform and Persuasion, 1895-1945*, W. Kaplan (ed.), (London: Thames and Hudson, 1995), p.25.
15. E. Sullivan, *The Book of Kells* (London: The Studio, 1914), p.26.
16. E. Sullivan, *The Book of Kells*, p.32.
17. N. G. Bowe, *Harry Clarke*, p.165.
18. E. Sullivan, *The Book of Kells*, p.30.
19. E. Reilly, 'Text and Illustration in Irish Historical Fiction, 1875–1920', *Images, Icons and the Irish Nationalist Imagination, 1870–1925*, L. McBride (ed.), (Dublin: Four Courts, 1999), p.99.
20. E. Reilly, 'Text and Illustration', pp.99-100.

21. J. Sheehy, *The Rediscovery of Ireland's Past: The Celtic Revival, 1830–1930* (London: Thames & Hudson, 1980), p.9.

22. S. Farrell Moran, 'Images, Icons and the Practice of Irish History', *Images, Icons and the Irish Nationalist Imagination 1870–1925* (Dublin: Four Courts, 1999), p.171.

23. M. W. Herren and S. A. Brown, *Christ in Celtic Christianity: Britain and Ireland from the Fifth to the Tenth Century* (Woodbridge, Suffolk: Boydell Press, 2002), p.212.

24. J. Masefield, *The Old Front Line* (New York: Macmillan, 1917), p.1.

25. N. G. Bowe, *Harry Clarke: The Life and Work* (Dublin: History Press Ireland, 2012), p.194.

26. M. McIntyre, Royal Berkshire Museum, Research Enquiry – Royal Berkshire Regiment, Personal communication, 9 March 2014. Email.

27. M. Camille, *Image on the Edge: The Margins of the Medieval Art* (London: Reaktion, 2004), p.9.

28. M. Camille, *Image on the Edge*, p.10.

29. M. Camille, *Image on the Edge*, p.16.

30. M. Bakhtin, *The Dialogic Imagination*, M. Holquist, (ed.), (Austin: University of Texas Press, 1982), p. 94.

31. See, for example, the work of P. Paul, 'Charles Chaplin and the Annals of Anality,' in *Comedy / Cinema / Theory*, A. S. Horton (ed.), (Berkeley: University of California Press, 1991), pp.109–130.

32. Quoted in N. G. Bowe, *Harry Clark*, p.12.

33. Letter from Harry Clarke to Thomas Bodkin (1925), National Library of Ireland, http://dh.tcd.ie.

34. P. Fussell, *The Great War and Modern Memory* (Oxford: Oxford UP, 1975), p.115.

35. A. Machen, 'The Bowmen,' *The Angels of Mons: The Bowmen and Other Legends of the War* (New York: G. P. Putnam's and Sons, 1915), p.29.

36. A. Machen, 'The Bowmen,' p.31.

37. D. Clarke, 'Rumours of Angels: A Legend of the First World War', *Folklore*, 13, 2 (October 2002), p.156.

38. S. Roud, 'Angels,' *The Penguin Guide to Superstitions of England and Ireland* (London: Penguin, 2006).

39. 'First World War', Commonwealth War Graves Commission, http://www.cwgc.org/about-us/history-of-cwgc/first-world-war.aspx.

40. M. B. Campbell, *The Witness and the Other World: Exotic European Travel Writing, 400–1600*. Ithaca: Cornell University Press, 1988, pp.77–86.

A Dirge of Victory

Lord Dunsany Edward Plunkett

Lift not thy trumpet, Victory, to the sky,
Nor through battalions nor by batteries blow,
But over hollows full of old wire go,
Where among dregs of war the long-dead lie
With wasted iron that the guns passed by.
When they went eastwards like a tide at flow;
There blow thy trumpet that the dead may know,
Who waited for thy coming, Victory.

It is not we that have deserved thy wreath,
They waited there among the towering weeds.
The deep mud burned under the thermite's breath,
And winter cracked the bones that no man heeds:
Hundreds of nights flamed by: the seasons passed.
And thou last come to them at last, at last!

IV

Spaces of Memory: *Ireland's Memorial Records* within the Irish National War Memorial Gardens

Full sets of *Ireland's Memorial Records* are located around the world, including libraries in Australia, Belgium, and France. *Ireland's Memorial Records* are also digitized online and in CD format for consultation by genealogists and military historians. As of this writing, digitized records may be accessed for a fee through Origins.net and Ancestry.co.uk, and an open access version through the In Flanders Fields Museum in Ypres, Belgium was announced in January 2014. While the open-access digitized version of *Ireland's Memorial Records* fulfils the vision of the memorial committee to retrieve the names, lost to viewers are the Clarke borders, the typography, and the complete tactile and visual experience of Arts and Crafts design.

Ireland's Memorial Records may be viewed in the space where they were intended to be displayed, the Irish National War Memorial

Gardens in Islandbridge, on the western outskirts of Dublin. Here, the books are kept in the cases that Edwin Lutyens designed for them, 'four books in line on the two side walls of the Book Room with a table in the centre'.[1] Just as Lútyens envisioned, the books 'lie open in locked glass cases'.[2] Memorial spaces such as the Irish National War Memorial Gardens and the First World War memorials at Menin Gate, Tyne Cot, and Thiepval manifest the presence of those who are absent and are meant to foster rituals surrounding death. The premier historian of the cultural aspects of the First World War, Jay Winter, has pointed out in his study of memorials that they 'were places where people grieved, both individually and collectively'.[3] Grief was not only private, but an important public manifestation of allegiance to the war effort and recognition of others' suffering, and thus 'War memorials marked the spot where communities were reunited, where the dead were symbolically brought home, and where the separations of war, both temporary and eternal, were expressed, ritualised, and in time, accepted.'[4] Many writers have addressed how, in Ireland, this process of acceptance was closed off by an official policy of forgetting.

A century later, while there may be an emerging spirit of reconciliation in Ireland, *Ireland's Memorial Records* may be considered objects that represent cultural control. The discourse of sacrifice mark rolls of remembrance as having a privileged value to the state. Books of the dead and war memorials are initiated by those in power, those who have the power to decide 'the society's presentation of itself to itself'.[5]

Furthermore, as lavish and expensive gifts from the state to the people, a response is expected. That the *Records* were reproduced and delivered to cathedrals around Ireland indicates that they were to intended to have ritual significance. As I noted earlier, First World War rolls of remembrance are in fact venerated in England in turning of the page ceremonies. However, as Arjun Appadurai points out, 'situations of extreme hardship' such as war can change the value of an object.[6] Preparing *Ireland's Memorial Records* spanned the Victory and Peace Day celebrations of 1919, and the

Irish Civil War. In that time, the value of *Ireland's Memorial Records* changed dramatically; shifting ideologies and allegiances gave them less value in history and in the daily life of the Irish people.

The books as objects of memory are embroiled in politics. Yet, the political implications are only one way of interpreting the objects. They may be approached as artistic achievements and as physical objects of memory, in which the sensory experience of touch raises its own meanings. Tactile objects, such as battlefield souvenirs, war medals, and photographs objectify grief. As Nicholas Saunders writes, after the First World War, 'the memory of the missing body was replaced by that of the present object' and through the sensation of touch, mourners could have a tangible connection to the spirit of the dead.[7]

Paths of Memory

War memorials take many forms. Some are simple plaques, lists of names of the dead displayed inside churches, businesses, libraries, and schools. Others are large and public, proclaiming a town's grief or a country's recognition of the sacrifice of its dead. These sites, humble or grand, have become places for pilgrimage where relatives and others may reflect upon the consequences of war and the individual struggles or glory of those who served. It was with these higher ideals in mind that a trust fund was created in July 1919 to raise money for the production of *Ireland's Memorial Records*.

In little over one month, by August 1919, the Irish National War Memorial Committee had received £13,000 in public subscriptions.[8] £5,000 of this money would be used for *Ireland's Memorial Records*, which were completed in 1923 and displayed at the Aonach Tailteann exhibit of 1924. The books were distributed to sites in Ireland and England, as well as libraries and religious organizations in several other nations. In Dublin, they found a permanent home at St Patrick's Cathedral and area libraries where the public could consult them. Eventually, over a decade after their publication, they would be integrated into the Irish National War Memorial Gardens at Islandbridge.[9]

Due to political unrest in Ireland between 1919 and the establishment of the Irish Free State, it wasn't until November 1924, five years after the first meeting of a general memorial group, that a committee was formed to settle on a design for a permanent national war memorial. By that time, the committee held over £40,000 in funds from family members of soldiers killed in the Great War. The concepts ranged from a suitable home for demobilized and injured soldiers from the Great War to the refurbishing of Merrion Square as a public park. Integration initiatives for veterans included plans to create 7,000 homes for soldiers in Killester and establish a psychiatric hospital in Leopardstown.[10] The Irish National War Memorial Committee worked on a local level to gather support for the Merrion Square proposition and in 1927 the proposal was approved by the Seanad, but rejected by the Dáil. In the meantime, the British Legion had sponsored several Armistice Day memorial parades and services in the city that drew large crowds to College Green, St Stephens Green, and Phoenix Park.

Eventually, in December 1930, President Cosgrave and Sir Andrew Jameson, the new chair of the Irish National War Memorial Committee, agreed on the present site at Islandbridge. Edwin Lutyens had drawn up initial sketches for the memorial buildings in 1930; the Irish National War Memorial Committee formally adopted the plans on 16 December 1931. A groundbreaking ceremony was held at Islandbridge in December 1931 and work began on the memorial in 1932. In the meantime, Harry Clarke, who it should be noted was not involved with any of the planning or decisions about the Irish National War Memorial Gardens, passed away in Davos, Switzerland. The memorial was essentially complete by 1938 and *Ireland's Memorial Records* were placed in the south-east bookroom, but its official opening was delayed initially because of the potential damage to the plantings on the grounds,[11] and then due to the uncertainty caused by Britain's declaration of war with Germany in 1939. After a period of neglect, the memorial was finally dedicated in 1988. Between 1940 and the formal opening in 1988, the memorial suffered devastating neglect and vandalism. Historian Jane Leonard described the state of the

FIGURE 4.1
Rose garden, fountain, and two bookrooms. Irish National War Memorial Gardens. Photo credit: Osioni, 2008. Wikimedia Commons license.

gardens in the late 1980s, listing dry fountains, graffiti, 'decapitated columns, broken-down hedges, rotted pergolas', and 'horses grazing and dogs being exercised'.[12]

Lutyens's Great Library

One way to think of the National War Memorial at Islandbridge is as a great library, constructed to house copies of Harry Clarke's magnificent books. While it is clear from the committee records that the books were part of the memorial concept from the initial general committee meeting on 17 July 1919, it is also significant that Lutyens's early drawings for the site included a reference to bookrooms on them. In the first (draft) drawing, the bookroom design that is eventually adopted is sketched, and marked with 'Entrance Book Rooms'.[13]The

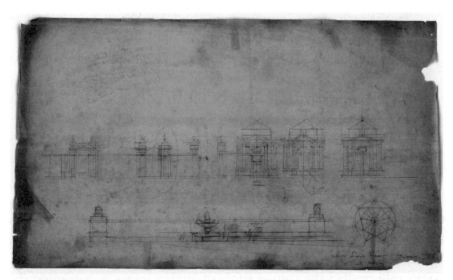

FIGURE 4.2
Entrance to bookrooms, Irish National War Memorial Gardens (1930) by Sir Edwin Lutyens.
DR 20/7 1: 1930. Royal Institute of British Architects Library Drawings & Archives
Collections.

concept is similar to those for the Scottish and Australian national
war memorials. Sir Robert Lorimer, an architect for the Imperial War
Graves Commission, designed the Scottish National War Memorial in
Edinburgh. Located in Edinburgh Castle, the memorial was opened
in 1927. Conceptualized in 1918 and completed in 1941 from a design
by Emil Sodersteen and John Crust, the Australian War Memorial is
library, shrine, and museum, housing rolls of honour, official histories
of the First and Second World Wars, and battlefield relics.

The impulse towards record-keeping may have arisen in post Civil-
War America, as numbers became a way of expressing what words
could not. The historian Drew Gilpin Faust points out that the
statistics from the American Civil War were 'the product of extensive
postwar reconstruction'.[14] She continues,

> Americans encountered the conflict and its death tolls
> predisposed to seek understanding in quantitative terms.

In the face of the immensity of the Civil War's scale and
horror, statistics offered more than just the possibility of
comprehension. Their provision of seemingly objective
knowledge promised a foundation for control in a
reality escaping the bounds of the imaginable. Numbers
represented a means of imposing sense and order on what
Walt Whitman tellingly depicted as the 'countless graves'
of the 'infinite dead'.[15]

The 'meaning of the figures' once assembled was a societal problem
that involved personal and national mourning and reflections on
the meaning of sacrifice. As William Fox commented in 1888, 'The
figures are too large.'[16] Jay Winter, the American historian who has
extensively studied the culture of death and memory surrounding the
First World War, has pointed out that 'The notion of remembering
the dead became critical when there was no place to go, when there
was no body to mourn.'[17] Therefore, the First World War gave rise to
the cult of names. In war memorials you will see them, in churches,
in Germany, all over the world. What matters is the list of the names
in the parish or the town, the school or the university. It is a way of
bringing the bodies back home in a metaphorical sense . Those names
defined families, schools, and businesses that were empty, those with
absences.

The numbers of American Civil War dead were not meant to be
impersonal, but ones that 'possessed a human face'.[18] 'A name upon a
list was like a name upon a grave, a repository of memory, a gesture
of immortality for those who had made the supreme sacrifice.'[19]
Although the United States military pension system required adequate
record-keeping, Faust argues that the need to account for the dead
extended far beyond bureaucracy to encompass the need to honour
the fallen. At this time, individual states began to compile Rolls of
Honour through the auspices of historical societies.

After a long period of decision-making by the committee for the
Irish National War Memorial Gardens, Edwin Lutyens was hired
in 1928 to sketch initial plans. Committee records vary about his

payment; he was paid somewhere between £1589.16.11 and £1,740 for his work in Dublin.[20] Lutyens was one of three official architects of the Imperial War Graves Commission in England. Between 1917 and 1918, this group had established the need for a roll of honour at each of its cemeteries in France, Belgium, Mesopotamia, and other theatres of war. These cemeteries would eventually number in the thousands. In an early letter to the IWGC's director Fabian Ware, Lutyens suggested that, 'Every grave enclosure should be made for permanence and to have one covered permanent building wherein a roll of honour may be kept indelible.'[21] These rolls of honour would be designed by Douglas Cockerell, one of the principal members of the Arts and Crafts publishing and printing industry in the early twentieth century. Cockerell executed the first cemetery registers for the IWGC in 1921 for the Frommelles cemetery, and his pattern and design are extant today. However, there is no evidence that Lutyens and Clarke shared any conversation about *Ireland's Memorial Records* after Clarke received the commission in 1919, despite their meeting in London in 1919 and – potentially – around the time of the Aonach Tailteann in 1924, where *Ireland's Memorial Records* were on display. It's highly likely that Lutyens never saw any copies of *Ireland's Memorial Records* because, in 1936, amidst the latter stages of the design and construction of the Irish National War Memorial Gardens in Dublin, he was surprised to learn that there was more than one book of remembrance.[22]

His confusion is not surprising, given that *Ireland's Memorial Records* are unique as honour rolls. Typical honour rolls are a single volume, covering a cemetery, a regiment, the members of a parish, or the residents of a town. The ambitious scope of *Ireland's Memorial Records* – to cover all the war dead of Ireland – and the attention to design and printing created the eight volumes. Perhaps without the decorative borders, the legible Golden Type, and the wide spacing between entries, there may have only been a single book. Nonetheless, it is surprising that during all the visits that Lutyens made to Ireland to examine the Islandbridge site and to meet with the Irish National War Memorial Committee, no member of the committee thought to show him all eight volumes.

Irish National War Memorial Committee

Ironically, the development of *Ireland's Memorial Records* and the Islandbridge memorial is due to the inception of Field Marshal Sir John Denton Pinkstone French, Lord Ypres. French was the first commander of the British Expeditionary Force, beginning in 1914. Despite clashes with British and French commanders and disastrous advances and retreats, French held his position until late 1915, when he was replaced by Field Marshal Sir Douglas Haig. In French's new post as commander of the Home Forces, he was in charge of supplying troops and ammunition to put down the Easter Rising in 1916.[23]

One of the greater ironies of the Irish Home Rule situation was the appointment of French as Lord Lieutenant of Ireland on 11 May 1918. As even the well-respected historian and biographer Richard Holmes concedes, French has not fared well in histories of the war, and his tenure as Lord Lieutenant was marked by a serious misunderstanding of the Irish people's regard for the dead of the Great War[24] and their support for the nationalist political party Sinn Féin.[25] Installed as Viceroy of Ireland, Lord Lieutenant, in May 1918, French immediately called for the arrest of Arthur Griffith and Éamon deValera, along with seventy-one others, raiding their homes ostensibly for evidence of collaboration with Germany.[26] However, the December 1918 general elections provided a resounding win for Sinn Féin, with seventy-three of 105 seats in Parliament given to the party. The Irish M. P.s refused to sit in London, the parliament of the occupying force.

Eager to impose martial law and conscription on Ireland to remove 'the useless and idle youths and men between eighteen and twenty-four or twenty-five',[27] it was French who, in late 1919, would recruit men from England to serve with the Black and Tans, a supplemental force for the Royal Irish Constabulary, or RIC. Holmes writes that, 'Rebel attacks on the [Irish members of the] RIC, coupled with the intimidation of policemen and their relatives, weakened the structure of the police: the drying-up of information [silence] was particularly damaging to their effectiveness.'[28] French authorized further recruiting

in July 1920, when he 'inaugurated' the Auxiliary Division of the RIC, a group of ex-officers from the Great War who were given 'the status of police sergeants'.[29] It is these two groups – the Black and Tans and the Auxies – who become legendary for their brutality in the story of Irish independence and the annals of the IRA. French even considered using airplanes to carry out surveillance and attacks on the rebel populace in Ireland.[30] On 19 December 1919, French was nearly assassinated by the IRA as he and his convoy made their way to the Viceregal Lodge.

In 1919, the Sinn Féin majority established the first Irish Parliament, the Dáil, and declared an Independent Irish Republic. The IRA was established as the official military of the Sinn Féin political party, with Michael Collins as its leader. Within weeks, the War of Independence was launched, touched off by the Soloheadbeg ambush in County Tipperary on 21 January 1919. Months later, on June 23, RIC District Inspector Hunt was shot by the IRA in Thurles, leading up to the Westminster Cabinet's decision to outlaw Sinn Féin and associated organisations on July 5. Fighting continued throughout the year 1919, in the midst of which Lord French held the first meeting of the Irish National War Memorial Committee in July. When Harry Clarke penned 'Irish Nat Memorials' into his diary for Monday, 29 September 1919, the Dáil had been outlawed by Prime Minister Lloyd George and its members were forced to meet in secret.

The first meeting of the Irish National War Memorial Committee would establish the Irish National War Memorial Fund 'to cover the cost of memorials to the Irish troops at home and abroad'.[31] In the words of the preface to *Ireland's Memorial Records*, French 'made an appeal to the Irish people to signify in an unmistakable way their pride in, and their appreciation of, their brave fellow-countrymen'. French also advocated the establishment of a right-wing political group called 'Comrades of the Great War', which would offer land and a cash benefit to returning soldiers. He also hoped that the Comrades would prevent the returning soldiers from joining up with Sinn Féin. This group would eventually become the British Legion.[32]

The 17 July 1919 meeting that would establish memorial rolls to honour 'the names of Irish Officers and men of all services who had fallen in the war'[33] was part of several formal national events held that week, including a 'Peace Day' parade in Dublin on Saturday 19 July.

FIGURE 4.3
Edwin Lutyens, Cenotaph, London. Photo credit: Godot13, 2014. Creative Commons Attribution Share-Alike 3.0 license.

The day was also celebrated in London by a parade down Whitehall and the unveiling of the Cenotaph designed by Lutyens. July 19 was declared a public holiday in Ireland, and the Union Jack, the American, and the Italian flags were raised over the GPO.[34]

Upon reflection, the Irish National War Memorial Gardens could not hope for an enthusiastic reception. Initiated by French, who had no real feeling for the Irish people and who became obsessed with eradicating the IRA; shepherded by a group of wealthy and politically powerful unionists; connected to the Peace Day military celebrations that triumphantly raised the English flag where the flag of the Republic had flown in 1916; and instigated amidst the turmoil and violence of the War of Independence, the time was not right. The ancient Greeks used a word to describe a propitious moment for action, *kairos*. In the *Rhetoric* of Aristotle, *kairos* refers to what is timely and appropriate, taking into consideration the political and social situation and the predispositions of the audience.[35] In announcing plans for an Irish National War Memorial Gardens, the organizers overestimated their own power and pressed on with a plan amid widespread dissatisfaction, suspicion, and hostility. Genuine sympathy may have existed for the Irish dead of the Great War, but the Irish had domestic issues to resolve in their future and did not need to look towards the past.

However, pressing on under the chairmanship of Sir Dunbar Plunket Barton, the Irish National War Memorial Committee put together an announcement to begin its fundraising efforts:

> The Memorial is to stand in the Capital of Ireland and is destined to keep alive in the hearts of the Irish people for ever, the glorious memory of their heroic dead, who in the world's greatest struggle for freedom, died for the honour of Ireland. The Memorial will be representative of every class and creed, it will include not only the names of the dead who served in Irish Regiments, but of all Irishmen who have fallen, no matter to what Regiments they belonged. It is proposed to erect a building to include

a Record Room which shall contain the names of all Irish Officers and men of the Army, Navy, and Air Force, who fought and fell for their country. To make the Memorial worthy of its lofty object, and a really National one, it is essential that contributions be received from all parts of Ireland.[36]

In another rhetorical miscalculation, the committee ignored a significant area of interpretation: who, in fact, were those 'heroic dead, who ... died for the honour of Ireland'? It must have seemed an affront to those who mourned the sixteen leaders of the Easter Rising, and the other casualties of 1916, who were also struggling 'for freedom'. Despite this demonstrative oversight, they were able to raise £50,000 by 1921, mostly from wealthy patrons. In court records dating from 1926, the cost for *Ireland's Memorial Records* is listed at £5157.14.2, which would have included Clarke's fee, production costs for printing, and fees for binding the books.[37] The remaining subscriptions were held in escrow until the memorial building site and architectural plans could be finalized.

Nonetheless, the War Memorial Committee's announcement established that books of remembrance were central to the conception of the memorial, as the new 'building [would] include a Record Room which shall contain the names of all Irish Officers and men of the Army, Navy, and Air Force, who fought and fell for their country'.[38]

War Memorials

Despite being certain that the books of remembrance would be central to their efforts, the Irish National War Memorial Committee was uncertain about a further physical memorial. Perhaps inspired by the example of the Cenotaph in London, the committee wanted a physical structure. Their initial suggestions included a home or club for demobilized and injured servicemen; refurbishing the privately held Merrion Square as a public park with a pavilion bookroom where *Ireland's Memorial Records* would be held; and a triumphal arch in St Stephen's Green.

Around Ireland, families, parishes, colleges, and businesses were commissioning their own memorials. D'Arcy's comprehensive record of these memorials includes over 1,000 local memorials from all provinces. In Dublin alone, memorial plaques, engravings, and windows include those created for Trinity College, Belvedere College, Guinness brewery, St Ann's Church in Dawson street, and St Patrick's Cathedral.[39] Writing about the Church of Ireland's role in Great War remembrance, Heather Jones suggests that the Protestant community, greatly reduced in size after partition, commemorated their war dead in 'intimate' ways that suggest the centrality of rolls of remembrance to rituals of memory:

> [T]he typical war memorial consisted of a list of names [and] the dead became a spiritual 'text'. Some parishes developed this idea even further by commissioning a roll of honour of those who had served. In the case of St Ann's Church in Dawson Street, Dublin, the names of the war dead and their regiments were inscribed in gold lettering on panels behind the altar – precisely where the Ten Commandments often appeared in other churches.[40]

It is well documented in histories of the post-war period that the creation of the Irish National War Memorial Gardens was a contentious process that dragged on for close to two decades. On 4 December 1937, Lutyens worried that the park had been sidelined by politics, writing to the committee secretary Miss Wilson, 'I have heard nothing about the Memorial ... I thought the Garden of Remembrance was to have been opened in November.'[41] Formally, work on the memorial was completed 27 January 1938, when Lutyens and the local architect T. J. Bryne, representing the Board of Works, signed the official paperwork.[42] There were many attempts, requests, and even demands made to open the memorial park prior to 1938; however, labour strikes and construction delays prevented the official opening. An oft-told tale is that Éamon de Valera refused to open the memorial on anti-unionist political grounds, a concept that locates conflict within Ireland; however, de Valera

recognized that the time for a national commemoration of war dead was hardly appropriate in the face of another European war. Between the end of the war and the dedication in 1988, the Irish National War Memorial Gardens site was neglected, overgrown, and marred by vandals. By 1966, the fifty year anniversary of the Battle of the Somme, Ireland was planning commemorations of the Easter Rising.

Looking back over the process, Jameson referred to the period after 1919 as the 'troubled years', surely one of the great understatements of the decade. In a speech to the Seanad in March of 1927, Jameson explained how it came to be that so many years elapsed between the initial committee meeting in 1919, the publication of *Ireland's Memorial Records*, and the beginning of the Irish National War Memorial Gardens site:

> Then came the troubled years 1920–21–22, in which it was impossible to go on. We then proceeded to collect the records of the men who had fallen. We took some years to do that, and it was a very expensive proceeding, but eventually we got the names of practically all the Irish officers and men in any service who had fallen in the war. We had those records put into shape, and had a few copies of them beautifully bound. One was presented to his Majesty the King, and I believe it is in the British Museum, and I think another copy was presented to His Holiness the Pope; and one to Saint Patrick's [Cathedral]. They have been distributed in places where they are available to everybody. Copies were sent to clubs and other places where relatives of the soldiers can see them easily. That cost about £5,000, and meant years of work. When the times began to settle down, in November 1923, a meeting of the General Committee was held to consider what form the memorial should take.[43]

Edwin Lutyens was not involved in the design process when Merrion Square was proposed as a site for the Irish National War Memorial

Gardens. In 1927, the final debate in the lower house of the Irish Parliament over the siting of the memorial at Merrion Square is intriguing because it points to the significant role of geography in cultural memory and historical narrative. One of the members opposed to the site, Deputy Kevin O'Higgins, who would be assassinated by the IRA four months later, argued:

> You have a square here, confronting [Leinster House] the seat of the Government of the country ... I say that any intelligent visitor, not particularly versed in the history of the country, would be entitled to conclude that the origins of this State were connected with the lives that were lost in the Great War in France, Belgium, Gallipoli and so on. That is not the position. This State has other origins, and because it had other origins I do not wish to see it suggested, in stone or otherwise, that it has that origin.[44]

The Merrion Square Bill was overwhelmingly defeated by the Dáil. Following the rejection of Merrion Square, a second memorial gateway in Phoenix Park was proposed, to be designed by a Frank Scarlett, 'a young English architect working in the University College Dublin School of Architecture'.[45] This monumental stone arc would balance the memorial, Fusilier's Arch, at the north-west corner of the park. This plan, too, was rejected. Sir Dunbar Plunket Barton was quoted in the *Irish Times* as saying at least twelve schemes were suggested and rejected by March 1931. Yet, in September 1931, the government and the Irish National War Memorial Committee had agreed on Islandbridge as the site of the Irish National War Memorial Gardens. As the work was covered in the Press, the deliberations of the Seanad on the memorial were reported, as were oppositions to the site. Sir Dunbar Plunket Barton confessed that Longmeadow Gardens was less than 'an ideal scheme': 'It falls short in several respects of our dreams and aspirations,' he continued, 'but it is an honourable and satisfactory resolution of an extremely difficult problem.'[46] The *Irish Independent* was careful to point out the demands of the site:

The Trustees have been advised that the War Memorial must be something public and visible, such as a monument or a park. In the proposal accepted yesterday, the two are combined. The project of a public park in the centre of the city having proved impracticable, the Government's offer of a site on the bank of the Liffey opposite the Phoenix Park provided the way out of the difficulty. The new park will be in a populous and rapidly extending quarter of Greater Dublin. It will be on high ground, and the imposing War Memorial which will be erected there will be visible for miles around the city.[47]

Around this time, the newspapers circulated the basic details of the war memorial park, which was to cover ten acres and contain 'a great Monolith of Remembrance' and 'the cross, some forty-five feet high', in addition to fountains, terraces, obelisk, 'pavilions for Name Records', and pergolas.[48] Eventually, the idea for the obelisk was absorbed into the design for the temple, and it serves today as the centre pillar for the temple along the river path.[49] In addition, the model and the initial site plans called for additional work on the road surrounding the monument itself: a bridge across the Great Southern Railway at what is now Heuston Station; a footbridge from Phoenix Park; and a 'river bridge,' and gate lodges at the eastern and western entrances. These improvements to the site would ensure access from four directions. Those who are familiar with the area will be able to recognize that there was never any hope of the Irish National War Memorial Gardens being visible for miles around, as Islandbridge lies in the Liffey river valley, at the base of two hills. The south road slopes from Kilmainham while the north slopes from Phoenix Park.

The selection of Inchicore was objected to by parties on either side of the political debate, the British Legion as well as the IRA. The British Legion (Dun Laoghaire branch) called it 'a veritable "no man's land"'.[50]

Yet, despite scattered opposition, work started on 30 December 1931. A photograph in the 31 December 1932 edition of *The Times*

shows digging beginning at the site.[51] The work was commenced with the stipulation that labour be divided, with 50 per cent going to British ex-service men, and 50 per cent to ex-national army men.[52] However, by 9 January 1932, workers threatened a strike over wages, and this slowed progress on the construction of the site.[53]

The contemporary writer Edward Madigan comments on the irony of Islandbridge being chosen as a site of memory of the war, noting that 'Islandbridge was ultimately chosen because it was suitable for a park, and, more importantly because it was remote from the city and from the consciousness of the people.'[54] In one sense, then, the Irish National War Memorial Gardens were prevented from being a site of memory by their location out of the notice of daily life. However, he notes that the memorial's location near 'other iconic sites of memory' in Dublin, makes the site 'highly appropriate', for 'within the same square mile ... the cityscape of Dublin contains a colossal monument to [Wellington] in Phoenix Park and a shrine to Irish republicanism at Kilmainham'.[55]

The work of American historian George Mosse helps to explain some of the incentive behind the creation of memorial spaces after the First World War. In particular, park cemeteries were intended to be pantheistic and regenerative, timeless spaces where nature could induce a sense of peace and healing. As Mosse points out, park and forest cemeteries inspired by the mid-nineteenth century American park cemetery movement 'were meant to displace the thought of death into the contemplation of nature'.[56] In England, J. C. Loudon's 1843 text *The Laying Out, Planting, and Managing of Cemeteries*, promoted the park cemeteries and established the language of cemetery design into the twentieth century. Its prescriptions are evident in the work of the IWGC in France and Belgium, and in the design that Lutyens brought to the memorial in Ireland: order and decorum, straight paths, graves 'laid out in double beds with paths in between'.[57] Plantings of yew trees, associated with English country churchyards, and flowers referenced the pre-industrial, rural Britain that was to die with the war. In addition, in Germany as well as England, 'A rock or boulder was thought especially apt as a monument, singled out a symbolic

of primeval power.'[58] Heroes groves were established in France, Italy, Germany, and England, framing the timeless and the sacred as a space apart.

Debates about War Memorials

In a wider perspective, the debates over the siting of the Irish National War Memorial Gardens and its appropriateness for its time and place were not unique. The very concept of national war memorials and cemeteries developed through the aegis of the Imperial War Graves Commission and was controversial. When, today, we look upon the War Stone at the centre of the Islandbridge Memorial Gardens, we cannot see that Lutyens fought a long artistic battle over its ubiquitous presence in the many cemeteries of the First World War.

The first disagreement with the IWGC came from families of the deceased, who wanted to bring their sons home to bury them in English or Irish soil. The British government forbade the exhumation and reburial, an injunction that was inspired by Fabian Ware, purportedly acting out of a democratic concern that rank and wealth should not influence the dead. He worried that only the wealthiest citizens of the Empire would be able to afford the reburials, leaving cemeteries in France, Belgium, Italy, and further afield to the poorest and lowest ranks.[59] And though one could never argue that Ware was anything but an imperialist, this gesture toward commonality pushed him towards a Labour perspective and set him at odds with the heirs to hereditary privilege, particularly Lord Cecil.

A second issue to arise was an argument over the sacred or secular nature of the iconography, particularly whether to erect a cross in each cemetery and memorial space. Lutyens, influenced by his Theosophist wife Emily and supported by Ware, greatly opposed the idea of the obvious Christian symbol.[60] The impetus behind the War Stone and its engraving was to unite religions in a space that could be broadly interpreted.

Even in the early months of the war, the British government realized that it needed to record and memorialize the dead. At the

outbreak of war in 1914, Fabian Ware had initially been assigned to a mobile branch of the Red Cross, a group of civilian volunteers who retrieved the wounded and buried the dead. With the cataclysm of the war quickly evident, Ware assembled a team and procedures for recording the dead and marking graves. With the overtaking of ground in certain areas and the consistent shelling, the graves were often disturbed and, in some cases, obliterated over the course of the war.[61] Eventually, the role of Ware's team increased so that by 21 May 1917, the British government granted an official charter to create the Imperial War Graves Commission. Planning for cemeteries began almost immediately. In February 1918, Ware recorded that all cemeteries would have a register of those interred.[62]

The Irish National War Memorial Gardens clearly fit into the pattern of British war cemeteries. Together with Sir Reginald Blomfield, Lutyens was responsible for establishing the language of the cemeteries, marked by two symbols of equal and powerful

FIGURE 4.4
Grave of an unknown soldier near Ginchy, September 1916, photograph by Ernest Brooks. © Imperial War Museum Q 1175.

importance: the Stone of Remembrance and the Cross of Sacrifice. Lutyens designed 126 cemeteries for the IWGC [63] and over fifty war memorials.[64] As a consulting architect for the IWGC, he was paid £400 annually.[65] His work for the Irish National War Memorial Committee was an independent commission, not contractually connected to his work for the IWGC. Nonetheless, in Ireland, Lutyens used a similar design to that of the IWGC memorials, which brought aesthetic harmony to the Irish National War Memorial Gardens and British First World War commemorative architecture worldwide.

Lutyens had previous connections to Ireland as an architect. It is often noted that there were general objections to the Irish National War Memorial Gardens because Lutyens was an 'imperial architect'.[66] However, the records of the Oireachtas do not support this contention. Lutyens had worked on four prior architectural projects in Ireland: Lambay Island (1905–12); Heywood Gardens, Laois (1906); Howth Castle (1910–11); and the proposed Hugh Lane Gallery in Dublin (1912). Lutyens had also met Harry Clarke in June 1919 when Clarke and Bodkin had been in London on one of their business trips. While it would be fanciful to think that the two had discussed the war and the appropriate forms of remembrance over their brunch in London on 2 June 1919, the fact that the Irish National War Memorial Gardens bring together these two major artists of the early century, both with ties to the Arts and Crafts Movement, and who had once travelled in the same artistic and social spheres, is significant in itself. Clarke designed a window for Lutyens, the St Julian window, but due to a problem with delivery, the window eventually went to Jane French.[67]

Of all the architects who worked on the war memorials as part of the IWGC, Lutyens's 'romantic and poetic vision' was rooted in the Arts and Crafts Movement, while also being 'inspired by the pure logic of classicism'.[68] The cemeteries are marked by simplicity, elegance, and measured design. As Crane writes, the 'common allegiance to the standards and principles of the Arts and Crafts Movement' . . . 'honesty, simplicity and good design that make the graveyards and memorials successful'.[69] 'The cemeteries, carefully tended, will rely

for their effect on the dignity of their layout and the beauty of the trees, the grass and the flowers,' said Reginald Blomfield in 1920.[70] Lutyens's work at Islandbridge draws heavily on his designs for Heywood Gardens in County Laois: a walled garden, completed in 1912, with plantings designed in collaboration with Gertrude Jekyll. Heywood is an elliptical garden centred on a fountain in a circular pool, surrounded by a ha-ha and rose bushes, with a classical pergola.

Lutyens travelled to France in July 1917 to visit the battlefields and extant cemeteries near the front lines. In addition to Lutyens, the working party for that visit included Charles Aitken (director of the Tate Gallery), the architect Herbert Baker, Colonel Arthur Messer on IWGC staff, Arthur Hill, and Fabian Ware. Lutyens wrote to his wife from Montreuil on 12 July 1917, noting, 'What humanity can endure and suffer is beyond belief':

> The cemeteries, the dotted graves, are the most pathetic things . . . haphazard from the needs of much to do and little time for thought. And then a ribbon of isolated graves like a milky way across miles of country where men were tucked in where they fell. Ribbons of little crosses each touching each across a cemetery, set in a wilderness of annuals and where one sort of flower is grown the effect is charming, easy and oh so pathetic. One thinks for the moment no other monument is needed.[71]

This letter offers an insight into the philosophy of the IWGC – to order chaos. For haphazard and isolated graves, the dead would be collectively replaced into an ordered, peaceful, bounded location that would be, to quote the British poet Rupert Brooke, 'forever England'. Rather than marking the bodies where they fell, the War Graves Commission symbolically reunited them in death with their colleagues. The 'charming' and 'pathetic' effects of the 'wilderness of annuals' would be amplified by formal plantings of roses and yew.

Lutyens designed the great stone that is visible in almost all of the cemeteries, including the memorial at Islandbridge. It is also known

as the War Stone, the Stone of Remembrance. Lutyens proposed 'one great fair stone of fine proportions, twelve feet in length, lying raised upon three steps, of which the first and the third shall be twice the width of the second. ... They should be known in all places and for all time, as the Great War Stones'.[72] One of the features that Lutyens conceived of was that 'each stone shall bear in indelible lettering, some fine thought or words of sacred dedication' and that would come to be the now immortal language offered by Rudyard Kipling, 'their name liveth for evermore'.[73] The Anglican community lobbied for a cross rather than a stone. The Presbyterian objected to the great stone being called an 'altar'. Lutyens was firm in his belief that the stone should represent 'equality of honour, for besides Christians of all denominations, there will be Jews, Mussulmens [Muslims], Hindus and men of other creeds'.[74]

The Stone of Remembrance that would become the defining feature of war grave cemeteries was the second great controversy that the IWGC faced. Sir Frederic Kenyon, hired by Fabian Ware to consult on architecture and design of the cemeteries, agreed that the Stone of Remembrance 'would meet many forms of religious feeling', but it significantly lacked 'the definitely Christian character' that he believed would speak to the majority of the families.[75] For this reason, Kenyon recommended that the committee adopt the cross as the 'central symbol' of sacrifice.[76] Ultimately, Winston Churchill silenced critics of the War Stone in the Westminster Parliament, 1920:

> I have heard it said that the stone of remembrance is a meaningless symbol, not possessing any Christian significance. The stone of remembrance, however, is part of the effort of the Commission to secure a permanent memorial. I have been speaking about periods of 200 or 300 years ago, which, after all, we may make arrangements for as far as we can, but these great stones of which I speak are of Portland stone, weighing about ten tons, with a common inscription, 'Their name liveth for evermore,' and there will be 1,500 or 2,000 of them

FIGURE 4.5
The Stone of Remembrance by Edwin Lutyens, in front of Lutyens's own Cross of Sacrifice.
Irish National War Memorial Gardens. Photo by the author.

on the plains of France alone, and these stones will
certainly be in existence 2,000 or 3,000 years hence. We
know the mutability of human arrangements, but even
if our language, our institutions, and our Empire all
have faded from the memory of man, these great stones
will still preserve the memory of a common purpose
pursued by a great nation in the remote past, and will
undoubtedly excite the wonder and the reverence of a
future age.[77]

Churchill captures the spirit of dissent in his speech, calling to
question the specifically Christian point of view of the War Stone's
critics. He cleverly extends and condenses millions of years, from
the Late Jurassic of Portland stone to three millennia in the
future, when the works of Lutyens 'will certainly be in existence'.
In doing so, he links the great stone with mysterious and timeless
archaeological elements of Stonehenge, Pulnabrone, and the Céide

Fields. However, as a committee ultimately undecided on whether the cross or Stone of Remembrance would be most suitable to the national cemeteries, the outcome was a compromise: each cemetery would contain both.

Tim Skelton points out that Lutyens did not allow the War Stone to be altered in any way, either in size or position relative to the graves, 'with the result that it was omitted from the smaller cemeteries where it was felt that it would be out of scale'.[78] While this may seem capricious, it was no doubt due to the careful mathematical proportions of the stone. Although the faces of the stone appear flat, they are 'actually parts of a sphere with a radius of nine-hundred feet'.[79] This principle is called *entasis*, derived from Greek architecture. In considering the effect of the Cenotaph and the War Stone, the architect Andrew Crompton recalls a line, almost an aside, from Lutyens's letter to his wife Emily in 1917, as he toured the front with Ware. The only suitable memorial he said would be 'a solid ball of Bronze', which would recall the horrible ordnance that had killed so many.[80] The War Stone is that ball, writ large.

Jeroen Geurst describes the War Stone as a 'fragment of two imaginary spheres ... of which one is imagined to be under the ground and the other above. The idea is that the stone is a fragment of a much larger entity ... Lutyens attempts to grasp something huge by realising a fragment of it'.[81] Crompton calls this Lutyens's 'invisible refinement'.[82] Lutyens would later use *entasis* to great effect in the London Cenotaph. Perhaps the purpose of this secret geometry is revealed in a note that Lutyens wrote about the Cenotaph to Sir Alfred Mond in November 1919: in 'setting out of its lines on subtle curvatures, the difference is almost imperceptible, yet sufficient to give it a sculpturesque quality and a life, that cannot pertain to rectangular blocks of stone'.[83]

Geurst writes of the Cenotaph something that could equally be said about the Stone of Remembrance: 'What distinguishes the monument is its stark severity and lack of decoration, which concentrates attention on the overall form.'[84] Although writing about the Cenotaph in particular, Greenburg extends his view of Lutyens's

'stoic view of the tragic destiny of human affairs' to other memorials, noting that the 'modesty and eloquence' of Lutyens's architecture evokes 'a profound acceptance of the reality of death in an unstable world'.[85] In Ireland, working outside an official IWGC commission, Lutyens allowed that the Stone of Remembrance might be thought of as an altar. In a letter to Andrew Jameson dated 6 February 1935, Lutyens wrote: 'I think it would be better to have no Inscription on the Great War Stone, save the Crosses essential to an Altar. The Altar could be blessed and consecrated by the Cardinal Archbishop and by the Anglican Bishop, and the Cardinal Archbishop could celebrate the Mass.'[86] At this point, over a decade after his work with the IWGC, Lutyens was reconciled with the idea that the Stone of Remembrance could contain an engraving of crosses, a modification specific to the Irish memorial. Interestingly, when photographs of the Stone of Remembrance were taken in 1937, there are no engravings of crosses or an inscription.[87] These must have been added sometime after 1950, as today Kipling's words are written in English on the great stone's north face. There are no crosses on the stone, nor is there evidence that an interfaith mass was celebrated there as envisaged.

All war cemeteries of the Imperial War Graves Commission contain common features. Although the Irish National War Memorial Gardens are not and never were intended to be either a cemetery or an official IWGC site, Lutyens nonetheless drew on these features in his designs. Historians note that, 'To all intents and purposes, the cemeteries were gardens.'[88] The sites are surrounded by a low hedge or wall constructed from local stone or brick;[89] a formal entrance gate; pergolas, paths, and benches settled amidst the gardens; the Stone of Remembrance; the cross; classically-styled shelter buildings for 'contemplation and prayer';[90] a cemetery register, 'the list of all of the graves and their occupants that is held inside a box with a bronze door that is usually set within either a gate pier or the shelter building';[91] and copious plantings of roses and deciduous and coniferous trees. Lutyens 'was quite happy to comment upon the horticulture'[92] as well as the architecture. A letter from 1935 to the Irish National War Memorial Committee

in Dublin reveals Lutyens was imaginatively walking through his creation, thoughtfully envisioning mature foliage. He wrote to the War Memorial Committee, 'I think you get greater dignity in any one avenue by keeping all the trees the same and not planting alternately with two varieties; but I feel it would be presumption on my part to raise any question with Sir Frederick Moore and the other gentlemen you have on the Planting Committee.'[93] In addition, Lutyens was cognisant of the need to have all inscriptions in Irish and English, so that 'there would then be no question of precedence, and the Altar and the Cross would become a bond between our two peoples'.[94]

The Islandbridge Site

From the south, the entrance to the memorial park is marked by gates and wide descending steps that lead to the cross. The effect is such that the wide expanse of the memorial extends to the east and west, the right and left, in front of the viewer. The viewer will take in the cross and the War Stone with the descent of the steps, with the Liffey, the life bringing water, beyond to the north. As the viewer moves into the memorial park, the grasses, fountains, bookrooms, and pergolas extend beyond the viewer's periphery to the right and the left in an extended and regular horizontal line that is peaceful and contained.

The Islandbridge memorial is surrounded by both a low wall of local stone and a hedge. The encircling walls harmonize and contain the gardens and features within, while also blending with the landscape outside the memorial area. A series of regular plantings mark the transition from ordinary, daily time to the ceremonial, sacred time of the memorial space. As the wall curves beyond the bookrooms and the rose gardens, it moves out of view, providing a sense of eternity.

One of the features of many of the war memorials around Europe was the duality between the Stone and the cross. The stone was always, forever a feature and it was always, forever designed by Lutyens. The cross, as if in concession to Lutyens occupying this pride of place, was given to Blomfield, who had argued long and hard over its

inclusion in the cemeteries of the IWGC. One thing that is notable about Islandbridge is that the cross is of Lutyens's design. Because he entered this contract as an independent designer, free of the oversight of the IWGC, he was able to create the cross that he desired. The result is harmonious. In it, we see Lutyens's modernist leanings, as well as his classical influences. Particularly notable is that the cross faces two directions: it looks to the River Liffey to the north of the city, while also facing the south.

The cemeteries of the Imperial War Graves Commission are complicated in their message. There is gratitude for the service of so many and a sense of obligation toward the loss of thousands; yet that the recognition of personal and collective sacrifice is coloured by the need to atone for sending so many to certain slaughter. One hundred years later, the war memorials may become spaces for the living. We can think of the Irish National War Memorial Gardens as one such public space, a significant location in which we may consider timeless questions on a personal scale. Visitors to the memorial site in Islandbridge tend to climb the steps of the cross or sit at its base. Pilgrims to the Western Front do the same thing in the war grave cemeteries. Rather than being sacrilegious, it is a very physical way to interact with the environment, making the memorial a true people's park.

After turning the pages of *Ireland's Memorial Records*, after finding the name of the family member who remains in Flanders or Gallipoli, readers may sit on a bench near the fountains. The smell of the roses, the interplay of red, pink, and yellow, and the splash of the falling water is consoling. Falling petals from the roses are smoothed between fingers or placed between the pages of a book. Rising, the visitor descends through the tall stand of trees that drop down to the Liffey.

NOTES

1. Dublin City Archive and Library RDFA 020/043. Letter [original] from Sir Edwin Lutyens, 5 Eaton Gate, London S.W.I to Miss H.G. Wilson, Secretary, Irish National War Memorial Committee, Room No. 7, 102 Grafton Street, Dublin.

2. Dublin City Archive and Library RDFA 020/043, ibid.

3. J. Winter, *Sites of Memory, Sites of Mourning: The Great War in European Cultural History*, (Cambridge: Cambridge UP, 1999), p.79.

4. J. Winter, *Sites of Memory, Sites of Mourning*, p.98.

5. I. Kopytoff, 'The Cultural Biography of Things: Commoditization as Process,' in A. Appadurai (ed.), *The Social Life of Things: Commodities in Cultural Perspective* (Cambridge: Cambridge UP, 1988), p.81.

6. A. Appadurai, *The Social Life of Things: Commodities in Cultural Perspective* (Cambridge: Cambridge UP, 1988), p.14

7. N. Saunders, *Matters of Conflict: Material Culture, Memory and the First World War* (London: Routledge, 2004), p.11, p.14.

8. N. G. Bowe, 'Ireland's Memorial Records, 1914–1918', *Ireland of the Welcomes*, November/December 2006, pp. 18–23.

9. A list of the known locations of *Ireland's Memorial Records* is printed in the appendix to this book.

10. P. Orr, *Field of Bones: An Irish Division at Gallipoli* (Dublin: Lilliput Press, 2006), p.213, 215.

11. 27 Apr 1939 Letter from Secretary, Department of Taoiseach to Secretary, Irish National War Memorial Committee regarding 'altered circumstances', Dublin City Archive and LibraryRDFA/020/108.

12. J. Leonard, 'Lest We Forget', *Ireland and the First World War*, D. Fitzpatrick (ed.), (Dublin: Lilliput Press, 1988), p.68.

13. Royal Institute of British Architects DR 20/7 1: 1930 for both of the drawings.

14. D. Gilpin Faust, '"Numbers on Top of Numbers": Counting the Civil War Dead', *Journal of Military History*, 70, 4, (2006), p.997.

15. D. Gilpin Faust, '"Numbers on Top of Numbers"', p.998.

16. William Fox as quoted in D. Gilpin Faust, '"Numbers on Top of Numbers"', p.1007.

17. J. Winter, 'World War I Created New Culture of Mourning', *Deutsche Welle*, 18 November 2013.

18. D. Gilpin Faust, '"Numbers on Top of Numbers"', p.1007.

19. D. Gilpin Faust, '"Numbers on Top of Numbers"', p.1006.

20. The figures vary as there were additional payments requested. Court documents dating from 1936 request £1589.16.11, Dublin City Archive and Library RDFA/020/055; 7 Dec 1938 Letter from Henry T. Phillips, Secretary, Office of Public Works, Dublin to Messrs. Lambert & Warren, Solicitors, Dublin, transmitting statement of expenditure cites £1,740, RDFA/020/098.

21. T. Skelton and G. Gliddon, *Lutyens and the Great War*, (Frances Lincoln, 2009), p.24.

22. 7 Jan 1936, Letter from E.J. Webb, Secretary to Sir Edwin Lutyens, to Irish National War Memorial Committee, Dublin City Archive and Library RDFA/020/042; 21 Jan 1936 Letter from Sir Edwin Lutyens to Irish National War Memorial Committee, Dublin City Archive and Library RDFA/020/043.

23. R. Holmes, *The Little Field Marshal: A Life of Sir John French* (London: Weidenfeld & Nicolson, 2004), p.310.

24. N. C. Johnson, 'The Spectacle of Memory: Ireland's Remembrance of the Great War, 1919', *Journal of Historical Geography,* 25, 1 (January 1999), p.46.
25. R. Holmes, *The Little Field Marshal,* p.343; pp.347–348.
26. R. Holmes, *The Little Field Marshal,* pp.340-341.
27. R. Holmes, *The Little Field Marshal,* p.343.
28. R. Holmes, *The Little Field Marshal,* p.353.
29. R. Holmes, *The Little Field Marshal,* p.353.
30. R. Holmes, *The Little Field Marshal,* pp.351-2.
31. T. Skelton and G. Gliddon, *Lutyens and the Great War,* p.101.
32. R. Holmes, *The Little Field Marshal,* pp. 344–45.
33. From Dublin City Archive and Library RDFA/020/001: Saorstát Éireann / High Court of Justice / Chancery Judge II / #24-21–16 / 1926.
34. N. C. Johnson, 'Spectacle of Memory', p.44.
35. Aristotle, 4:1 Definition of Rhetoric, *Rhetoric, Stanford Encyclopedia of Philosophy,* http://plato.stanford.edu/entries/aristotle-rhetoric/#4.1.
36. From Dublin City Archive and Library RDFA 020/001: Saorstát Éireann / High Court of Justice / Chancery Judge II / #24-21–16 / 1926
37. Dublin City Archive and Library RDFA/020/001: Saorstát Éireann / High Court of Justice / Chancery Judge II / #24-21–16 / 1926.
38. Dublin City Archive and Library RDFA/020/001: Saorstát Éireann / High Court of Justice / Chancery Judge II / #24-21–16 / 1926.
39. H. Jones, 'Church of Ireland Great War Remembrance in the South of Ireland: A Personal Reflection', in J. Horne and E. Madigan (eds), *Towards Commemoration: Ireland in War and Revolution, 1912–1923* (Dublin: Royal Irish Academy, 2013), pp.78–79.
40. H. Jones, 'Church of Ireland Great War Remembrance', p.79.
41. 10 Dec 1937 Letter from Sir Edwin Lutyens to Irish National War Memorial Committee, Dublin City Archive and Library RDFA/020/078.
42. Certification issued by Sir Edwin Lutyens and T.J. Byrne, Dublin City Archive and Library RDFA/020/084.
43. A. Jameson, speech to the Seanad, Merrion Square (Dublin) Bill, 1927, 9 March 1927; Seanad Éireann Debate, Vol. 8 No. 9.
44. Kevin O'Higgins, speech to the Dáil, Private Business, Merrion Square (Dublin) Bill, 1927, Seanad Resolution, 29 March 1927; Dáil Éireann Debate Vol. 19 No. 5.
45. K. Jeffery, *Ireland and the Great War* (Cambridge: Cambridge UP, 2000), p.116.
46. 'Work at Phoenix Park Nears Completion,' *Irish Times,* 16 April 1934, pp.9–10.
47. 'The War Memorial,' *Irish Independent,* 14 December 1931, p.7.
48. 'Irish National War Memorial, Site and Plan Approved,' *Irish Times* 15 December 1931, p. 7.
49. Royal Institute of British Architects DB24/5.
50. 'Proposed War Memorial', *Irish Independent,* 29 September 1931; 'The National War Memorial,' *Irish Times,* 17 December 1931, p.4.
51. *Irish Times,* 31 December 1932.
52. N. Johnson, *Ireland, the Great War and the Geography of Remembrance* (Cambridge: Cambridge UP, 2003), p.109.

53. N. Johnson, *Ireland, the Great War,* p.109.
54. J. Horne and E. Madigan (eds), *Towards Commemoration: Ireland in War and Revolution, 1912-1923* (Dublin: Royal Irish Academy, 2013), p.3.
55. J. Horne and E. Madigan (eds), *Towards Commemoration,*p. 3.
56. G. Mosse, *Fallen Soldiers: Reshaping the Memory of the Great War* (Oxford: Oxford UP, 1991), p.43.
57. G. Mosse, *Fallen Soldiers,* p.44.
58. G. Mosse, *Fallen Soldiers,* p.88.
59. D. Crane, *Empires of the Dead* (London: Collins, 2013), p.72.
60. D. Crane, *Empires of the Dead,* pp.112-114.
61. D. Crane, *Empires of the Dead,* 30-58.
62. D. Crane, *Empires of the Dead,* p.129.
63. J. Geurst, *Cemeteries of the Great War by Sir Edwin Lutyens* (Rotterdam: nai010 Publishers, 2013), p.64.
64. T. Skelton, 'Remembering the Great War with Lutyens', *British Archaeology* 109 (2009).
65. T. Skelton, 'Remembering the Great War with Lutyens'.
66. Dublin City Gallery, The Hugh Lane. *Dublin Divided: September 1913* (Dublin: Hugh Lane, 2013).
67. N. G. Bowe, *Harry Clarke,* p.163.
68. E. Wilhide, *Sir Edwin Lutyens: Designing in the English Tradition* (New York: Abrams, 2000), p. 24, p. 9.
69. D. Crane, *Empires of the Dead,* p.121.
70. D. Crane, *Empires of the Dead,* p.121.
71. T. Skelton and G. Gliddon, *Lutyens and the Great War,* p.25.
72. Lutyens quoted in D.Crane, *Empires of the Dead,* p.110.
73. Lutyens quoted in D. Crane, *Empires of the Dead,* p.110.
74. Lutyens quoted in D. Crane, *Empires of the Dead,* p.113.
75. Kenyon quoted in D. Crane, *Empires of the Dead,* p.127.
76. Kenyon quoted in D. Crane, *Empires of the Dead,* p.128.
77. House of Commons, Imperial War Graves Commission. HC Deb 04 May 1920 vol 128 cc1929-72; D. Crane, *Empires of the Dead,* p.165.
78. T. Skelton, 'Remembering the Great War with Lutyens'.
79. A. Crompton, 'The Secret of the Cenotaph,' cromp.com,p.4.
80. D. Crane, *Empires of the Dead,* p.110.
81. J. Geurst, *Cemeteries of the Great War by Sir Edwin Lutyens* (Rotterdam: nai010 Publishers, 2013), p.76, p.78.
82. A. Crompton, 'The Secret of the Cenotaph,' cromp.com,p.5.
83. A. Greenburg, 'Lutyens's Cenotaph', *Journal of the Society of Architectural Historians,* 48, 1, (March 1989), p.11.
84. J. Geurst, *Cemeteries of the Great War,* p.75.
85. A. Greenberg, 'Lutyens's Cenotaph', p.20.
86. 6 February 1935 Letter from Sir Edwin Lutyens to Sir Andrew Jameson, Dublin City Archive and Library RDFA/020/026.

87. See, for example, Figure 112 'The Stone of Remembrance' in C. Hussey, *The Life of Sir Edwin Lutyens* (London: Country Life, 1953).
88. T. Skelton and G. Gliddon, *Lutyens and the Great War*, p.123.
89. T. Skelton and G. Gliddon, *Lutyens and the Great War*, p.118.
90. T. Skelton and G. Gliddon, *Lutyens and the Great War*, p.119.
91. T. Skelton and G. Gliddon, *Lutyens and the Great War*, p.122–123.
92. T. Skelton and G. Gliddon, *Lutyens and the Great War*, p.114.
93. 6 November 1935 Letter from Sir Edwin Lutyens to Irish National War Memorial Committee, Dublin City Archive and Library RDFA/020/038.
94. 6 Feb 1935 Letter from Sir Edwin Lutyens to Sir Andrew Jameson, Dublin City Archive and Library RDFA/020/026.

Afterword

Myles Dungan

If, as Marguerite Helmers suggests, *Ireland's Memorial Records* are 'a document designed to bridge the two faiths' in that 'the elaborate drawings of martyred soldiers amidst the instruments of their torture and demise speak to the traditions of Catholic iconography, while the list of names of the dead is a canonical feature of Church of Ireland and Church of England remembrance' then it has to be said that the Roman Catholic Church got by far the better part of the bargain. While the iconography is *non pareil*, the listing of names is defective and internally inconsistent.

It is now possible to consult the Irish National War Memorial Records without being exposed to the exquisite work of Harry Clarke that dominates the printed version of this flawed document. This is both a shame and a blessing. The availability of the data in the online version[1] of *Ireland's Memorial Records* bypasses Clarke's magnificent designs. In a sense, Clarke's work was the only absolute truth contained within the Books of the Dead. The online image made available when a request for information is inputted graphically illustrates, in its own way, the deficiencies of the *Records*. While Clarke's illustrations – the 'site of confrontation' (Michael Camille) – are full and imaginative, the physical gaps, as visually obvious in the online record as are Clarke's immaculate drawings in the printed version, highlight the flaws in the data contained within the lush borders created by the artist. Clarke's illustrations might well 'problematise [the] text's authority' (Camille) had the text not already been highly problematic.

There have been many criticisms of the digitized version of *Ireland's Memorial Records,* not least because they exclude the most successful

element of the original: the work of Clarke. But the online *Ireland's Memorial Records* cannot be expected to rise above one of the axioms of the digital age, namely the fabled acronym, GIGO – 'garbage in, garbage out'. The basic information obtainable from the original records is strewn with errors, assembled with an agenda that went far beyond the taxonomical, and guilty of egregious sins of omission. The shortcomings of *Ireland's Memorial Records* can only be rectified by a project designed to sweep aside the agenda, correct the errors and deal with the omissions. There seems to be little support for such a venture. This may change, and if it does we may yet get a comprehensive, but not entirely flawless, record – such an outcome is not feasible – for future generations.

The apparent desire of Eva Barnard and her colleagues to embellish Ireland's 'contribution' to the Great War by choosing to include all combatants with Irish military units did this country a huge disservice. The same is true of the half-hearted attempt to include Irishmen who died in the service of forces other than that of the United Kingdom (I dislike the use of the description 'The British Army' – it was far from bring British). I have counted barely 120 such names in the *Records*, as against almost 1,000 Irish-born combatants who died in the Australian forces alone.[2] None of the Irish women who had died in the course of their duties near the battlefronts were included either. Neither were Irishmen who had died in the Mercantile Marine. Nor were many Irishmen who died of wounds at home rather than on the actual battlefield.

According to one reliable calculation, only 30,986 of the names recorded in *Ireland's Memorial Records* are of men born in Ireland.[3] More than 11,000 fatalities were included by Barnard and her associates by virtue of the fact that they fell while serving in Irish units, mostly in the 10th, 16th and 36th Divisions. She then, of course, conveniently had it both ways by including a number of Irishmen who had fallen while serving in British regiments. This group, however, is also far from exhaustive. A third category lists the names of 7,405 men who are of unknown origin. These include, to cite but three of the most egregious examples, the former Irish Party MP, Tom Kettle

(from Dublin), the first Victoria Cross winner of the war Maurice Dease (born in Westmeath), and the Greystones cleric Everard Digges La Touche.

The picture is further complicated when even a cursory study is made of a cross-section of the 2,600 men buried in Commonwealth War Graves Commission (CWGC) graves in 681 cemeteries in the Republic of Ireland and Northern Ireland. Some, a very small percentage, are not Irish. But, after some rudimentary research, it is clear that many of those Irishmen whose graves here are tended by the Office of Public Works on behalf of the Commonwealth War Graves Commission have not found their way into the Irish National War Memorial Records. The cut-off date for *Soliders Died in the Great War* and *Officers Died in the Great War*, would have contributed to this anomaly.

A number of local Irish historians (Brian Scanlon in Sligo, Margaret Connolly in Leitrim, Mark Scott in Fermanagh, Michael Feeney in Mayo, Noel French in Meath and Tom Burnell starting with Tipperary before spreading his wings to a number of other counties) have uncovered further discrepancies in *Ireland's Memorial Records*. For example, in the case of Sligo 395 names are recorded in the eight volumes. To date, Brian Scanlon has identified and verified 548 deceased veterans. 694 men from Mayo are listed in *Ireland's Memorial Records*. The poignantly beautiful Great War Memorial Wall in the Peace Park in Castlebar contains more than 1,100 names. Some, but by no means all of these, can be accounted for as men who came from these counties and who died in the service of the USA or the 'Colonial' armies.

What of those Irishmen who enlisted (Australia) or were conscripted (Canada, USA, New Zealand) in armies other than that of Britain? How many died in the service of Colonial forces and that of the USA? How are their deaths currently reflected in *Ireland's Memorial Records*? The answer to the former question is, as with so many statistical questions related to the Great War, that we don't know. We can come up with a rough estimate, but detailed and intensive

research would be required to give a definitive answer, if indeed such an answer is possible.

Thanks to the Trojan work of Professor Jeff Kildea and the Irish Anzacs Database, we now know that 5,774 Irish-born soldiers fought in the Australian Imperial Force in the Great War, of whom 860 died.[4] This study reveals as a major underestimate the figures compiled by the Commonwealth War Graves Commission, which puts the number of Irish-born dead in the Australian armed forces at 488. There are 230 Australian names listed in *Ireland's Memorial Records*, however, there is no indication of the place of birth of 192 of those men.

My own researches into the Irish dead in the New Zealand army suggests a figure of around 280 Irish fatalities in units of that 100,000-strong force. This is largely confirmed by the information gleaned from the Commonwealth War Graves Commission website.

It appears that around 20,000 Irishmen served in a Canadian Expeditionary Force that conscripted 630,000 men (just over 400,000 of whom went to Europe).[5] Of those, around 65,000 were lost.[6] On that basis (a 10.3 per cent death rate), up to 2,000 Irishmen may have died while serving in the CEF. However, the Commonwealth War Graves Commission website suggests around half this figure. It records 960 Canadian fatalities of Irish origin.[7] However, given the CWGC Australian underestimate, the numbers may be higher. Canadian attestation papers asked the question 'in what town, township or parish and in what country were you born?' It is possible that a number of recruits neglected to include their country of birth or used an abbreviation such as 'Irl', thus rendering themselves inaccessible on the CWGC website. The same may be true of other colonial forces – this may account for the Australian discrepancy.

The USA is proving, and will continue to prove, most problematic.

By the end of the war, the US Army numbered almost 4.4 million men.[8] However, only half of these actually served overseas. The figure for US fatalities was 116,000 (around half that number died of flu). There is, unfortunately, no indication in the three-volume publication listing American fatalities, *Soldiers of the Great War*, of the birthplaces

of any American dead. They are listed, on a purely residential basis, by US state of origin.

What we do know is that twenty-four million American men were required to register for the draft.[9] Around 18 per cent of those either volunteered for service or were conscripted, though less than 10 per cent served on the Western Front.

The probable total of those with Irish origins who registered for the draft comes to 65,025.[10] Extrapolating from the overall figure, that would give us a cohort of around 11,700 (18 per cent) Irish-born men actually serving in the US Armed Forces. There may well have been more if Irish-born men volunteered in disproportionate numbers, but the names of early volunteers do not show up in the Draft Registration Cards. However, this potential increase in numbers is unlikely, given Irish-American antipathy to the war before American entry into the conflict in April 1917. In addition, many of the most enthusiastic Irish are reckoned to have gone to Canada and joined the CEF.

We don't know how many of that highly speculative number, of just under 12,000, actually went abroad. If we extrapolate once again, we come up with a figure of under 6,000. The American fatality rate was relatively small, around 6 per cent, or a ratio of one death for every seventeen serving soldiers (1:17). On that basis, Irish-born fatalities in the US Army could have been as low as 350, on a par with that of New Zealand in absolute terms but small in proportionate terms.[11] The truth is that we don't know; the process of arriving at the figure of 350 is highly speculative and it would be extremely laborious and time-consuming to attempt to discover the true figure.

As regards Irishmen in the South African and Indian armies, while there were undoubtedly some serving in both forces, the bulk of the million-strong Indian Army was Indian-born and suffered 62,000 deaths, while total South African fatalities came to under 7,000 of the 74,000 who served.[12] The Commonwealth War Graves Commission lists eighty names of members of the South African armed forces associated with Ireland and thirteen (all officers) for the Indian Army. In the case of the former, however, the South Africa War Graves project lists 181 names associated with Ireland, though a detailed

examination is required to ascertain how many of these are likely to have been born in this country.

Based on hard but incomplete evidence for Australia, New Zealand, India, South Africa, and Canada, and little more than informed speculation regarding the USA, the figures for Irish-born dead in the main Imperial armed forces and those of the USA might, at a minimum, look something like this.

AUSTRALIA	860
NEW ZEALAND	280
CANADA	960
INDIA	13
SOUTH AFRICA	80
USA	350
TOTAL	c.2,543

There is, however, a further difficulty with these figures. Although the names of these men should be included in a revised *Ireland's Memorial Records*, taking their place beside Clarke's incomparable designs (thankfully out of copyright), it is not possible simply to add this cohort to the total number of Irish dead recorded in *Ireland's Memorial Records*. Almost 1,000 of the names in that database are of men who served in the Colonial or American armed forces. In most cases there is no indication in the *Records* as to their place of birth; they have simply been included in the volumes. However, despite the fact that they are numbered among the 7,405 men recorded in *Ireland's Memorial Records* but not assigned a country of birth, it is likely that most are of Irish origin. It would appear utterly pointless to have included the names of men serving in, for example, the Australian or Canadian armies, in a record of the Irish dead, if they had no connection whatever with this country. We must assume that certain information was available to the compilers of *Ireland's*

Memorial Records, which meant these names warranted inclusion in the Irish records while the criterion used (Ireland as place of birth) was not included in the record of the dead soldiers.

IRELAND'S MEMORIAL RECORDS RECORDING OF DECEASED IN COLONIAL OR US ARMIES

	TOTAL	IRISH	OTHER	NO NATIONALITY INDICATED
CANADA	644	58	4	582
USA	52	14	20	18
AUSTRALIA	230	21	17	192
NEW ZEAL.	75	15	3	57
INDIA	127	11	73	43
S.AFRICA	72	10	8	54
TOTAL	1200	129	125	946

Only those numbered in Column 3 (Other) are unambiguously *not* Irish. The 129 names in Column 2 are definitively identified as Irish – the mystery is the place of birth of the remaining 946 and why, if they are not Irish, they found their way into *Ireland's Memorial Records* in the first place.

After the inclusion of Irish dead who did not serve in the UK Armed Forces, and including an extrapolation from the mysterious unidentifiable 7,405,[13] the final total of *all* Irish-born soldiers who died in the Great War is likely to come to around 40,000. A definitive reckoning, given the extent to which the 'fog of war' pervades the First World War's fatality statistics, is too much to hope for.

There is, of course, ample room for fevered debate, endless argument, controversy and an unfortunate but unavoidable series of internecine splits over what precisely constitutes an Irishman. Does,

for example, Herbert Kitchener's Ballylongford origins entitle him to inclusion as an Irish casualty?[14] Would he wish to be included? Are his wishes – assuming we were cognisant of them – of any relevance? What about men who resided in Ireland, were of Irish parentage, enlisted in Ireland but might have been born elsewhere because of parental military service, temporary emigration, or an accident of birth? Should there ever be an attempt to 'clean up' *Ireland's Memorial Records* by excluding those clearly unconnected with this country? A set of criteria, rigid and yet flexible, would need to be devised to decide which names were going to replace them.

All of this explains why the only really truthful representation of the sacrifice of Irish combatants in the Great War comes from the imagination and the graphic skills of Harry Clarke.

NOTES

1. The 'In Flanders Fields' project [http://www.inflandersfields.be/en] which digitized and placed online in a searchable document the names of those recorded by the *Ireland's Memorial Records* in 1923.
2. http://jeffkildea.com/wp-content/uploads/2013/02/Irish-Anzacs-2013.pdf - accessed 29.3.2015.
3. www.findmypast.ie - accessed 30.3.2015.
4. http://www.irishtimes.com/news/ireland/irish-news/irish-in-australia-were-not-shirkers-in-first-world-war-1.1967446.
5. http://www.1914-1918.net/faq.htm - accessed 28.3.2015.
6. http://www.cwgc.org/learning-and-resources/publications/annual-report.aspx- accessed 28.3.2015.
7. The methodology employed here was simple and far from foolproof. The word 'Ireland' was inserted in the 'additional information' box in the CWGC 'Find War Dead' search engine. 'First World War' and 'Canadian Forces' were also selected. This brought up 975 records matching the search criteria. sixteen of these represented non-Irish entries of men named 'Ireland'. The same methodology was employed in the case of Australia, New Zealand, South Africa and India.
8. http://www.pbs.org/greatwar/resources/casdeath_pop.html - accessed 28.3.2015.
9. http://search.ancestry.co.uk/search/db.aspx?dbid=6482- accessed 28.3.2015.
10. This calculation is based on the insertion of 'Ireland' as a keyword in the Ancestry.com Draft Registration Cards 1917–18 (66713) and the subtraction from that figure of 1688 men whose surname was Ireland.

11. A recent article in *Irish America* (April/May 2015) by Megan Smolenyak suggests 976 Irish-born dead in the US Armed Forces. The methodology used is speculative but superior to my own in that it is based on actual casualty data rather than draft registration data, albeit from a single state, New Jersey - http://irishamerica.com/2015/03/war-numbers-counting-the-irish-born-dead-in-wwi/ - accessed 30 March 2015.
12. http://www.1914-1918.net/faq.htm - accessed 28.3.2015.
13. Based on a ratio of c.3:1 Irish to non Irish in the INWMR (31,000: 11,000) it can be plausibly argued that c.5400 of those 7405 names are Irish-born.
14. For the record he is included in *Ireland's Memorial Records*.

Appendix

Harry Clarke's War:
Ireland's Memorial Records,
1914–1918

The preface to *Ireland's Memorial Records* states that 100 sets were printed, and the volumes were distributed to principal libraries. Consulting library indexes and newspaper reports, it has been possible to locate seventy-nine of the 100 volumes.

Volumes located as of 2015

1. Canadian War Museum
2. New York Public Library
3. Library of Congress
4. National College of Art and Design, Dublin
5. National Library of Ireland
6. National Library of Scotland
7. Queen's University of Belfast
8. Cathedral Church of St Anne, Belfast
9. Trinity College Library, Dublin
10. Royal Hibernian Academy
11. British Library: Special Editions
12. Vatican Library: Special Edition
13. University of Oxford

14. National Library of South Africa, Cape Town
15. Australian War Memorial, Canberra
16. Royal Irish Academy
17. Irish National War Memorial Gardens, Dublin
18. St Patrick's Cathedral, Dublin
19. Westminster Cathedral, London (RC): St Patrick's Chapel
20. Marsh's Library, Dublin
21. Scottish National Library
22. National Library of Wales, Aberystwyth
23. Folkestone Library
24. Toronto
25. Delhi
26. Melbourne
27. Paris
28. Brussels
29. Royal Library at Windsor
30. St Columb's Cathedral, Derry
31. Belfast Historical Society
32. Belfast Public Library
33. Belfast Linen Hall Library
34. Flanders' Fields Museum (Ypres)
35. Ottawa – Parliamentary Library
36. Ottawa – Department of National Defence
37. New Zealand
38. Limerick
39. Waterford
40. Rathmines
41. Dublin – Trinity Royal College of Science
42. Armagh

43. Birmingham
44. Liverpool
45. Bristol
46. Edinburgh
47. Kingstown
48. Glasgow
49. Manchester
50. Listowel
51. Omagh
52. Perth Bounemouth
53. Southampton
54. Carrick-on-Shannon
55. Coleraine
56. London – Irish Guards
57. Maryborough
58. London – House of Commons
59. Dundalk
60. Sligo
61. Donegal
62. Cork
63. Kilkenny
64. Wexford
65. Enniskillen
66. Victoria Barracks, Belfast
67. Western Command, Chester
68. Southern Command, Tidworth
69. Eastern Command, Shorncliffe
70. Scottish Command, Edinburgh
71. Clonmel

72. Downpatrick
73. Northern Command, York
74. Curragh Camp
75. Newcastle-on-Tyne
76. South Africa
77. Ballymena
78. Drogheda
79. King's Inns, Dublin
80. Boston College

Bibliography

Archives: Manuscripts and Special Collections

Anne S. K. Brown Military Collection, Hay Library, Brown University: *The Irish Soldier.*

The Archive of British Publishing and Printing, University of Reading, Records of George Allen & Unwin Ltd.: MS 3282.

British Library, London, General Reference Collection: C.121.f.1.

Commonwealth War Graves Commission, Maidenhead; Commonwealth War Graves Commission: Douglas Cockerell, Catalogue No. 1069.

Dublin City Archive and Reading Room, Royal Dublin Fusiliers Association papers: RDFA 020.

Early Printed Books, Trinity College Dublin.

Imperial War Museum, London.

James Joyce Library, Special Collections, University College Dublin: *The Irish Soldier.*

Kohler Art Library, University of Wisconsin Madison.

Marsh's Library, Dublin.

National Archives of Ireland, Dublin, Chancery Records 1926; War Memorial Records: TSCH/3/S4156 B.

National Library of Ireland, Dublin: MS 39,202/B, contains Harry Clarke's diaries from 1914 and 1919.

National Photographic Archive, National Library of Ireland, Dublin.

Royal Institute of British Architects Collections at the Victoria and Albert Museum, London: Lutyens papers, DR 20.

Ryerson and Burnham Libraries, Art Institute of Chicago.

Secondary Sources

Abbott, H. H., 'Black and White', in L. D'Oyly Walters (ed.), *The Year's at the Spring: An Anthology of Recent Poetry* (London: Harrap, 1920).

A. Appadurai, *The Social Life of Things: Commodities in Cultural Perspective* (Cambridge: Cambridge UP, 1988).

Australian Army, WWI Gallipoli, http://www.army.gov.au/Our-history/ History-in-Focus/WWI-Gallipoli.

Bakhtin, M., *The Dialogic Imagination*, M. Holquist (ed.), (Austin: University of Texas Press, 1982).

Benest, D., 'Aden to Northern Ireland, 1966–76,' H. Strachan (ed.), *Big Wars and Small Wars: The British Army and the Lessons of War in the Twentieth Century* (London: Routledge, 2006).

Bodkin, T., 'The Art of Mr Harry Clarke,' *The Studio*, 79 (November 1919), Vol. 79, no. 320, pp.44–52.

Bourke, A., *The Burning of Bridget Cleary* (London: Pimlico, 1999).

Bowe, N. G., 'The Book in the Irish Arts and Crafts Movement,' *The Irish Book in the Twentieth Century*, Claire Hutton (ed.), (Sallins: Irish Academic Press, 2004).

Bowe, N. G., 'Evocative and Symbolic Memorials and Trophies by Percy Oswald Reeves', *Irish Arts Review*, 16 (2000).

Bowe, N. G., *Harry Clark: The Life and Work* (Dublin: History Press Ireland, 2012).

Bowe, N. G., 'The Iconic Book in Ireland, 1891–1930,' Hutton, C. and P. Walsh (eds.),. *The Oxford History of the Irish Book*: Volume V/The Irish Book in English 1891–2000 (Oxford: Oxford UP, 2011), pp.390-412.

Bowe, N. G., 'Ireland's Memorial Records, 1914–1918', *Ireland of the Welcomes*, November/December 2006, pp. 18–23.

Bowe, N. G., 'The Irish Arts and Crafts Movement (1886–1925)', *Irish Arts Review* Yearbook (1990–1991).

Bowe, N. G., 'Preserving the Relics of Heroic Time: Visualizing the Celtic Revival in Early Twentieth-Century Ireland', B. Cliff and N. Grene (eds), *Synge and Edwardian Ireland* (Oxford: Oxford UP, 2011).

Bowe, N. G., 'Wilhelmina Geddes, Harry Clarke, and their Part in the Arts and Crafts Movement in Ireland', *The Journal of Decorative and Propaganda Arts* 8 (April 1988).

Bowe, N. G., and E. Cumming, *The Arts and Crafts Movements in Dublin and Edinburgh: 1885–1925* (Dublin: Irish Academic Press, 1998).

Bowen, C., 'Lady Butler: The Reinvention of Military History', *Revue LISA / LISA e-journal*, 1, 1 (2003).

Bowles, J. M., 'William Morris as a Printer: The Kelmscott Press', *Modern Art*, 2, 4 (Autumn, 1894).

Bowman, T., 'The Irish at the Somme', *History Ireland*, 4, 4 (Winter 1996).

British Artists at the Front, (London: Published from the offices of *Country Life*, 1918).

Brittain, V., 'Lament of the Demobilised', *Oxford Poetry* (Oxford: Basil Blackwell, 1920).

Brown, K., *The Yeats Circle, Verbal and Visual Relations in Ireland, 1880-1939* (London: Ashgate, 2011).

Burnell, T., *The Tipperary War Dead: History of the Casualties of the First World War* (Dublin: Nonsuch, 2008).

Callan, P., 'The Irish Soldier: A Propaganda Paper For Ireland September – December 1918', *The Irish Sword*, 15 (1982).

Callan, P., 'Recruiting for the British Army in Ireland During the First World War', *Irish Sword* 17 (1987).

Camille, M., *Image on the Edge: The Margins of Medieval Art* (London: Reaktion, 2004).

Campbell, M. B., *The Witness and the Other World: Exotic European Travel Writing, 400 –1600* (Ithaca: Cornell UP, 1988).

Casey, P., 'Irish Casualties in the First World War', *Irish Sword* 20, 81 (1997).

Catalogue of an Exhibition of Drawings by Léon Bakst for Ballets, Plays, and Costumes (London: Fine Art Society, 1913).

Catalogue of Designs for the Ballet 'La Belle au Bois Dormant' by Léon Bakst (London: Fine Art Society, 1917).

Clarke, D. 'Rumours of Angels: A Legend of the First World War', *Folklore*, 13, 2 (October 2002), p.156.

Clarke, K. *Kathleen Clarke: Revolutionary Woman* (Dublin: The O'Brien Press, 2008), p.120.

Commonwealth War Graves Commission. *Dedication of the Cross of Sacrifice by the President of Ireland, Michael D. Higgins and centenary commemoration of the First World War attended by HRH Prince Edward, Duke of Kent,* Commonwealth War Graves Commission (31 July 2014).

Condon, D. 'Going to the Pictures in Phibsboro in 1914.' Unpublished manuscript, 2014.

Condon, D., 'Rolls of Honour: Irish Film Businesses and the War, Autumn 1914', *Early Irish Cinema*, 22 October 2014.

Condon, D.,'"Temples to the Art of Cinematography": The Cinema on the Dublin Streetscape, 1910–1920', J. Carville (ed.), *Visualizing Dublin: Visual Culture, Modernity and the Representation of Urban Space* (Bern: Peter Lang, 2013).

Condon, D. 'The Volta Myth,' *Film Ireland* 116 (May/June 2007).

Cope, E. M. *Commentary on the Rhetoric of Aristotle,* (Cambridge. Cambridge University Press, 1877).

Corcoran, M., *Through Streets Broad and Narrow: A History of Dublin Trams* (Ian Allan Publishing, 2008).

Cork, R., *A Bitter Truth: Avant-Garde Art and the Great War* (New Haven: Yale, 1994).

Cotton, A. L., 'The Kelmscott Press and the New Printing', *The Contemporary Review*, 74 (London: Isbister and Company, 1898).

Crane, D. *Empires of the Dead* (London: Collins, 2013).

Crompton, A., 'The Secret of the Cenotaph,' cromp.com,

Cronin, M., 'The State on Display: The 1924 Tailteann Art Competition', *New Hibernia Review / Irish Éireannach Nua*, 9, 3 (Autumn 2005).

D'Arcy, F., *Remembering the War Dead: British Commonwealth and International War Graves in Ireland Since 1914* (Dublin: The Stationery Office, 2007).

Denman, T., *Ireland's Unknown Soldiers: The 16th (Irish) Division in the Great War, 1914–1918* (Dublin: Irish Academic Press, 1992).

deVries, D., D.B. Johnson, and L. Ashenden, *Vladimir Nabokov and the Art of Painting* (Amsterdam: Amsterdam University Press, 2006).

Dooley, T., *Irishmen or English Soldiers? The Times and World of a Southern Catholic Irish Man (1876–1916) Enlisting in the British Army During the First World War* (Liverpool: Liverpool University Press, 1995).

Dowling, W. J., 'Harry Clarke: Dublin Stained Glass Artist', *Dublin Historical Record*, 17, 2 (March 1962).

Dublin City Gallery, The Hugh Lane. *Dublin Divided: September 1913* (Dublin: Hugh Lane, 2013).

Eksteins, M., *Rites of Spring: The Great War and the Birth of the Modern Age* (Boston: Houghton Mifflin, 1989).

Eliot., T. S., 'Dramatis Personae', *Criterion*, 1 (April 1923).

Faust, D. G., '"Numbers on Top of Numbers": Counting the Civil War Dead,' *Journal of Military History*, 70, 4 (2006).

Forces War Records, Royal Berkshire Regiment, http://www.forces-war-records.co.uk/units/475/royal-berkshire-regiment/.

Forces War Records, Royal Hampshire Regiment, *Forces War Records*, http://www.forces-war-records.co.uk/units/256/royal-hampshire-regiment/.

Forster, E. M., *Howards End* (New York: Knopf, 1921).

Frow, E. and R. Frow, 'William Morris and Ireland,' *Saothar*, 21 (1996).

Fussell, P. *The Great War and Modern Memory* (Oxford: Oxford UP, 1975).

Gallatin, A. E., *Art and the Great War* (New York: E.P. Dutton & Co., 1919).

Geurst, J., *Cemeteries of the Great War by Sir Edwin Lutyens* (Rotterdam: nai010 Publishers, 2013).

Glaister, G. A., *Encyclopedia of the Book* (New Castle, Del.: Oak Knoll Press, 1996).

Gliddon, G., *The Battle of the Somme: A Topographical History* (Stroud: Sutton Publishing, 1998).

Gosling, L., *Brushes and Bayonets: Cartoons, Sketches and Paintings of World War I* (Oxford: Osprey, 2008).

Greenburg, A., 'Lutyens's Cenotaph', *Journal of the Society of Architectural Historians*, 48, 1 (March 1989).

Gunning, T., 'Chaplin and the Body of Modernity', *Early Popular Visual Culture*, 8, 3 (August 2010).

Gwynn, S. and T. Kettle, *Battle Songs for the Irish Brigades* (Dublin: Maunsel & Co., 1915).

Hammond, M., "'So Essentially Human": The Appeal of Chaplin's *Shoulder Arms* in Britain, 1918', *Early Popular Visual Culture*, 8, 3 (2010).

Hanks, S., 'The Birth of the Tramp: Chaplin, Gesture, and the Rhythms of Modernity', *Postgraduate English*, 26 (March 2013).

Harrap, G., *Some Memories, 1901–1935* (London: Harrap, 1935).

Harrington, A., 'Eloquent Silence: Akhmatova, Mandelśhtam, Early Cinema, and Modernism', *Slavonica*, 18, 2 (October 2012).

Hart, P., *Gallipoli* (Oxford: Oxford UP, 2011).

Hartcup, G., *Camouflage: A History of Concealment and Deception in War* (New York: Scribner, 1980).

Helmers, M., 'Iconic Images of Wounded Soldiers by Henry Tonks', *Journal of War and Culture Studies*, 3, 2 (2010).

Herren, M. W. and S. A. Brown, *Christ in Celtic Christianity: Britain and Ireland from the Fifth to the Tenth Century* (Woodbridge, Suffolk: Boydell Press, 2002).

Holme, C. (ed), 'The Great War, Depicted by Distinguished British Artists,' *The Studio: An Illustrated Magazine of Fine and Applied Art* (1918).

Holmes, R., *The Little Field Marshal: A Life of Sir John French* (Weidenfeld & Nicolson, 2004).

Hone, J. M., *Memories of W. B. Yeats, Lady Gregory, J. M. Synge and Other Essays* (Dublin: Rosemary Hone, 2007).

Horne, J., *Our War: Ireland and the Great War* (Dublin: Royal Irish Academy, 2008).

Horne, J. and E. Madigan, *Towards Commemoration: Ireland in War and Revolution, 1912-1923* (Dublin: Royal Irish Academy, 2013).

Hussey, C. *The Life of Sir Edwin Lutyens* (London: Country Life, 1953).

Hutton, C. and P. Walsh (eds.), *The Oxford History of the Irish Book*: Volume V/The Irish Book in English 1891-2000 (Oxford: Oxford UP, 2011).

Hutton, C. (ed.), *The Irish Book in the Twentieth Century* (Sallins: Irish Academic Press, 2004).

Jeffery, K., 'Artists and the First World War', *History Ireland*, 1, 2 (Summer 1993).

Jeffery, K., *Ireland and the Great War* (Cambridge: Cambridge UP, 2000).

Johnson, N. C., *Ireland, the Great War and the Geography of Remembrance* (Cambridge: Cambridge UP, 2003).

Johnson, N. C., 'The Spectacle of Memory: Ireland's Remembrance of the Great War, 1919', *Journal of Historical Geography*, 25, 1 (January 1999).

Johnstone, T., *Orange, Green, and Khaki: The Story of the Irish Regiments in the Great War, 1914–18* (Dublin: Gill and MacMillan, 1992).

Jones, H., 'Church of Ireland Great War Remembrance in the South of Ireland: A Personal Reflection', J. Horne and E. Madigan (eds.), *Towards Commemoration: Ireland in War and Revolution, 1912–1923* (Dublin: Royal Irish Academy, 2013).

Journal and Proceedings of the Arts and Crafts Society of Ireland, 1, 3 (1901).

Kahn, E., 'Art from the Front: Death Imagined and the Neglected Majority,' *Art History*, 8, 2 (June 1985).

Kahn, E., *The Neglected Majority: "Les Camoufleurs," Art History and World War* (London: UP of America, 1984).

Kaplan, W., 'Traditions Transformed: Romantic Nationalism in Design, 1890–1920', *Designing Modernity: The Arts of Reform and Persuasion, 1895–1945*, W. Kaplan (ed.), (London: Thames and Hudson, 1995).

Keegan, J., *The First World War* (New York: Knopf, 1999).

Kopytoff, I., 'The Cultural Biography of Things: Commoditization as Process,' in A. Appadurai (ed.), *The Social Life of Things: Commodities in Cultural Perspective*, (Cambridge: Cambridge UP, 1988), p.81.

Leland, M., *The Honan Chapel: A Guide* (Cork: Honan Trust, 2004).

Leonard, J., '"Lest We Forget"', *Ireland and the First World War*, D. Fitzpatrick (ed.), (Dublin: Lilliput Press, 1988).

Levitch, M., 'Death and Material Culture: The Case of Pictures During the First World War', N. Saunders (ed.), *Matters of Conflict: Material Culture, Memory and the First World War* (London: Routledge, 2004).

Longworth, P., *The Unending Vigil: The History of the Commonwealth War Graves Commission* (Barnsley: Pen and Sword, 2003).

Machen, A. 'The Bowmen,' *The Angels of Mons: The Bowmen and Other Legends of the War* (New York: G. P. Putnam's and Sons, 1915), p.29.

Macleod, J., *Reconsidering Gallipoli* (Manchester: Manchester UP, 2004).

Malone, C., 'A Job Fit for Heroes? Disabled Veterans, The Arts and Crafts Movement and Social Reconstruction in Post-World War I Britain', *First World War Studies*, 4, 2 (2013).

Malvern, S. '"War As It Is": The Art Of Muirhead Bone, C. R. W. Nevinson and Paul Nash, 1916–17', *Art History*, 9, 4 (December 1986).

Masefield, J., *The Old Front Line* (New York: Macmillan, 1917).

McCabe, S., 'Delight in Dislocation: The Cinematic Modernism of Stein, Chaplin, and Man Ray', *Modernism / Modernity*, 8, 3 (2001).

Middlebrook, M., *The First Day on the Somme, 1 July 1916* (New York: Norton, 1972).

Moran, S. Farrell, 'Images, Icons and the Practice of Irish History', *Images, Icons and the Irish Nationalist Imagination 1870–1925* (Dublin: Four Courts, 1999).

Morris, W., 'The Ideal Book: A Paper by William Morris', Delivered at the Bibliographical Society, London, 19 June 1893, (London: L.C.C. Central School of the Arts and Crafts, 1908).

Morris, W., *Arts and Crafts Essays* (London: Longmans, Green, & Co., 1899).

Mosse, G., *Fallen Soldiers: Reshaping the Memory of the Great War* (Oxford: Oxford UP, 1991).

Murray, P. *Skippy Dies* (New York: Macmillan, 2010).

Murphy, L., 'Charlot Francais: Charlie Chaplin, The First World War, and the Construction of a National Hero', *Contemporary French and Francophone Studies*, 14, 4 (September 2010).

Nash, P., *Outline: An Autobiography* (London: Faber & Faber, 1949).

O'Connell, J., *The Arts and Crafts Society of Ireland and Guild of Irish Art Workers Catalogue of The Fifth Exhibition, 1917* (Dublin: George Roberts and Co., 1917).

O'Connor, E., *Seán Keating: Art, Politics and Building the Irish Nation* (Dublin: Irish Academic Press, 2013).

Orr, P., *Field of Bones: An Irish Division at Gallipoli* (Dublin: Lilliput Press, 2006).

Paul, P., 'Charles Chaplin and the Annals of Anality,' in *Comedy / Cinema / Theory*, A. S. Horton (ed.), (Berkeley: U of California P, 1991).

Pearse, P., 'The Rebel', *Plays, Stories, Poems* (Dublin: Maunsel, 1917).

Pennell, C., *A Kingdom United: Popular Responses to the Outbreak of the First World War in Britain and Ireland* (Oxford: Oxford UP, 2012).

Peterson, W. S., *The Kelmscott Press: A History of William Morris's Typographical Adventure* (New York: Oxford, 1991).

E. Reilly, 'Text and Illustration in Irish Historical Fiction, 1875–1920', *Images, Icons and the Irish Nationalist Imagination, 1870–1925*, L. McBride (ed.), (Dublin: Four Courts, 1999), p.99.

Rendell, J., *Profiles of the First World War: The Silhouettes of Captain H.L. Oakley* (Stroud, Gloucestershire: Spellmount, 2013).

Rewald, S., 'Introduction', *Max Ernst: A Retrospective*, W. Spies (ed.), (New Haven: Yale, 2005).

Roud, S. 'Angels,' *The Penguin Guide to Superstitions of England and Ireland* (London: Penguin, 2006).

Royal Academy of Arts, *War Memorials Exhibition 1919* (London: William Clowes and Sons, 1919).

Russell, G., 'Nationality or Cosmopolitanism', *Irish Writing in the Twentieth Century: A Reader*, D. Pierce (ed.), (Cork:

Russell, G., *The National Being: Some Thoughts on an Irish Polity* (Dublin: Maunsel, 1916).

Ryan, L., 'A Question of Loyalty: War, Nation and Feminism in Early 20th Century Ireland', *Women's Studies International Forum*, 20, 1 (1997).

Sacco, J., *The Great War: July 1, 1916: The First Day of the Battle of the Somme* (New York: W. W. Norton, 2013).

Saunders, N., *Matters of Conflict: Material Culture, Memory and the First World War* (London: Routledge, 2004).

Sheehy, Jeanne J., *The Rediscovery of Ireland's Past: The Celtic Revival, 1830–1930* (London: Thames & Hudson, 1980).

Simkins, P., *Kitchener's Army: The Raising of the New Armies, 1914–1916* (Pen and Sword, 2007).

Skelton T., and G. Gliddon, *Lutyens and the Great War* (Frances Lincoln, 2009).

Skelton, T., 'Remembering the Great War with Lutyens', *British Archaeology*, 109 (2009).

Smith, C. *Catalogue of the War Memorials Exhibition, 1919*, Victoria and Albert Museum, (London, 1919).

'Splendid Example of Dublin Book-Production,' *Irish Printers' Advertiser*, 3, 3 (July 1924), pp.3-6.

Staunton, M. D., 'The Nation Speaking to Itself: A History of the Sinn Féin Printing and Publishing Co. Ltd., 1906–1914,' *The Book in Ireland*, J. Genet, S. Mikowski and F. Garcier (eds), (Newcastle: Cambridge Scholars Publishing, 2008).

Strachan, J. and C. Nally, *Advertising, Literature and Print Culture in Ireland, 1891-1922* (New York: Palgrave, 2012).

Sullivan, E., *The Book of Kells* (London: The Studio, 1914).

'The King's Book Of Heroes: The Most Moving and Poignant Memorial to Those Who Died in the First World War', *York Press*, 23 July 2014.

Thomson, E. M., 'Aesthetic Issues in Book Cover Design 1880–1910', *Journal of Design History*, 23, 3 (2010).

Townshend, C., *Easter 1916: The Irish Rebellion* (London: Allen Lane, 2005).

Turpin, J., 'The Education of Irish Artists, 1877–1975', *Irish Arts Review*, 13 (1997).

Weintraub, S., *Beardsley* (New York: Penguin, 1972).

Wells, W., *John Redmond: A Biography* (London: Nisbet and Co., 1919).

White, G. and B. O'Shea, *A Great Sacrifice: Cork Servicemen Who Died in the Great War* (Cork: Echo, 2010).

Wilhide, E. *Sir Edwin Lutyens: Designing in the English Tradition* (New York Abrams, 2000).

Winter, J. *Sites of Memory, Sites of Mourning: The Great War in European Cultural History* (Cambridge: Cambridge UP, 1999).

Winter, J., 'World War I Created New Culture of Mourning', *Deutsche Welle*, 18 November 2013.

Yeats, W. B., 'Ireland and the Arts,' *The Collected Works of W. B. Yeats: Volume IV, Early Essays* (New York: Scribner, 2007).

LIST OF FIGURES

LIST OF PLATES

reverse. *Ireland's Memorial Records, 1914–1918.* Harry Clarke, illustrator. Dublin: Maunsel and Roberts, 1923. Image courtesy of Eneclann.

Plate 8 'Plate Six,' Recto (Chapter 3). A soldier in silhouette stands reverently at a grave. The Madonna and Child are on the left side of the page. *Ireland's Memorial Records, 1914–1918.* Harry Clarke, illustrator. Dublin: Maunsel and Roberts, 1923. Image courtesy of Eneclann.

Plate 9 'Plate Eight,' Recto (Chapter 3). Grenade throwers in silhouette and a gas mask. *Ireland's Memorial Records, 1914–1918.* Harry Clarke, illustrator. Dublin: Maunsel and Roberts, 1923. Image courtesy of Eneclann.

Plate 10 'Plate Seven,' Verso (Chapter 3). Drawn from the Elizabethan 'carpet page' style and always bound together with its reverse, this page is largely ornamentation. *Ireland's Memorial Records, 1914–1918.* Harry Clarke, illustrator. Dublin: Maunsel and Roberts, 1923. Image courtesy of Eneclann.

Plate 11 'Plate Seven,' Recto (Chapter 3). Carpet page. *Ireland's Memorial Records, 1914–1918.* Harry Clarke, illustrator. Dublin: Maunsel and Roberts, 1923. Image courtesy of Eneclann.

Plate 12 End paper. *Ireland's Memorial Records, 1914–1918.* Harry Clarke, illustrator. Dublin: Maunsel and Roberts, 1923. Image courtesy of Eneclann.

INDEX